PAINTING *fabulous* FLOWERS

with DONNA DEWBERRY

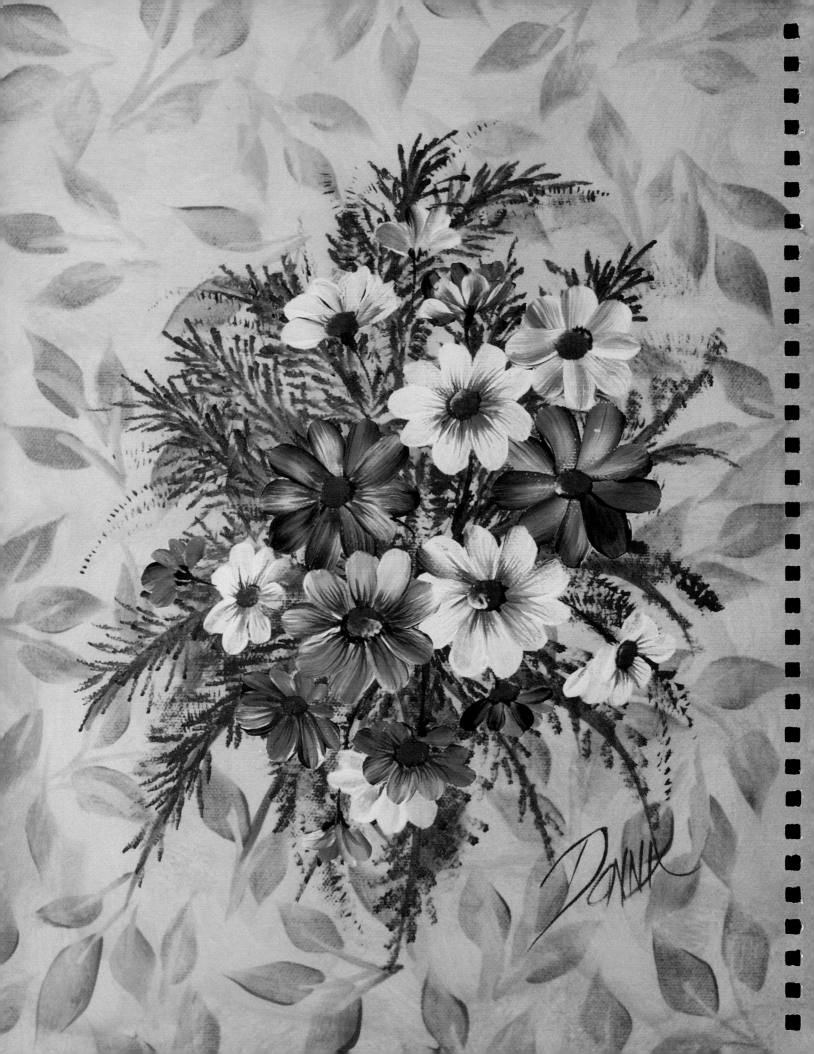

PAINTING *fabulous* FLOWERS

with DONNA DEWBERRY

NORTH LIGHT BOOKS
Cincinnati, Ohio
www.artistsnetwork.com

Painting Fabulous Flowers with Donna Dewberry. Copyright © 2006 by Donna Dewberry. Manufactured in China. All rights reserved. No part of this book may be reproduced in any form or by any electronic or mechanical means including information storage and retrieval systems without permission in writing from the publisher, except by a reviewer who may quote brief passages in a review. The content of this book has been thoroughly reviewed for accuracy. However, the author and publisher disclaim any liability for any damages, losses or injuries that may result from the use or misuse of any product or information presented herein. It is the purchaser's responsibility to read and follow all instructions and warnings on all product labels. Published by North Light Books, an imprint of F+W Publications, Inc., 4700 East Galbraith Road, Cincinnati, Ohio, 45236. (800) 289-0963. First edition.

fw
F+W PUBLICATIONS, INC.

Other fine North Light Books are available from your local bookstore, art supply store or direct from the publisher.

10 09 08 07 06 5 4 3 2 1

Distributed in Canada by Fraser Direct
100 Armstrong Avenue
Georgetown, ON, Canada L7G 5S4
Tel: (905) 877-4411

Distributed in the U.K. and Europe by David & Charles
Brunel House, Newton Abbot, Devon, TQ12 4PU, England
Tel: (+44) 1626 323200, Fax: (+44) 1626 323319
Email: postmaster@davidandcharles.co.uk

Distributed in Australia by Capricorn Link
P.O. Box 704, S. Windsor NSW, 2756 Australia
Tel: (02) 4577-3555

Library of Congress Cataloging-in-Publication Data
Dewberry, Donna S.
 Painting fabulous flowers with Donna Dewberry.
 p. cm.
 Includes index.
 ISBN-13: 978-1-58180-856-8 (alk. paper)
 ISBN-10: 1-58180-856-9 (alk. paper)
 ISBN-13: 978-1-58180-857-5 (pbk. : alk. paper)
 ISBN-10: 1-58180-857-7 (pbk. : alk. paper)
 1. Flowers in art. 2. Painting—Technique. I. Title.

ND1400.D435 2006
751.45'4343—dc22
 2006048255

Edited by Kathy Kipp
Designed by Clare Finney
Interior layout by Kathy Gardner
Production coordinated by Greg Nock
Photographed by Christine Polomsky

METRIC CONVERSION CHART

TO CONVERT	TO	MULTIPLY BY
Inches	Centimeters	2.54
Centimeters	Inches	0.4
Feet	Centimeters	30.5
Centimeters	Feet	0.03
Yards	Meters	0.9
Meters	Yards	1.1
Sq. Inches	Sq. Centimeters	6.45
Sq. Centimeters	Sq. Inches	0.16
Sq. Feet	Sq. Meters	0.09
Sq. Meters	Sq. Feet	10.8
Sq. Yards	Sq. Meters	0.8
Sq. Meters	Sq. Yards	1.2
Pounds	Kilograms	0.45
Kilograms	Pounds	2.2
Ounces	Grams	28.3
Grams	Ounces	0.035

about the author

Donna Dewberry is the most successful decorative painter ever. She is the originator of the One-Stroke painting technique, and has developed the One-Stroke Certified Instructor (OSCI) program for teachers. She is seen weekly on PBS stations nationwide with her program "One-Stroke Painting with Donna Dewberry" and is also a regular presenter on the Home Shopping Network. Her designs are licensed for home décor fabrics, wallpapers, borders, stick-ons, bedding, needlework, and paper crafts. Donna has published nine books with North Light; her most recent is *Donna Dewberry's Designs for Entertaining*.

dedication

To Maribel and Althea...

I would like to dedicate this book to two very important people in my life. These two wonderful ladies have been instrumental in my ability to complete books like this. They have given not only of their time but also of themselves. They have worked long hours not only assisting in this book but have done many of the never-ending daily tasks associated with Dewberry Designs, Inc. so that I might concentrate on the completion of this book. There is no way to put that kind of dedication into words.

Maribel and Althea are truly wonderful and are two of the hardest working people I know. They have been such an inspiration to me at times and I appreciate all they do for me. I probably haven't expressed that as often or as well as I should but I do appreciate all they do to assist me. In many instances I find myself thinking of them as my sisters and realize how lucky I am to have such wonderful friends. I guess I sometimes treat them like sisters as well, and that may not be so wonderful for them... Maribel and Althea, thank you for all you do and thank you for being my friends.

Love, Donna

acknowledgments

I would like to thank Kathy Kipp, my editor at North Light Books, for her dedication and all the hard work she so willingly gives to each and every one of my books. Kathy directs my creativity so that I keep my focus on the task at hand. I appreciate all her input and consider her a friend as well. Thank you, Kathy!

table of contents

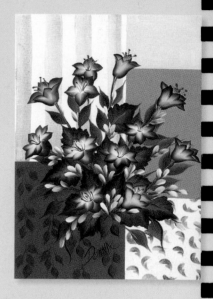

painting fabulous flowers step by step

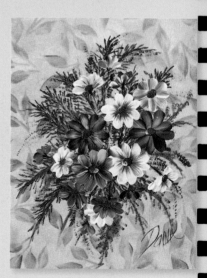

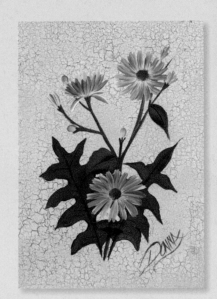

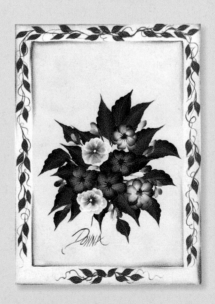

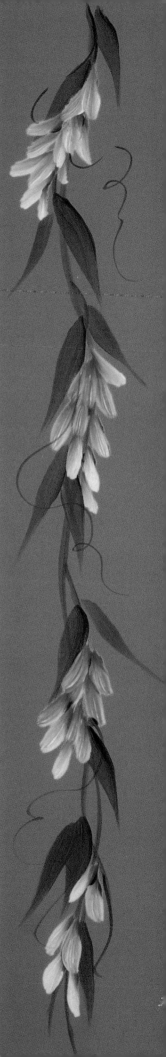

paints and mediums

ACRYLIC PAINTS

Plaid FolkArt acrylic colors are high-quality acrylic paints that come in handy 2-oz. (59ml) squeeze bottles. Their rich and creamy formulation and long open time make them perfect for decorative painting. They are offered in a wide range of wonderful pre-mixed colors.

ARTISTS' PIGMENTS

FolkArt Artists' Pigments are pure colors that are perfect for mixing your own shades. Their intense colors and creamy consistency are wonderful for blending, shading and highlighting. Because they're acrylic paints, they're easy to clean up and have no odor.

MEDIUMS

FolkArt Floating Medium is a clear gel that is specially formulated for "floating" acrylic colors. It won't run like water can, and it dries quickly without extenders. I use it often to make my acrylic colors more transparent (for example, when painting shadow leaves) and to float shading around and between flower petals and leaves, and to add shadows.

Glazing Medium is mixed with acrylic colors to provide translucency over large areas. In this book, I use it to create subtle faux-finish backgrounds for the flower paintings.

Crackle Medium is used to create a large or fine crackled-paint finish for an aged look. See pages 82-85 for examples of crackled backgrounds and crackled frames.

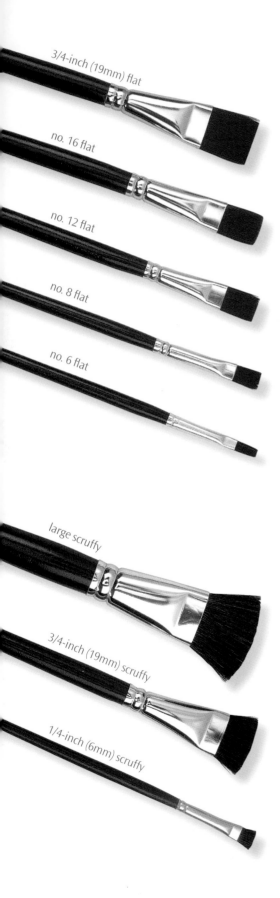

3/4-inch (19mm) flat

no. 16 flat

no. 12 flat

no. 8 flat

no. 6 flat

large scruffy

3/4-inch (19mm) scruffy

1/4-inch (6mm) scruffy

brushes

FLAT BRUSHES

Painting the One-Stroke technique requires the use of flat brushes. Flats are designed with longer bristles and less thickness in the body of the bristles to allow for a much sharper chisel edge. In the instructions for the flower painting projects in this book, I often say "begin on the chisel edge" or "lift back up to the chisel edge." A sharp chisel edge is essential to the success of your one-stroke painting.

FILBERT, ANGULAR AND FEATHER BRUSHES

A filbert brush is a flat brush with a chisel edge that has been cut into a curve. This brush creates a rounder outer edge on the petals of flowers such as daisies and lilacs. An angular brush is also a flat brush with a chisel edge, but its bristles are trimmed at an angle, making one side longer (the toe) than the other side (heel). The angular brush makes painting comma strokes much easier. The feather brush is a flat brush whose bristles thin out along the chisel edge. I love using this brush to paint feathery blossoms such as bottlebrush and even palm fronds.

SCRUFFY BRUSHES

Scruffy brushes come in several sizes from very large to very small. I use them to pounce on mosses, wisteria, flower centers, faux finishes and shading textures, among others. Do not use water when painting with scruffy brushes.

ROUND AND LINER BRUSHES

A round brush can be used to paint scrolls, flower petals, leaves and lettering. It holds a lot of paint and the roundness eliminates sharp edges, making elegant strokes easy. Liners are round brushes with very thin bristles. Use these with "inky" paint for curlicues and tendrils, and with regular paint to dot in flower centers.

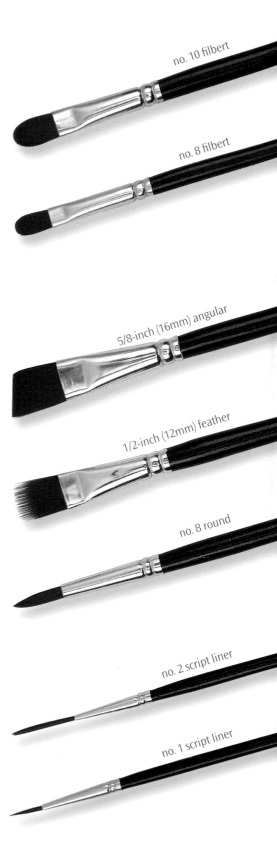

no. 10 filbert

no. 8 filbert

5/8-inch (16mm) angular

1/2-inch (12mm) feather

no. 8 round

no. 2 script liner

no. 1 script liner

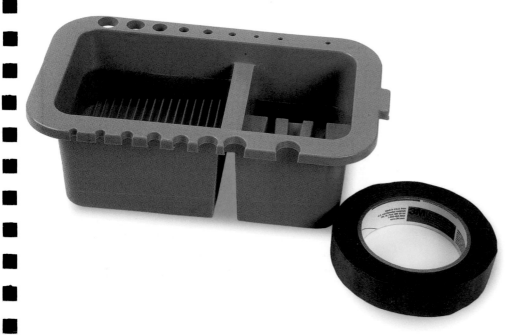

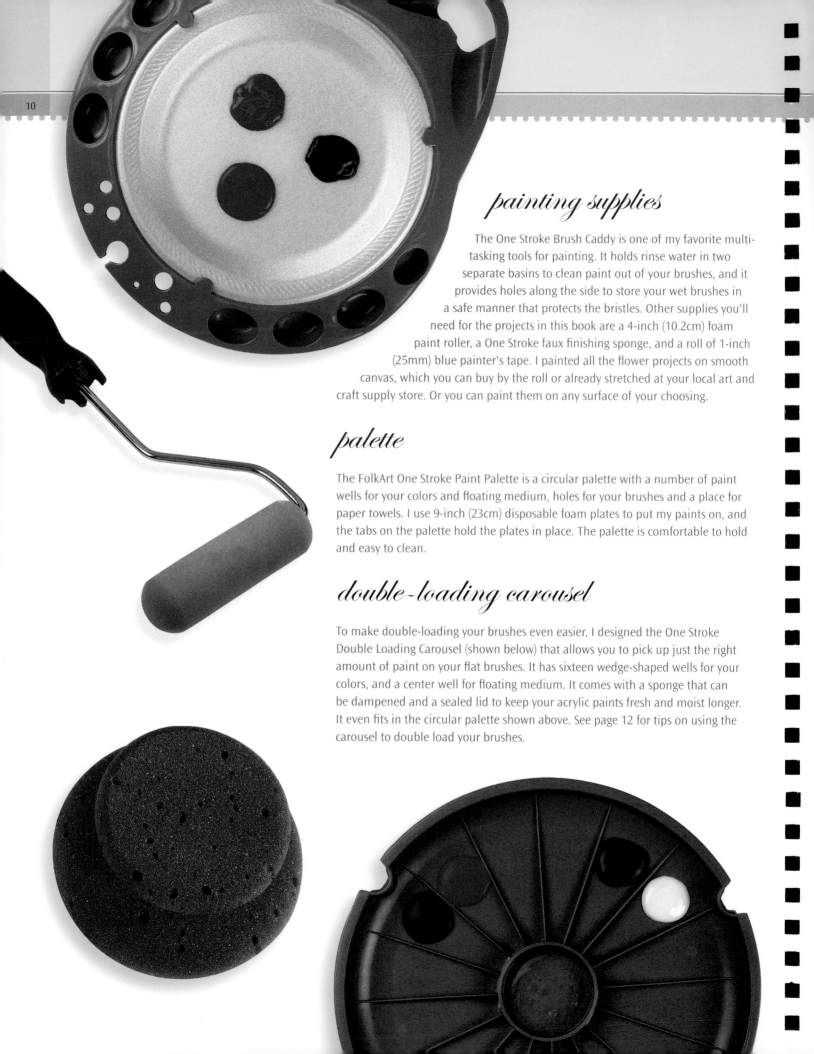

painting supplies

The One Stroke Brush Caddy is one of my favorite multi-tasking tools for painting. It holds rinse water in two separate basins to clean paint out of your brushes, and it provides holes along the side to store your wet brushes in a safe manner that protects the bristles. Other supplies you'll need for the projects in this book are a 4-inch (10.2cm) foam paint roller, a One Stroke faux finishing sponge, and a roll of 1-inch (25mm) blue painter's tape. I painted all the flower projects on smooth canvas, which you can buy by the roll or already stretched at your local art and craft supply store. Or you can paint them on any surface of your choosing.

palette

The FolkArt One Stroke Paint Palette is a circular palette with a number of paint wells for your colors and floating medium, holes for your brushes and a place for paper towels. I use 9-inch (23cm) disposable foam plates to put my paints on, and the tabs on the palette hold the plates in place. The palette is comfortable to hold and easy to clean.

double-loading carousel

To make double-loading your brushes even easier, I designed the One Stroke Double Loading Carousel (shown below) that allows you to pick up just the right amount of paint on your flat brushes. It has sixteen wedge-shaped wells for your colors, and a center well for floating medium. It comes with a sponge that can be dampened and a sealed lid to keep your acrylic paints fresh and moist longer. It even fits in the circular palette shown above. See page 12 for tips on using the carousel to double load your brushes.

colors used

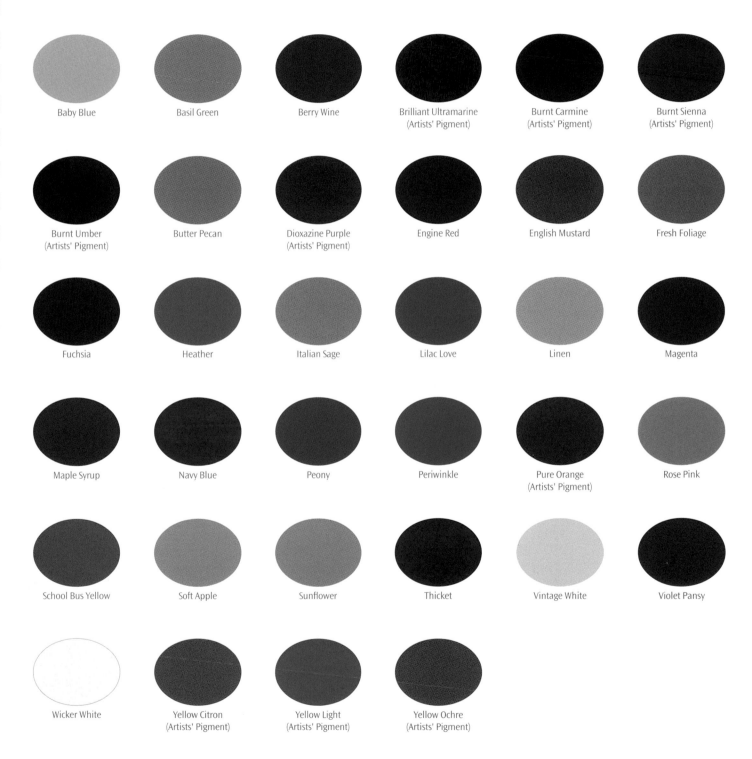

| Baby Blue | Basil Green | Berry Wine | Brilliant Ultramarine (Artists' Pigment) | Burnt Carmine (Artists' Pigment) | Burnt Sienna (Artists' Pigment) |

| Burnt Umber (Artists' Pigment) | Butter Pecan | Dioxazine Purple (Artists' Pigment) | Engine Red | English Mustard | Fresh Foliage |

| Fuchsia | Heather | Italian Sage | Lilac Love | Linen | Magenta |

| Maple Syrup | Navy Blue | Peony | Periwinkle | Pure Orange (Artists' Pigment) | Rose Pink |

| School Bus Yellow | Soft Apple | Sunflower | Thicket | Vintage White | Violet Pansy |

| Wicker White | Yellow Citron (Artists' Pigment) | Yellow Light (Artists' Pigment) | Yellow Ochre (Artists' Pigment) |

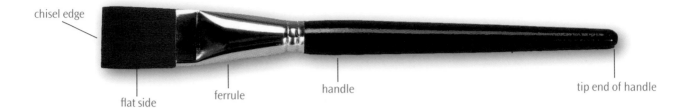

chisel edge

flat side

ferrule

handle

tip end of handle

DOUBLE-LOADING A FLAT BRUSH

1. Using the Double Loading Carousel, place puddles of paint in the wedge-shaped sections of the carousel. Place the colors you'll be double loading next to each other. Here, I've placed Fuchsia and Wicker White, but I'll also be double loading Violet Pansy and Wicker White.

2. Stand the flat brush straight up with half the bristles in one color and half in the other. Slide back and forth to fill the bristles with paint. The carousel's divided wedges keep the colors separate for you.

3. Move your brush to an open wedge and work the paint into the bristles. If you don't have any open wedges available, use your palette or a foam plate for this. Repeat this process each time. you pick up more paint.

4. Keep your loading spot no more than 1½ inches (38mm) to 2 inches (51mm) long. Don't allow it to stretch longer and longer as you work the paint into the bristles.

5. This is a correctly loaded flat brush. Your bristles should be no more than two-thirds full with paint.

LOADING AN ANGULAR BRUSH

HEEL
On an angular brush, the heel is the shorter side of the bristles.

TOE
The toe is the longer side of the bristles. Hold the brush so the toe is at the top.

1. Dampen the brush. Stroke between the two puddles of color. Here, I'm loading Magenta onto the heel and Wicker White onto the toe.

2. Work the colors into the bristles. Pick up more paint as you stroke. It takes quite a few strokes to get the toe fully loaded with color.

3. This is how a properly loaded angular brush should look.

MULTI-LOADING

Double load your brush. Then dip one corner into a third color. Add lighter colors to the light side of the brush and darker to the dark side.

SIDE LOADING

1. To sideload your brush, begin by pulling some paint from the edge of the first paint puddle.

2. Stroke right next to the second color puddle to pick up a little paint on the edge of the brush.

LOADING A SCRIPT LINER

1. Add a few drops of clean water next to the puddle of paint. Pull a little paint into the water to thin it to an inky consistency.

2. As you pull the brush out, roll the brush in your fingers and drag the tip of the bristles on the palette to bring them to a point.

CURLICUES

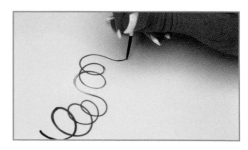

To paint curlicues and tendrils, brace your little finger on the surface and move your whole arm, not just your wrist.

DOUBLE-LOADING A FILBERT BRUSH

1. Dampen your filbert brush with water. Pull paint outward from the edge of your first puddle of color.

2. Flip the brush over to the other side. Pull the second color out from the edge of the puddle.

3. When you stroke with the loaded filbert, the key thing to remember is that the color facing upward is the dominant color. Here it's the orange.

4. But here the dominant color is the yellow because the yellow side of the brush is facing upward.

DOUBLE-LOADING A SCRUFFY BRUSH

1. A scruffy brush is loaded differently than a flat. Never dampen it first with water, and never dip it into the middle of a paint puddle. Instead, pounce the scruffy at the edge of the puddle to load half of the brush with the first color.

2. This shows how only one-half of the bristles are loaded with paint so far.

3. Now pounce the other side of the scruffy into the edge of the puddle of the second color.

4. Now you can see how the brush is double-loaded evenly with the two colors.

LOADING A FEATHER BRUSH

1. Dampen your feather brush with water. Pull paint out from the very edge of the puddle of color.

2. The feather brush is great for making a series of fine lines, like a bottlebrush flower or little palm fronds.

ADDING FLOATING MEDIUM

1. If your brush begins to feel dry when you're painting, add floating medium. Dip the loaded brush straight into the puddle of medium.

2. Work the medium into the bristles on your palette. Use floating medium only every third or fourth stroke.

LOADING THE BRUSH FOR FLOATING

1. First load your brush with floating medium by pulling it out from the side of the puddle.

2. Sideload into your puddle of color ever so lightly on the corner of the brush.

DOTTING FLOWER CENTERS WITH THE HANDLE END

1. This is the easiest and fastest way to dot in the centers of flowers. Turn your brush upside down and dip the tip end of the handle into the paint, holding your brush straight up and down.

2. Touch the handle end to the center area of the flower and lift straight out. Don't turn or twist the handle or make a circular motion. And be careful not to smear the dot while it's drying.

MAKING STARTER STROKES

1. Every time you load your brush and before you apply a stroke to your painting, you need to do a starter stroke. A starter stroke is actually three or more strokes right on top of each other. To begin, touch and push down on the bristles.

2. Then lift and repeat three or more times until the color is the way you want it to be. The starter stroke spreads the bristles and blends the colors.

CHISEL-EDGE PETAL STROKE

1. Double load the brush with the two colors you need for your flower petals. Begin on the chisel edge and then lean.

2. Pull the length of the petal and lift back up to the chisel edge to finish the stroke.

3. For a thicker petal, touch down and lean, pushing down a little harder for the thickness you want. Then lift back up to the chisel.

COMMA STROKES

 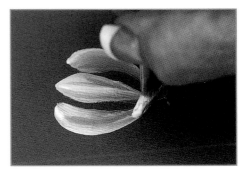

1. Begin on the chisel edge. Touch, push down on the bristles, pull a curving stroke, then lift back up to the chisel.

2. To make a series of petal strokes for a daisy-like flower, begin with a chisel-edge petal stroke, then add a comma stroke to one side.

3. Add another comma stroke to the other side of the chisel-edge petal stroke. Continue with more comma strokes to fill in.

SHELL STROKE

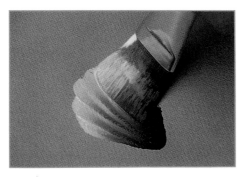

JAGGED-EDGE PETAL

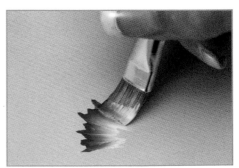

Double load a flat brush and begin with a starter stroke (see page 15). Wiggle out and slide back in half way. Wiggle out for the next segment and slide back half way. Wiggle out for the third segement, pivoting on the darker side of the brush, and slide back half way. Continue wiggling out and sliding back until you have the size petal needed. Finish by sliding back all the way and lifting to the chisel.

Double load a flat brush. Start on the chisel edge, touch, and lean toward the flat side of the brush. Use quick zig-zagging motions to create the jagged edge of the petal.

TEARDROP PETAL STROKE

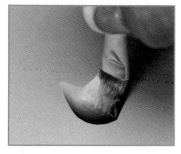

1. Double load a flat brush. Begin a short teardrop shaped stroke by touching down on the chisel edge, pushing down and curving around.

2. Continue the stroke without turning or pivoting your brush, then lift back up to the chisel.

LAYERING A FIVE-PETAL FLOWER

3. A five petal flower is a series of teardrop strokes all started from the same center. To layer them, start with a cluster of three or four teardrop strokes.

4. Then paint a complete five-petal flower overlapping the first set of strokes. To make a large cluster for hydrangea blossoms, continue painting three-, four- and five-petal florets that overlap each other.

C-STROKE AND U-STROKE FLOWER BUDS

 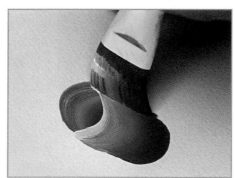

1. Double load or multi-load a flat brush. To make the back petal of the bud, begin on the chisel, push up and over in a C-shaped stroke. Watch the top edge of the brush as you stroke.

2. Starting at the left edge again, make the front petal of the bud. Begin on the chisel, push down and over in a U-shaped stroke and connect to the right edge of the back petal. Again, watch the top edge of the brush as you stroke.

POINTED SINGLE-STROKE PETAL

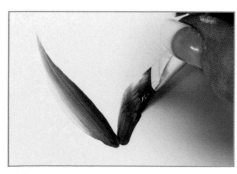

1. Double load a flat brush. Start at the base of the petal, lean down on the chisel and start sliding up towards the tip.

2. As you stand back up on the chisel, twist the brush in whichever direction you want the petal to turn.

3. This is how a flower made up of long, pointed petals looks. This is a great stroke for making orchids or lilies or any flower with long, slender petals that radiate out from the center.

PETALS WITH A RUFFLED EDGE

1. Petals with a ruffled side edge are found in many different flowers such as irises, parrot tulips, and orchids. To begin, double load a flat brush with your two petal colors. Start at the base of the petal, push down on the bristles and wiggle up.

2. Stop wiggling the brush as you near the tip. Slide smoothly the rest of the way to the tip and lift back up to the chisel edge. This will give the tip its pointed shape.

3. Without turning or lifting your brush from the surface, reverse the direction of the bristles and begin leaning down on them. Compare the position of the bristles in this photo with the bristles in Step 2.

4. Apply more pressure on the brush as you start to slide smoothly back down to the base of the petal.

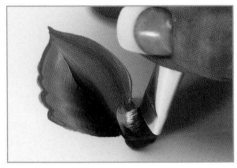

5. Lift back up to the chisel edge to end the stroke at the base of the petal. Notice that the darker side of the brush is in the same position as it was when you started the stroke.

OUTLINING PETALS

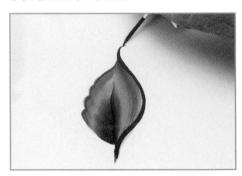

Here's a quick tip for adding interest to a petal or leaf. Outline one side of it with a darker shade. Load a script liner with inky paint and pull a smooth line following the shape from base to tip, lifting off to come to a point.

PETALS WITH RUFFLED TOP EDGES

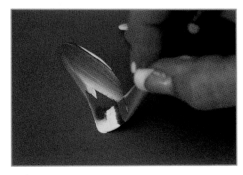

1. Side view flowers and opening buds often have ruffled edges along the top. First create the general shape of the base of the flower with a C-stroke using a double loaded flat brush.

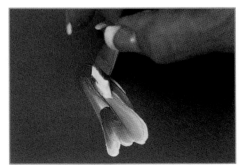

2. Now paint the petals. Begin on the chisel, wiggle the brush a few times, then slide back down into the base. Don't turn or twist the brush.

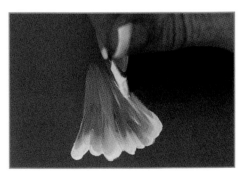

3. Repeat for the rest of the petals. When you have enough, slide back to the base, ending on the chisel.

TRUMPET FLOWER PETALS

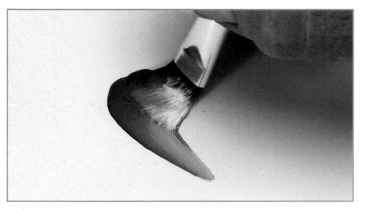

1. Begin by painting the base of the trumpet. Double load a flat brush. Keeping the darker side of the brush to the outside, stroke upward toward the base of the trumpet, watching the outer edge as you stroke.

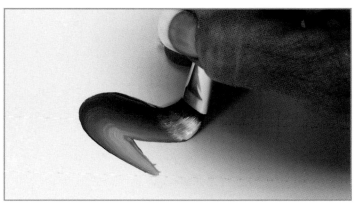

2. Pivot the brush at the base of the trumpet and slide back down the other side. Lift back up to the chisel. Don't worry about filling in the center—it will be covered by the next strokes.

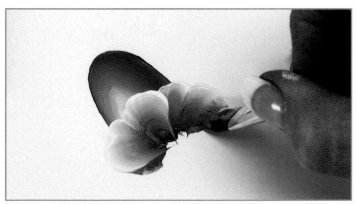

3. Double load your flat brush again with the same colors, but this time turn the brush so the lighter side is to the outside edge. Add the upper part of the ruffled opening with a series of little shell strokes.

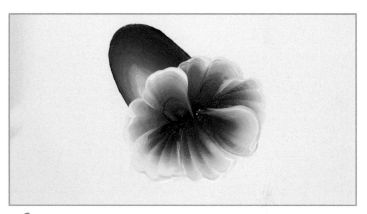

4. Continue with little shell strokes for the lower part of the ruffled opening, turning your work so it's easier to stroke and keeping the lighter side of the brush to the outside edge.

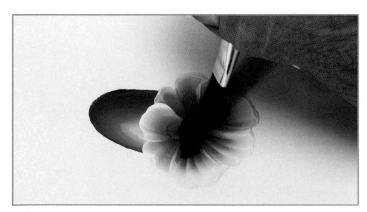

5. To shade and deepen the throat of the trumpet, load a flat brush with floating medium, then sideload into your darker paint color. Start your stroke on the left and pull across to the right side, creating a wavy shape that is pointed on both sides and wider in the middle.

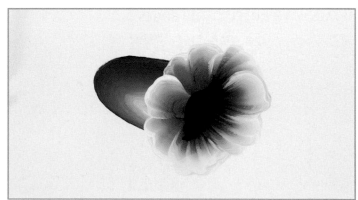

6. Using the chisel edge of the same brush, pull little streaks out from the shading onto the lower part of the ruffled petals. Keep the upper edge of the shaded area sharp and distinct to create the illusion of depth to the trumpet.

FLOAT SHADING

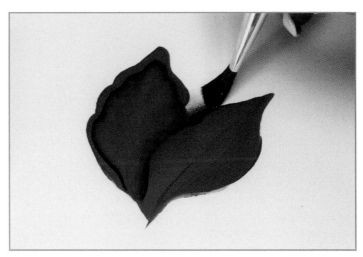

1. Float-shading is an easy way to give shape and dimension to your flower petals. I use this technique when painting magnolia blossoms and other cupped flower petals (see pages 67 and 85 for examples). Let your petals dry, then load a flat brush with floating medium and sideload into Burnt Umber. With the Burnt Umber side of the brush next to the edge of the petal, paint along the inside edge as shown. This gives the effect of the petal's edge turning inward.

2. To separate the upper petal from the lower one, load a flat brush with floating medium and sideload into Burnt Umber. With the Burnt Umber side of the brush next to the outside edge of the lower petal, paint along the petal's edge as shown. Continue shading all around the petal to separate it from the background.

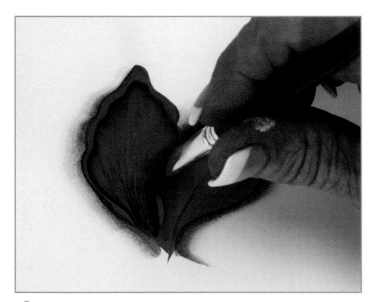

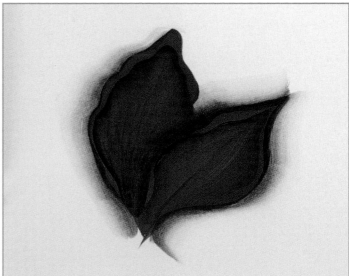

3. Float shade around the left side of the back petal to separate it from the background. Using the same brush, pull little chisel-edge streaks upward from the base of the petal to deepen the shading within.

4. The key to successful float-shading is to load your brush properly (see page 15) and to follow along the edges of the petal or leaf you are shading. If your shading seems too dark, you can always pick up more floating medium on your brush and soften the shading.

BASIC ONE-STROKE LEAF

1. Double load a flat brush with a darker green and a lighter green or yellow. Touch the chisel edge of the brush to the surface to make two guidelines for the start and end of the one stroke leaf.

2. Place the chisel edge on the left guideline and press down on the bristles so the flat of the brush is laying on the surface.

3. Turn the darker green side of the brush slightly so it is parallel with the right guideline.

4. Slide forward at the same time as you release the pressure and lift to the chisel, ending the stroke at the right guideline.

LONG, WIDE LEAF

 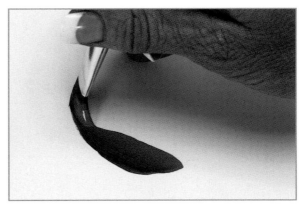

1. Double load a flat brush with green and yellow. Begin at the base of the leaf and stroke with the flat of your brush to make the wide part of the leaf.

2. Twist the brush in your fingers so the green side of the brush is leading, and pull to the tip, lifting to the chisel as you go.

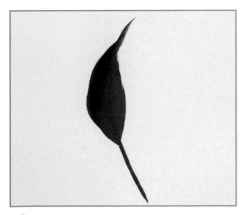 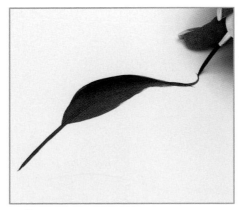 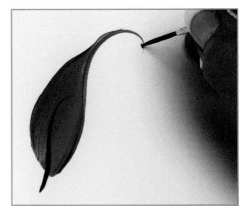

3. Pull a stem partway into the center of the leaf using the chisel edge of your brush.

4. As an added touch, try outlining one side of the leaf. Load a script liner with inky green paint and pull a line up the entire side of the leaf from base to tip. This will redefine that edge.

5. Here's a variation on the long, wide leaf. Outline the yellow side of the leaf from base to tip with inky green paint and a script liner. Extend the tip into a long, graceful curve.

LONG LEAF WITH SCALLOPED EDGE

1. This leaf has one edge that is smooth and one edge that is scalloped. Double load a flat brush with a dark green and a yellow. Paint the scallop-edge side of the leaf using the flat of the brush and leading with the green side.

2. Lift back up to the chisel and slide smoothly the rest of the way to the tip.

3. For the other half of the leaf, turn the brush so you are leading with the yellow side. Stroke smoothly upward from the base, putting pressure on your brush at the base and releasing pressure gradually as you stroke upward.

4. Slide smoothly to the tip, lifting back up to the chisel.

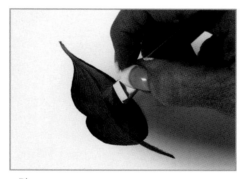

5. Finish by pulling a stem halfway in to the center of the leaf, using the chisel edge of the brush and leading with the yellow side.

WIGGLE-EDGE, SMOOTH-SIDED LEAF

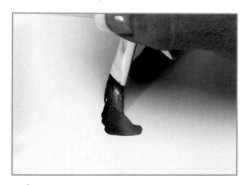

1. Double load a flat brush with dark green and yellow. Start at the base of the leaf. Apply pressure to the flat of the brush and wiggle up to the tip of the leaf, turning the green side of the brush slightly towards the tip.

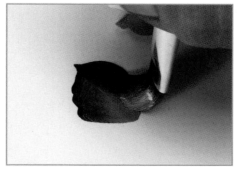

2. Reverse the direction of the bristles without lifting your brush off the surface. Apply pressure and slide smoothly back down to the base.

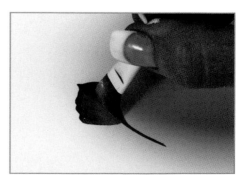

3. Pull a stem halfway in to the center of the leaf, using the chisel edge of the brush and leading with the yellow side.

FOLDED TULIP LEAF

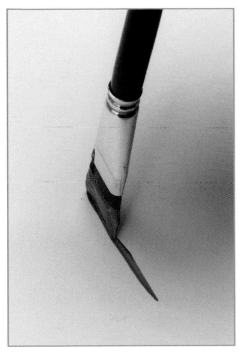

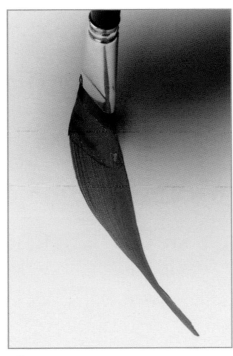

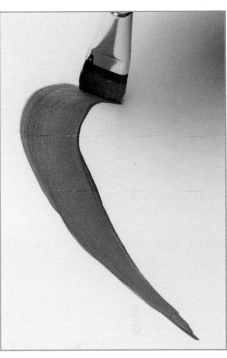

1. The long pointed leaves that surround spring-flowering tulips often fold over on themselves as they age. Here's how to achieve that look with one smooth motion. Double load a large flat brush with a dark green and a lighter green. Start by pulling the stroke upward from the base, staying up on the chisel edge and leading with the darker green side of the brush.

2. Press down on the brush to widen the stroke as you slide the brush at a slightly diagonal angle.

3. Make a gently curved hook at the top, then lift up to the chisel and turn, reversing your direction.

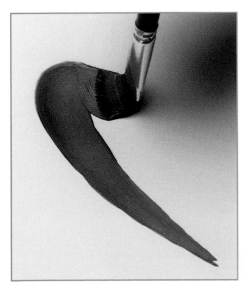

4. Press down again on the bristles to widen the stroke.

5. Slide down, then lift back up to the chisel and slide to the tip. To delineate the leaf edge, turn your brush so the dark green side is to the left and re-stroke the folded-over part of the leaf.

FERNS

1. There are two kinds of ferns I like to paint as fillers for my floral compositions. One has wider leaves that are close together along the stem. The other fern has airy, lacy-looking fronds with tiny leaflets. For both ferns, start by painting a long curving stem, staying up on the chisel edge and leading with the lighter color. On the lacy fern stem, add smaller branches that have even smaller branches attached to them.

2. On the wide leaf fern, add two rows of one-stroke leaves. On the lacy fern, the tiny leaves are painted using short, light chisel-edge strokes, pulling inward toward the stems.

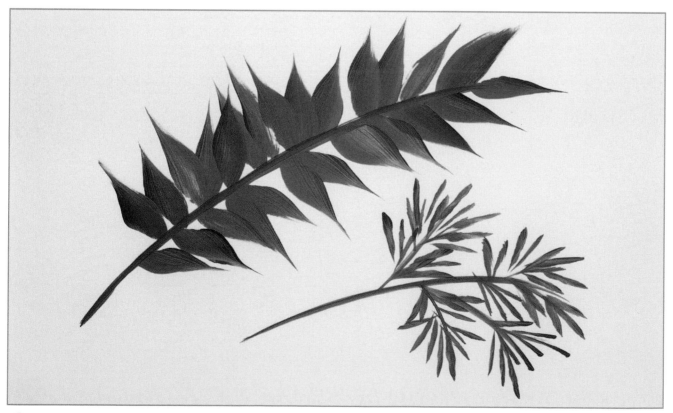

3. When the wide-leaf fern is finished, pull a new stem up the center to clean up the edges. Finish the lacy fern with more leaflets to fill in the frond.

PAINTING GRASS WITH AN ANGULAR BRUSH

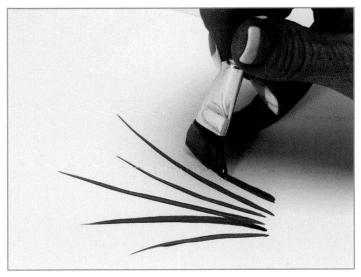

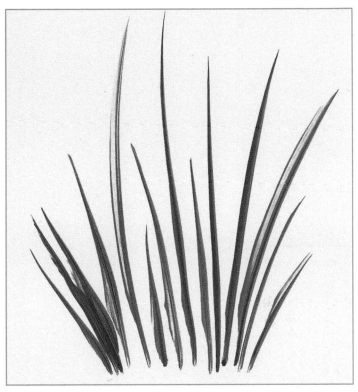

1. Grass blades of varying heights and thickness are quick and easy to paint with an angular brush. Load a dark green onto the toe of the brush, and a light yellow onto the heel. Stroke upward, leading with the heel (the yellow side) and dragging the toe. Stay up on the chisel and lift off at the tip of each grass blade to create a point.

2. Double loading the angular brush makes it easy to shade and highlight each blade of grass in one stroke.

PAINTING GRAPEVINES WITH AN ANGULAR BRUSH

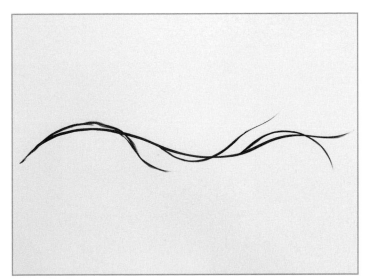

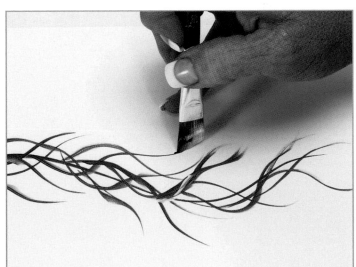

1. Vines and grapevines are also easy to paint with an angular brush. Load Burnt Umber on the toe and Wicker White on the heel. Starting at the left, paint the main vine with a gently curving line, leading with the heel (the Wicker White side) and dragging the toe. Stay up on the chisel edge. For the crossing vines, always start at the main vine and pull smaller, curving vines across from one side to the other.

2. Continue pulling shorter vines, weaving back and forth over the main vine as you go. Don't do too much—keep your grapevines light and airy.

For the flower painting demonstrations in this book, I have created a variety of interesting and attractive backgrounds you can use that coordinate with and enhance your flower portraits. These backgrounds are very easy to do and require only a few supplies, such as sponges, glazing medium, crackle medium, or brushes. These materials are shown on pages 8-10. Also, because background color is so important to the success of your paintings, on pages 36-37 you'll see a variety of color choices, some good, some not so good, and some exactly right. Keep these in mind when choosing the background colors for your own flower paintings.

LACE PAPER DOILY

This background can make a strong statement depending on what color you use. For a softer background use a color closer to white, such as Vintage White or Linen. Examples of lace doily backgrounds used in finished paintings are on pages 48, 70, 80, 93 and 119.

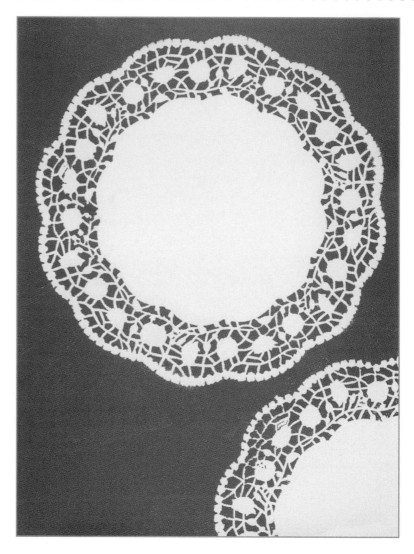

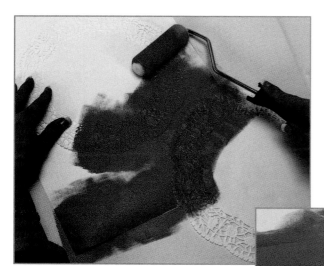

1. For this background you'll need a packet of 10½ inch (26.6cm) wide lace paper doilies from a craft or party supply store, a spray-on, low-tack adhesive, and a 4-inch (10.2cm) foam roller. Spray one side of the paper doily with a light coating of adhesive and place the doily where you want it on your painting surface. Make sure all the little edges and holes are pressed down to the paper or canvas. Load the foam roller with Basil Green and roll over the entire painting surface all the way out to the edges.

2. Carefully remove the doily while the paint is still wet by lifting it straight off the surface.

3. Let the paint dry completely before you begin painting the floral design you've chosen. Don't worry if some of the areas are not perfect—you can always paint over them with your flowers or leaves.

TONE ON TONE

This is a sponged-on background that uses two closely-related colors to create very subtle tones and textures. Examples of tone-on-tone backgrounds used in finished paintings are on pages 39, 51, 87, 121 and 133.

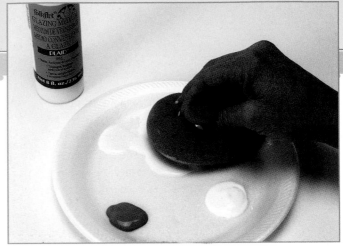

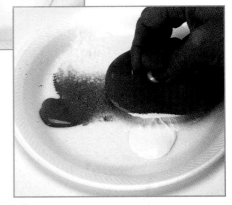

1. Place puddles of glazing medium, Butter Pecan, and Wicker White on your palette. Dampen a faux finish sponge in clean water and pounce evenly into the puddle of glazing medium.

2. With the glazing medium on your sponge, pounce into the edge of the puddle of Butter Pecan.

3. Turn your sponge slightly and pounce into the edge of the puddle of Wicker White.

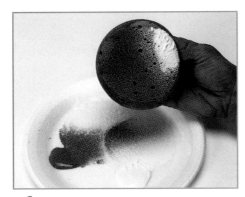

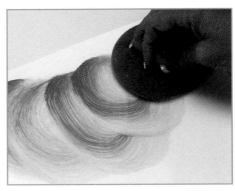

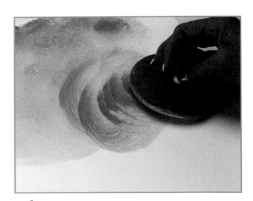

4. This is how your sponge should look when it's properly loaded. Notice that the Butter Pecan and the Wicker White are on different areas of the sponge, not right on top of each other.

5. Now move to your canvas or paper and begin applying your background colors with a circular motion to one small area at a time.

6. Pounce the area you just applied in Step 5, moving the sponge around in random motions. Reload the sponge with glazing medium and the two colors and work on the next area. Begin with circular motions, then pounce it out. Anyplace you feel you've lost one of the colors, you can go back and re-load and re-sponge that area.

This is a sponged-on background that uses three pale colors over a light blue basecoat to create a feeling of the sky at sunset. Examples of sky-and-clouds backgrounds used in finished paintings are on pages 41, 59, 65, 73, 79 and 91.

1. Place puddles of Baby Blue, Wicker White and glazing medium on your palette. Pounce a faux finish sponge into the glazing medium, then into the Baby Blue and Wicker White. Sponge a pale blue basecoat onto your canvas or paper and let dry. Using 1-inch (25mm) low-tack painter's tape, tape off all four sides of your surface.

2. Using the same palette as in step 1, add a puddle of Sunflower and a puddle of Heather. Pounce your sponge into glazing medium, then pick up Sunflower and Wicker White. This is how your sponge will look if it's loaded correctly.

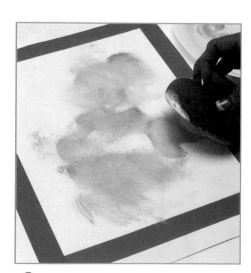

3. Pounce the sponge randomly over the pale blue basecoat. Don't try to cover all areas, just pounce the yellow here and there.

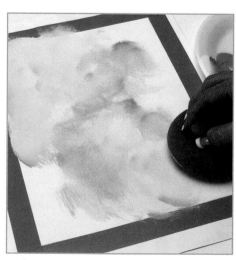

4. Pick up more glazing medium, then Baby Blue and Heather on the sponge. Pounce randomly over the surface, allowing areas of yellow and blue to show through.

5. Blend with the sponge so there are no hard edges anywhere, but don't overblend so your colors get muddy. You should still be able to see areas of blue, white, yellow and lavender.

shadow leaves

Shadow leaves make a beautiful background for flower paintings because they reflect the natural shapes and colors of the leaves in your design. Shadow leaves can be done in any color; for this demo I'm using a light green. Examples of shadow leaf backgrounds used in finished paintings are on pages 47, 53, 123, 125, 127 and 131.

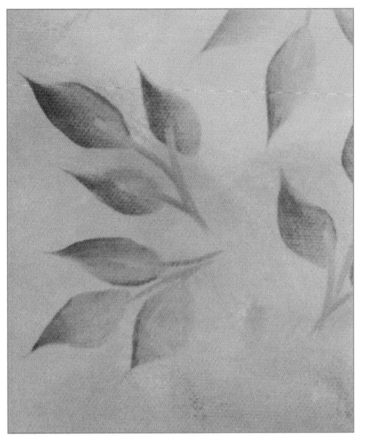

1. Place puddles of Fresh Foliage, Wicker White and glazing medium on your palette. Pounce a faux finish sponge into the glazing medium, then into the Fresh Foliage and Wicker White. Sponge on a pale green basecoat onto your canvas or paper and let dry.

2. Double load a no. 12 flat brush with Wicker White and Fresh Foliage. Work the brush into a puddle of floating medium to make the color very soft and translucent.

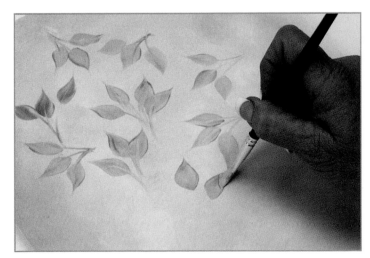

3. Paint little one-stroke leaves and stems, usually in clusters of three or more leaves, all over the sponged-on background. Turn your surface constantly so your leaves face in different directions, but keep them roughly the same size.

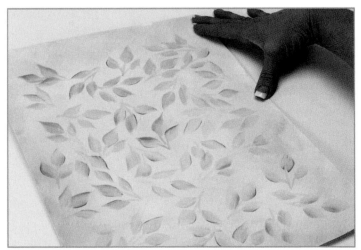

4. Let your shadow leaf background dry completely before painting your flower design on it. Notice that the shadow leaves above are not uniform in color—some are lighter and some a bit darker. The more floating medium you have in your brush, the more translucent the leaves will be.

allover crackle

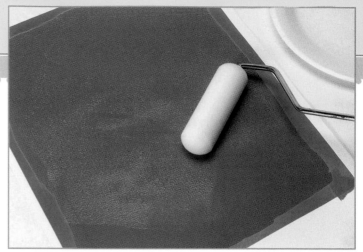

An allover crackled background can give a rustic or antique look to your painting, depending on how large or fine the crackling is. Be sure to follow the manufacturer's directions on the bottle of crackle medium. Examples of allover crackled backgrounds used in finished paintings are on pages 83, 101, 109 and 113.

1. For this background you'll need a bottle of crackle medium, a roll of 1-inch (25mm) low-tack painter's tape, and a 4-inch (10.2cm) foam roller. Tape off the edges of your canvas or paper with painter's tape and basecoat the surface with Basil Green. Let dry. Place a puddle of crackle medium on your palette. Dampen the foam roller, load into the crackle medium and roll over the entire painting surface all the way out to the edges. Crackle medium is clear so check your surface to make sure it's completely covered. Let the crackle medium dry to the touch.

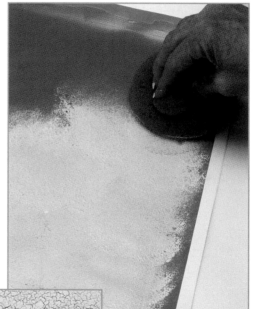

2. Dampen a faux finish sponge and pounce into a puddle of Vintage White. Pounce the sponge onto the dried crackle medium starting at one end and working across. Don't go back over your pounced areas or you'll just pick up the paint. The thinner the paint layer, the finer the crackle.

3. As soon as you've finished pouncing the paint on, remove the painter's tape before the paint dries so you don't pull the paint off with the tape. As you can see, the Vintage White has crackled just enough that you can see bits of the Basil Green basecoat underneath. It's important that your basecoat color be harmonious with your flower colors because it will show.

crackled frame

In this background, only the outer edges are crackled to give the illusion of an old painted wooden frame that's seen better days. Any time you use a crackling medium, be sure to read and follow the manufacturer's directions. Examples of finished paintings with crackled frames are on pages 75, 85, 95, 107, 111 and 115.

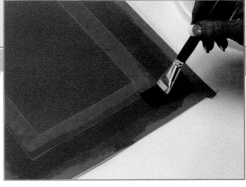

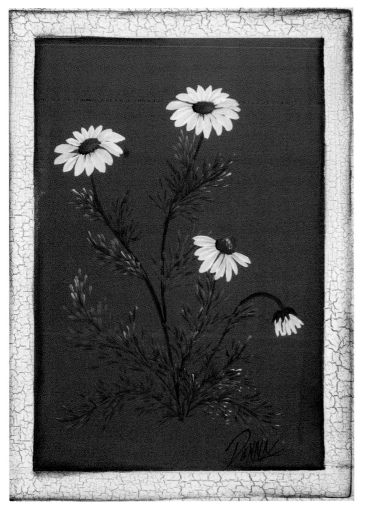

1. Tape off your canvas or paper along the outer-most edges with 1-inch (25mm) painter's tape. Basecoat with your chosen color and let dry. Decide how wide you want your crackled frame to be, then measure in that distance from the inner edge of the painter's tape on all four sides. Place four more strips of tape. Be sure these pieces are straight and the corners form 90 degree angles. Dampen a 1-inch (25mm) flat brush, then load it into a puddle of crackle medium on your palette. Apply a heavy coat of crackle medium to the space between the tape along all four sides, and let the crackle medium dry to the touch.

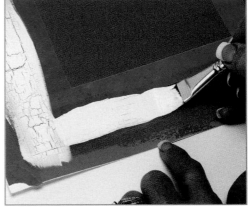

2. Load Wicker White on a 1-inch (25mm) flat brush and paint over the area where you've applied the crackle medium. Work quickly and don't go back over any areas that have already started to crackle or you'll lift it off. Apply the paint heavily if you want a large, noticeable crackle pattern, as shown here.

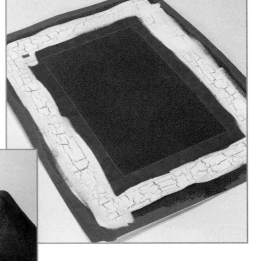

3. Here you can see the crackled effect forming all the way around. Compare the size of the crackle above to the finer crackle on page 30.

4. Before the paint dries, remove all the painter's tape by pulling slowly and steadily straight up. If you wait until the paint has dried, you could pull some of it off when you lift the tape.

faux leather

This leather-look background is very dramatic with its deep, rich colors and realistic texture. It provides an interesting, almost masculine contrast to the delicate look of flowers. Examples of faux leather backgrounds used in finished paintings are on pages 43, 55, 63 and 69.

1. Begin by taping off the edges of your canvas or paper with low-tack painter's tape and basecoating it with Burnt Umber. Let dry. Dampen a 4-inch (10.2cm) foam roller and roll it into a puddle of glazing medium on your palette.

2. With the glazing medium on your roller, load one side with Burnt Sienna and the other side with English Mustard.

3. Roll on the colors and glazing medium in a random pattern here and there on your basecoated surface. Don't cover the Burnt Umber basecoat entirely—allow it to show through in several areas.

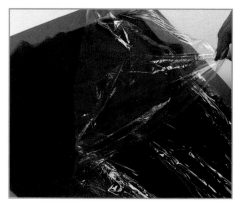

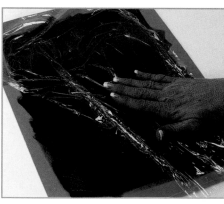

4. Place a large piece of clear plastic wrap over the wet paint, allowing it to wrinkle up naturally. Press down but don't try to smooth out the wrinkles.

5. Before the paint dries, pull off the plastic wrap. Here you can see how the wrinkles in the plastic wrap create a leathery-looking texture.

6. Now remove the painter's tape from the edges of your surface before the paint dries so you don't pull any of it off. If there are any bad spots along the edges, just touch them up with straight Burnt Umber paint. The leather effect shows up best when the paint is totally dry.

antiqued

This is a sponged-on background that uses three subdued colors to create old-world tones and textures. This background will give instant age to your paintings. Examples of antiqued backgrounds used in finished paintings are on pages 61, 77, 99, 105 and 129.

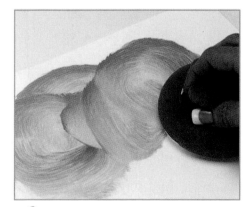

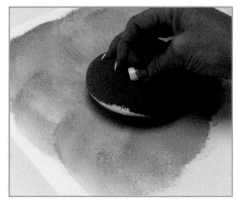

1. Begin by dampening a faux finish sponge, then loading it into a puddle of glazing medium on your palette.

2. With the glazing medium on your sponge, load one side into Butter Pecan and the other side into Italian Sage.

3. Now load another area of the sponge with Wicker White. Check your sponge—you should see three distinct areas of color: Butter Pecan, Italian Sage and Wicker White.

4. Move to your canvas or paper surface and begin making smooth circular motions with the sponge.

5. Lightly pounce over the surface in random motions to give it a subtle texture. Reload your sponge into glazing medium, then into the three colors separately as needed. Continue applying the paint with circular motions, then pouncing the sponge in random patterns to create an overall texture.

6. Keep pouncing the sponge until there are no more hard edges, but don't overblend the colors. You want to see areas of brown, green and white showing through, which helps give your painting a softly aged look.

patchwork squares

This is the most complex looking background design but the individual squares are still very easy and fun to paint. Choose your paint colors so they harmonize with your flower and leaf colors. Examples of finished paintings with a patchwork squares background are on pages 45, 67 and 97.

1. Start by making a template of different size squares and rectangles. First decide the overall size of your background, then take a piece of card-stock that size and cut it up into the shapes you want. Place these templates on your canvas or paper and arrange them as you wish into a patchwork design. Having the individual templates makes it easy to move them around until you're satisfied with the layout.

2. With a sharp pencil, trace lightly around each separate template on your painting surface.

3. Check your traced pattern to see if you like it.

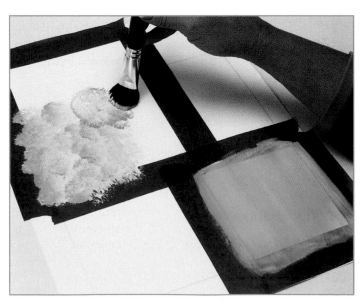

4. Tape off your different colored areas with low-tack painter's tape and burnish the edges of the tape so the paint doesn't seep underneath. Mix Wicker White and Rose Pink and basecoat one of the squares. While that's drying, double load a large 1-inch (25mm) scruffy brush into the same two colors and pounce a mottled design into another square.

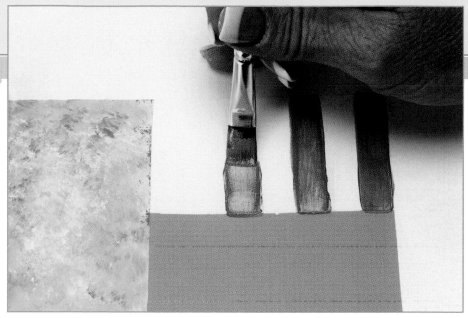

5. Remove the tape before the paint dries on the section you've just painted. Then let those sections dry. To paint the next section, tape off around it, making sure your previously painted sections are dry or the tape will pick up the wet paint. In this design, I've basecoated the rectangle with Butter Pecan, the square with Basil Green, and I've left the upper right corner just plain white.

6. In the plain white square you can paint floated stripes. Load a no. 12 flat brush with Butter Pecan and dip into floating medium. Paint freehand stripes, using your little finger to brace your hand. If you feel your hands aren't steady enough, just tape off the stripes and paint between the pieces of tape.

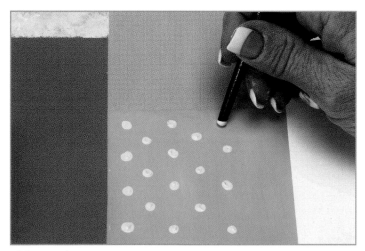

7. For a polka-dot square, load the tip end of a brush handle into a light pink mixed from Rose Pink and Wicker White. Dot on in even rows, four dots in one row, three in the next, and so on. Let these dry so you don't accidentally smear them with your hand when you're painting the next square.

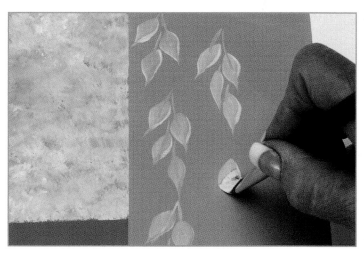

8. For the shadow leaves, double load a no. 12 flat with floating medium and a color that is in the same color family as the background color. Here I'm using Linen for the shadow leaves on a Butter Pecan background.

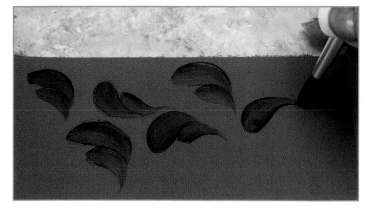

9. In the final patchwork square, try painting some nested comma strokes. Again, keep the comma strokes in the same color family as the background. Here, I've double loaded Thicket and a small amount of floating medium on a no. 8 round brush. To paint nested commas, start with a large one, then add a smaller one that is nested into the curve of the large one. Let everything dry completely before painting any flowers on this background.

CHOOSING THE *right background colors*

POOR

This is not the best choice of background color for this flower painting. First, the color is too intense and takes attention away from the tulip. Second, the blue-green of the leaves does not work well with the yellow-green background.

BETTER

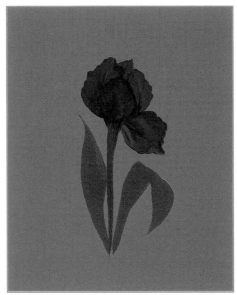

Blue is a better choice. The foliage looks great against this color, but the flower color goes a little flat.

BEST

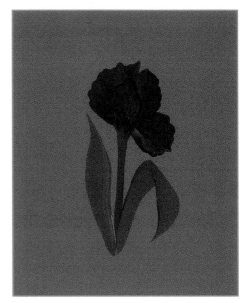

This background is painted with Sunflower. It's the best color choice because it provides an even intensity and draws your eye immediately to the center of interest. It also reveals depth in the flower color and lights up the leaves.

POOR

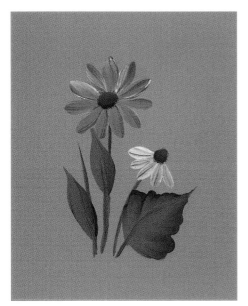

When you have a light-colored flower such as these daisies as your center of interest, your background color should provide contrast. This color doesn't, and besides, it's rather drab.

BETTER

This background is certainly brighter and more intense than the one at left, but now it's too much—it overwhelms the design as a whole. The flowers stand out but the leaves are lost.

BEST

Here's the best background color for these daisies. It doesn't grab your attention, yet it provides enough contrast that the daisies seem to "pop." The color, Maple Syrup, is rich and deep.

POOR

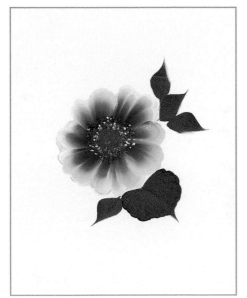

This is a good example of the mistake painters make most often when choosing a background color. Take a look at the edges of the flower. How well can you see them? If the edges of your flowers are white, choose a background color other than white so the edges will be clearly visible.

BETTER

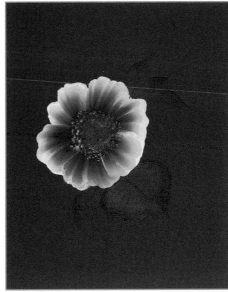

This is a better choice only because the flower edges are now visible. However, this color, School Bus Yellow, is way too intense and completely takes away from the flower. It also has no relation to the yellow used for the center stamens.

BEST

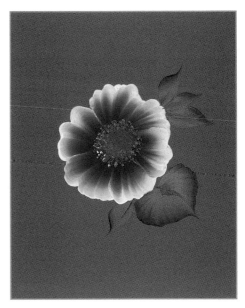

Of the three, this is the best choice. The Basil Green shows off the flower colors and delineates the white edges. It's comfortable to look at, and relates to the greens used for the flower center and the leaves.

POOR

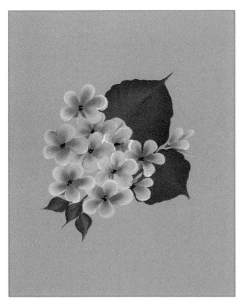

When your flowers are as light as these white hydrangeas, your background color needs to provide contrast. This is a pretty color but the flowers almost disappear against it.

BETTER

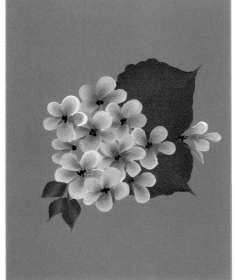

This bright pink background may provide more contrast, but it has no color relationship to the flowers. The leaves stand out better but the flowers are still secondary.

BEST

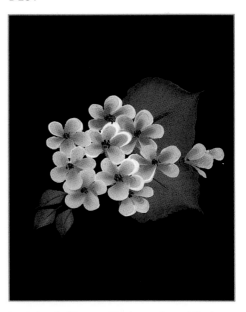

Don't be afraid to use black once in a while. It has a strong presence, but look at how those white flowers pop! It helps show depth in the flower colors and enlivens the leaves too.

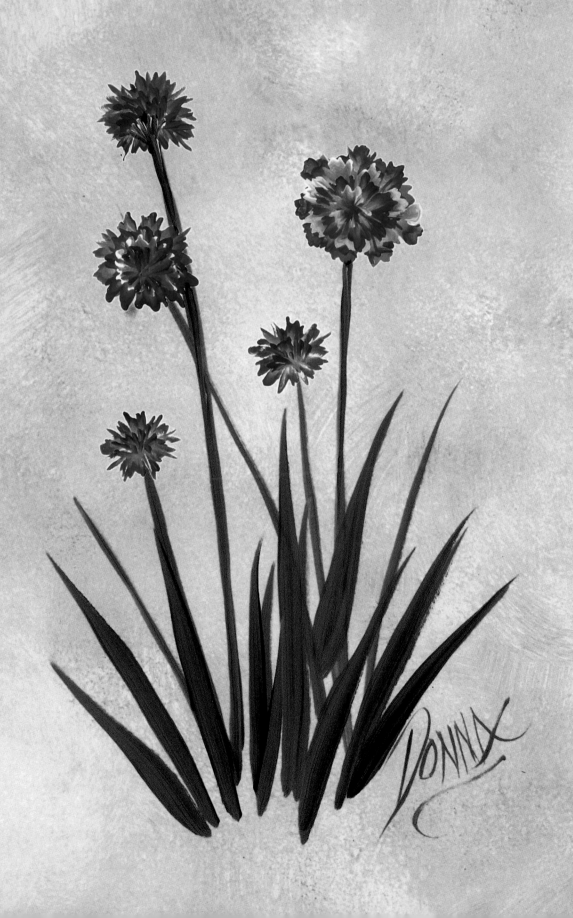

cornflower

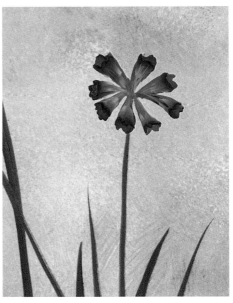

1. Start with a Tone-on-Tone background sponged on with Butter Pecan and Wicker White. Let dry. Double load a no. 16 flat with Thicket and Yellow Citron and paint the tall stems and grassy leaves.

2. Double load a no. 8 flat with Brilliant Ultramarine and Wicker White and paint the first layer of petals. The outer edge of each petal is notched.

3. Pick up more Brilliant Ultramarine on your brush and detail the outer edges of each petal.

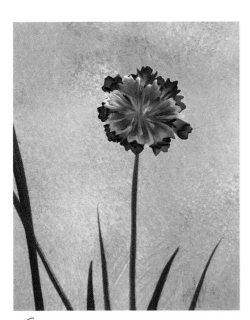

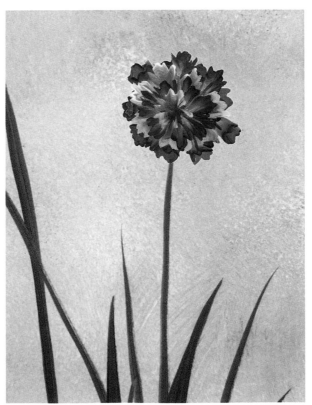

4. Now pick up more Wicker White on your brush and add another smaller layer of petals that are a bit lighter than the first layer.

5. Continue adding more layers of petals, picking up more Brilliant Ultramarine to darken the petals in the center mound. The blossoms seen from the side in the distance are less detailed and look like little balls of spiky petals. Cornflowers are also known as Bachelor's Buttons and their deep blue color often adds depth and contrast to compositions of lighter flowers. Try painting them with bright red and sunny yellow flowers for a pretty French country bouquet.

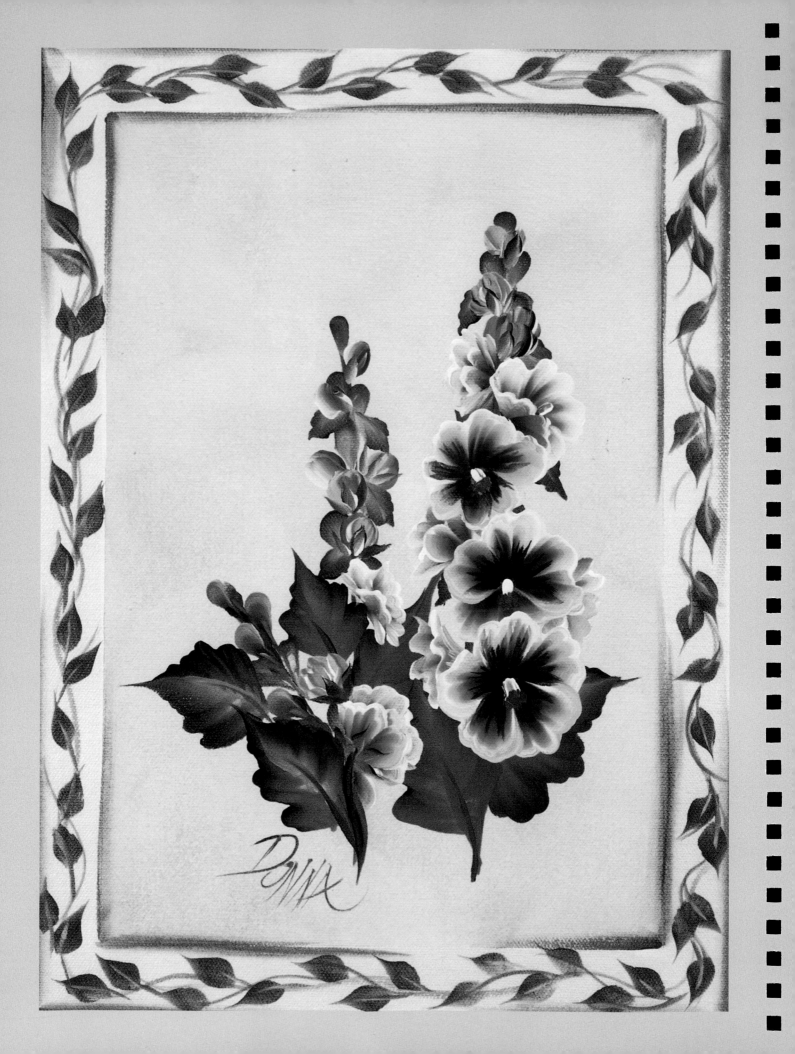

hollyhock

brushes
3/4-inch (19mm) flat • no. 10 flat • no. 12 flat

colors
Thicket • Yellow Light • Wicker White
Magenta • Butter Pecan

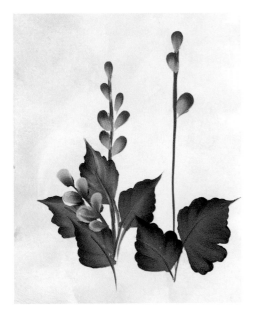

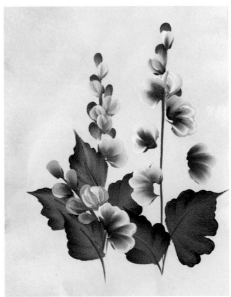

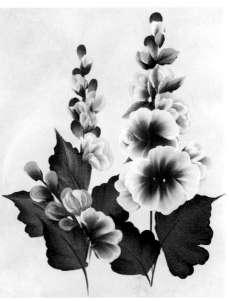

1. Begin by taping off a frame with 1-inch (25mm) painter's tape. Sponge on a light blue background using glazing medium, Baby Blue and Wicker White. Let dry. Double load a 3/4-inch (19mm) flat with Thicket, Wicker White and a little Yellow Light. Paint the large leaves. The long stems and unopened green buds are Wicker White and a little Thicket on a no. 12 flat.

2. Double load a no. 12 flat with Magenta and Wicker White. Paint the opening buds with three comma strokes layered on top of each other. With the same brush and colors, paint the back petal layers of the sideview blossoms.

3. Paint the large open petals of the holly-hocks using Magenta and Wicker White. Each large circular petal is made up of about five to six sections. Keep the Magenta side of the brush toward the center of the petals.

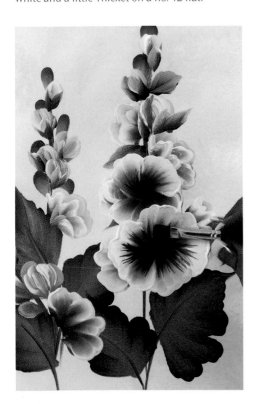

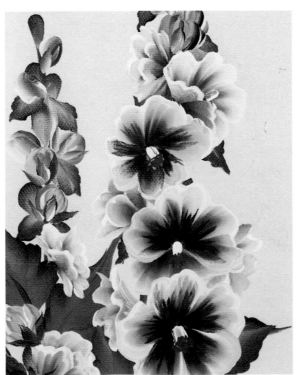

4. To shade and add depth to the flower centers, load a no. 10 flat with straight Magenta and paint little chisel edge streaks, moving the brush outward from the center.

5. Stroke in the stamens in the open blossoms with a no. 10 flat and Wicker White. Pick up Yellow Light on the corner of the brush and tap on the rounded yellow pollen dots. To finish, remove the painter's tape from the frame. Load a no. 12 flat with floating medium and Butter Pecan. Paint a border of shadow leaves in the frame, then outline the frame on both sides with the same brush and colors. Note that the leaves are all carried around the frame in a clockwise direction.

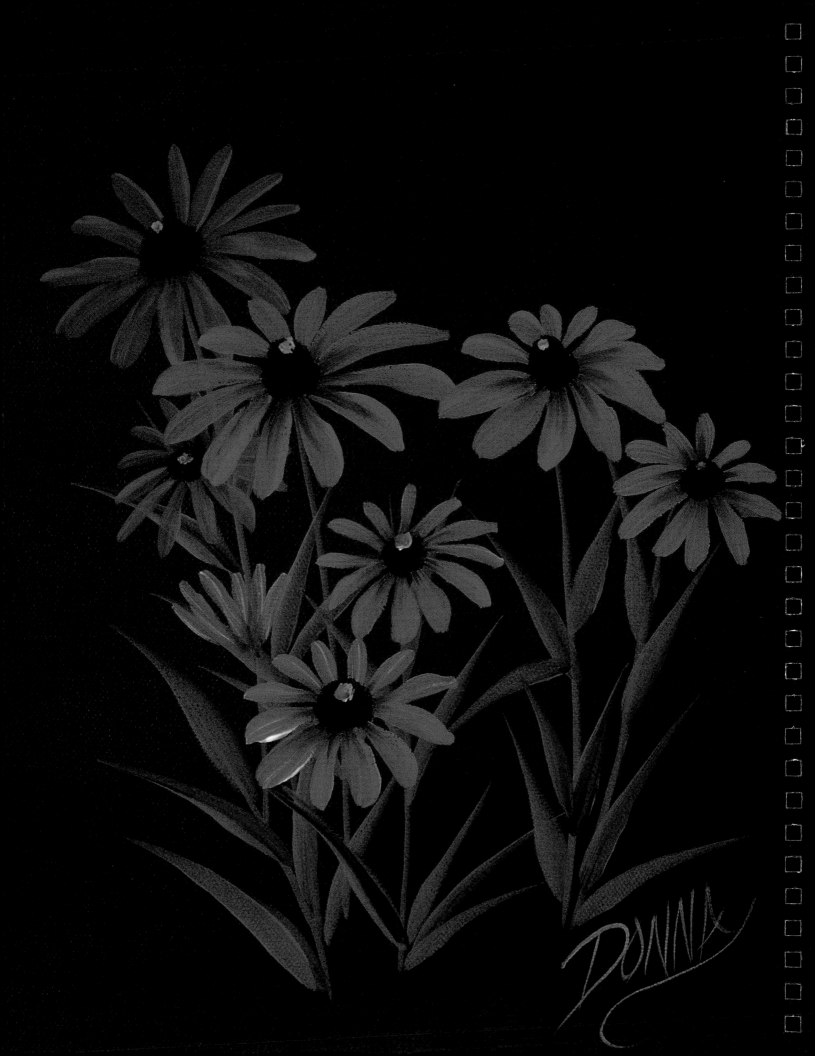

black-eyed susan

brushes
no. 12 flat • 1/4-inch (6mm) scruffy

colors
Thicket • Yellow Light • Fresh Foliage
Burnt Sienna • Burnt Carmine • Rose Pink

1. Create a Faux Leather background following the instructions on page 32. Let dry. Paint the stems and long thin leaves with Thicket and Fresh Foliage double loaded on a no. 12 flat. Occasionally pick up Yellow Light to vary the colors of the leaves.

2. Begin the blossoms with the background flowers and opening bud. Load Yellow Light on a no. 12 flat, sometimes picking up a little Burnt Sienna to shade the petals. Paint each petal by starting at the outer tip and pulling toward the center.

3. For the foreground blossoms, load a no. 12 flat with Yellow Light and pull the back petals first. The petals are shorter in the back and get longer as they come around the sides. The front petals are longest. To paint the center cones, load a 1/4-inch (6mm) scruffy with Burnt Carmine. Pounce on the centers of the open blossoms. While the Burnt Carmine is still wet, pull little streaks out onto the petals with a no. 12 flat and Burnt Sienna.

4. Clean up the edges of the cones with dots of Burnt Carmine. Highlight the tips of the cones with Rose Pink on a no. 12 flat.

english rose

brushes

no. 10 flat • no. 16 flat • no. 1 script liner

colors

Thicket • Soft Apple • Rose Pink • Peony
Berry Wine • Wicker White • Yellow Light

1. Create a Patchwork Squares background following the instructions on pages 34-35, leaving off the stripes and polka dots. Let dry. Double load a no. 16 flat with Thicket and Soft Apple and paint the stems and leaves. Add the flower stems and open calyxes with the same colors.

2. Double load a no. 16 flat with Rose Pink and Wicker White and begin painting the upper back petal of the rosebuds and the outermost layer of the open rose. I placed the rose against the green patchwork square because it provides the most contrast to the white edges of the rose petals.

3. With the same brush and colors, continue painting the second and third layers of the open rose, and add the front petal (a U-stroke) to the upper rosebud.

4. To shade and add depth to the rose center, double load a no. 10 flat with Rose Pink and Wicker White, plus a little Peony on the Rose Pink side. Paint the centermost petals of the rose and the final petals of the bud. Load a no. 1 script liner with Berry Wine and pull little stamen strokes out from the center of the open rose.

5. Following steps 2-4, paint the lower rose and finish the lower rosebud petals. With Yellow Light on a no. 1 script liner, add little pollen dots to the stamens of the open roses. Double load a no. 10 flat with Thicket and Soft Apple and stroke calyxes over all the rosebuds. If you wish to add a monogram to your design, find a lettering stencil you like and trace the letter onto the upper left corner patchwork square. Paint it with Peony and outline with Wicker White.

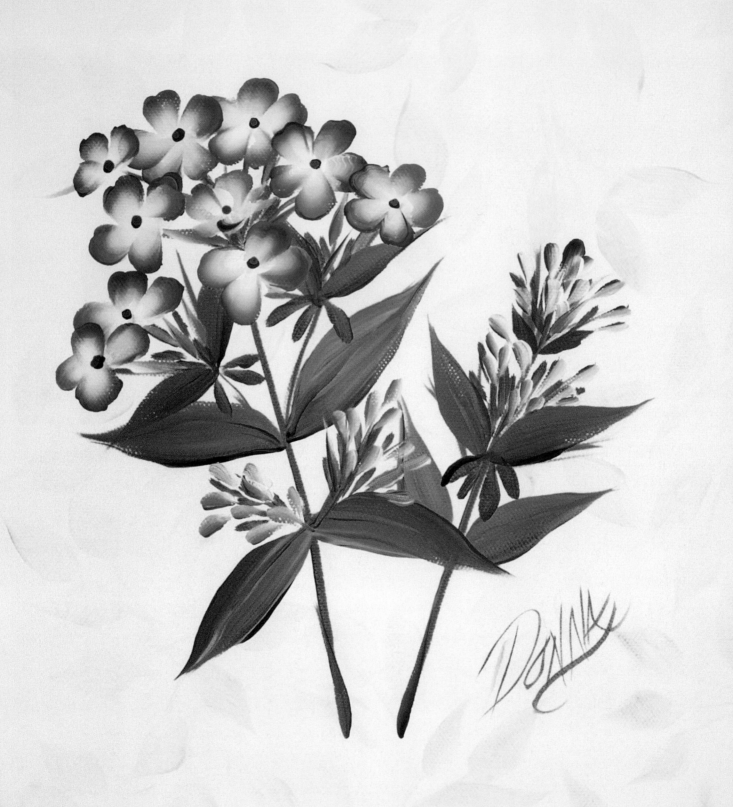

garden phlox

1. Create a Shadow Leaves background following the instructions on page 29. The sponged background colors are Wicker White and Violet Pansy, and the shadow leaves are Wicker White and Lilac Love. Let the background dry. To paint the phlox leaves and pods, double load a no. 12 flat with Thicket and Wicker White and pick up a little Yellow Citron on the white side. Paint the stems first for placement, then the large leaves and little pods.

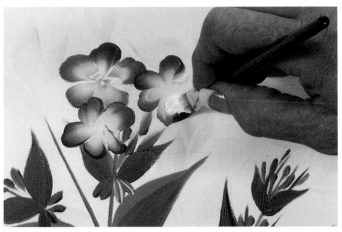

2. Double load Magenta and Wicker White on a no. 12 flat and paint the five-petal florets, keeping the Magenta to the outside edges of the petals. Add a few little pink flower buds in among the fully open petals.

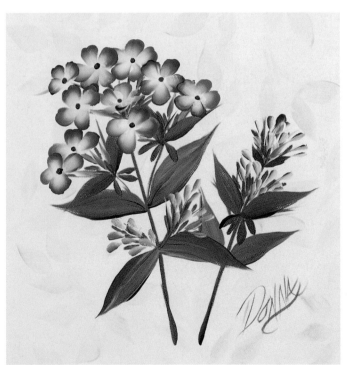

3. (Left) Using the same brush and colors, fill in the buds on the lower right stem with little comma strokes and chisel-edge petal strokes (see page 16). Dot in the centers of the open petals with Magenta, then highlight the center dots with smaller dots of Yellow Citron.

4. (Above) Continue filling in with more flower buds and open florets. Be sure to layer the five petal flowers by overlapping the florets (see page 17). Keep the Magenta to the outside, and dot in the centers with Magenta, then highlight with Yellow Citron.

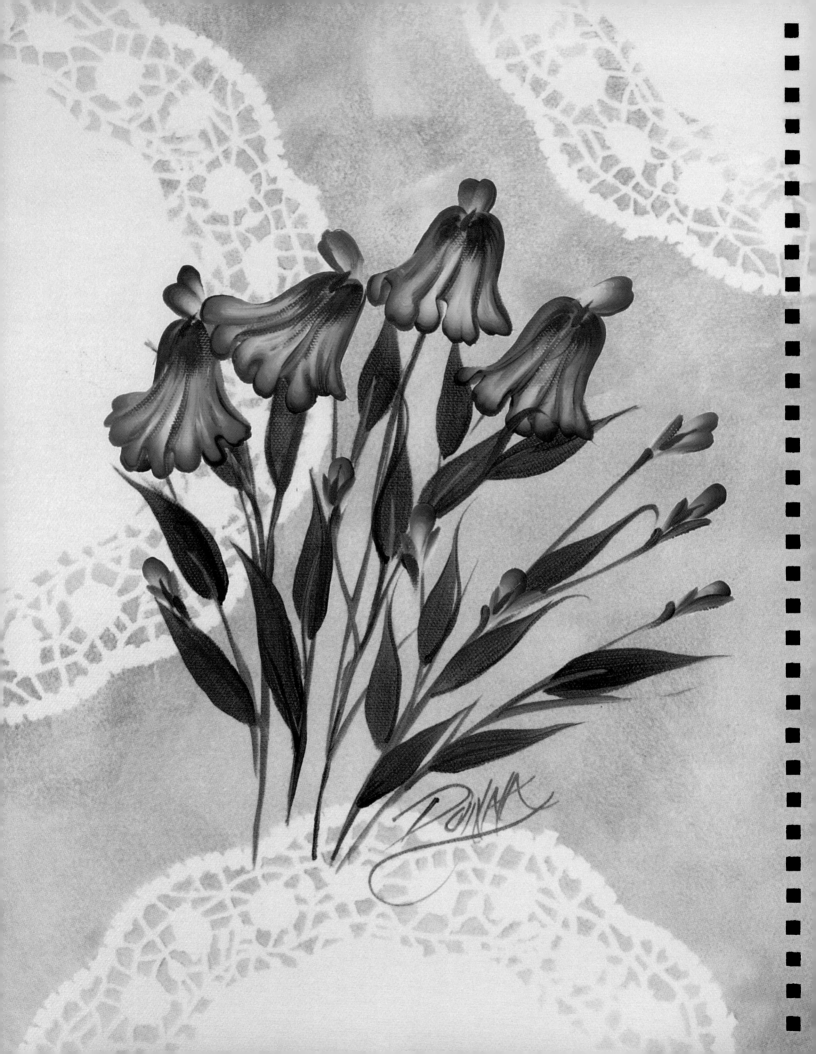

salvia

1. The background for the salvia is the Lace Paper Doily. Follow the instructions on page 26, but change the colors to Linen and Wicker White. Let dry. Double load a no. 16 flat with Thicket and Yellow Citron and paint the stems and long, slender leaves.

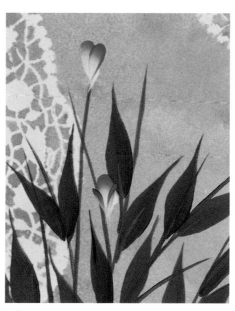

2. Double load a no. 16 flat with Magenta and Wicker White and paint a bud and the upper petals of the salvia blossom.

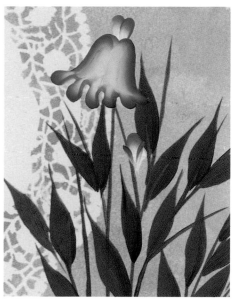

3. With the same brush and colors, paint the main petal using ruffled-edge strokes (see page 18).

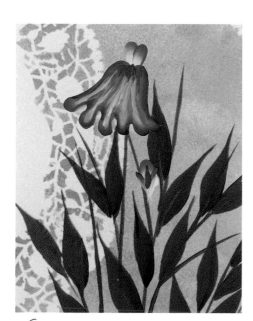

4. Load a no. 10 flat with Magenta. Using the chisel edge of the brush, pull some streaks down from the top of the main petal, then pull some streaks up from the ruffly edge. Add small stamens to the top of the petal and the bud with Yellow Citron.

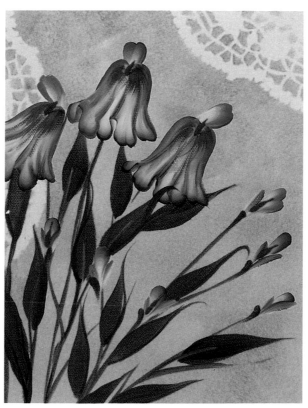

5. Fill in with more buds and large petals, varying their placement and angle. Some of the buds are closed, some are beginning to open. Notice how the roundness of the salvia design echoes the roundness of the three lace doilies in the background.

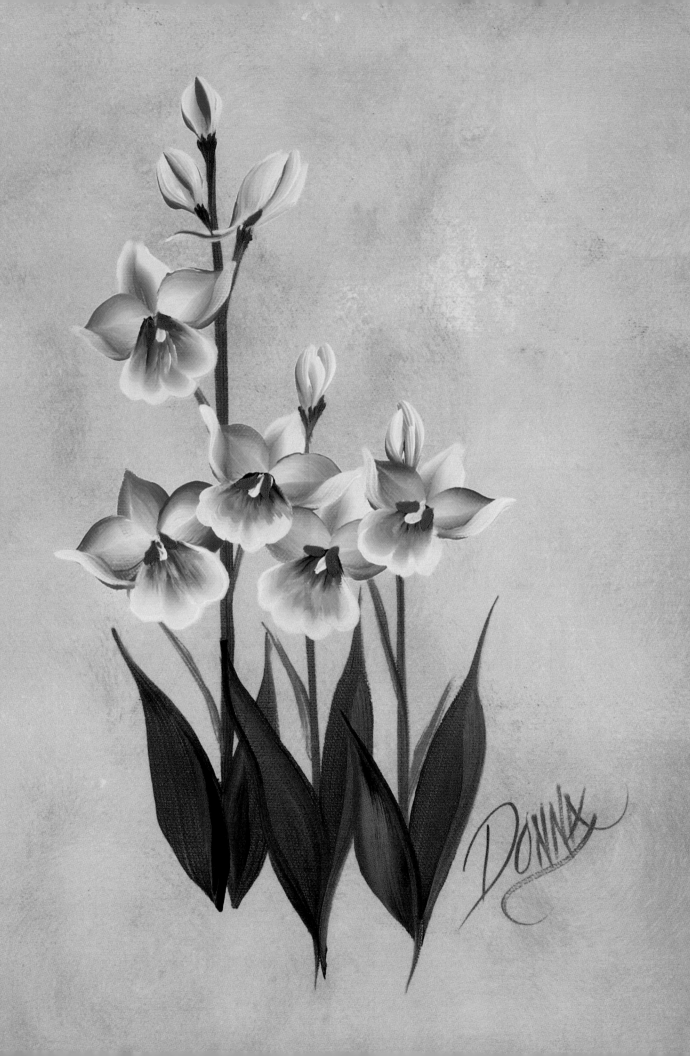

larkspur

brushes
no. 8 flat • no. 16 flat

colors
Thicket • Fresh Foliage • Wicker White
Dioxazine Purple • Yellow Light • Violet Pansy

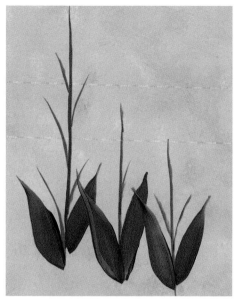

1. Create a Tone-on-Tone background using Butter Pecan and Wicker White, following the directions on page 27. Let dry. Double load Thicket and Fresh Foliage on a no. 16 flat. Place the tall stems and the smaller stems branching off. Paint long thin leaves at the base of the stems starting on the chisel; touch, push down on the bristles and slide, then lift back up to the chisel.

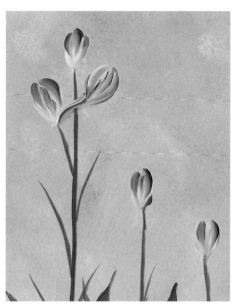

2. Double load a no. 16 flat with Dioxazine Purple and Wicker White. Occasionally pick up a little Violet Pansy on the purple side for variation. Stroke in the buds with three or four side-by-side comma strokes. Add a little tail to the largest bud with Yellow Light and Wicker White.

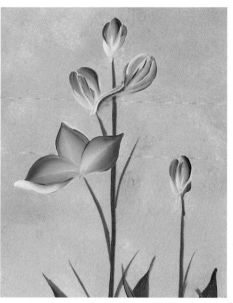

3. Double load a no. 16 flat with Dioxazine Purple and Wicker White and stroke the three back petals of the open blossom.

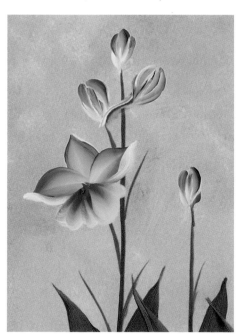

4. With the same brush and colors, paint the lower petals using a shell stroke for each petal.

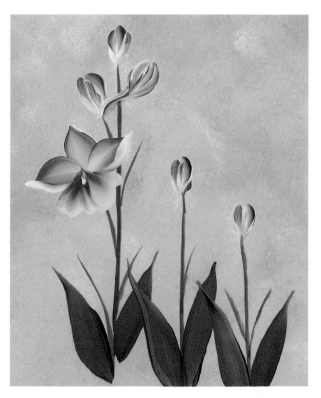

5. Double load a no. 8 flat with Yellow Light and Wicker White and paint three yellow stamens in the center of the open blossom. Go over the middle stamen with Wicker White. To finish your larkspur composition, add four more open blossoms below the two buds on the right. Before painting the stamens, shade the centers if needed with chisel edge streaks of Dioxazine Purple.

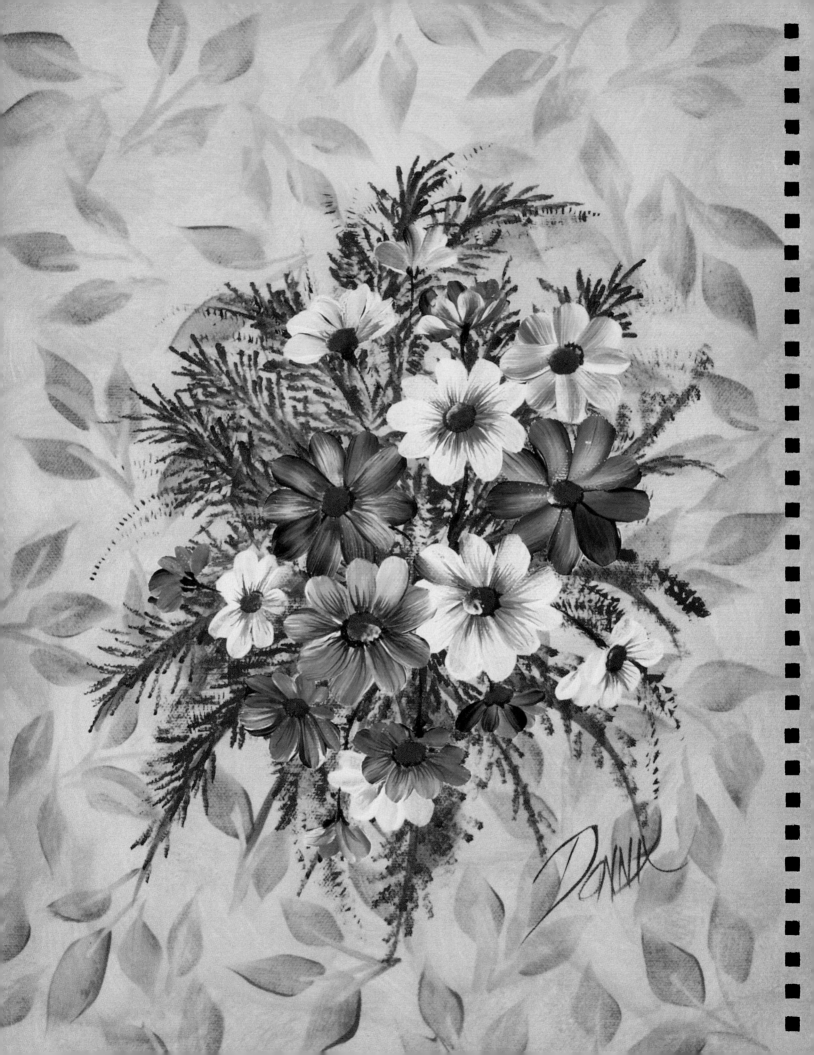

cosmos

brushes
no. 12 flat • no. 8 filbert
1/4-inch (6mm) scruffy • no. 2 script liner

colors
Fresh Foliage • Thicket • Wicker White
Magenta • Yellow Light • School Bus Yellow

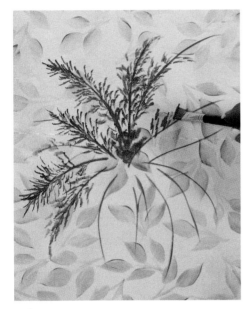

1. Create a Shadow Leaves background following the directions on page 29 and using Fresh Foliage and Wicker White for the background and shadow leaves. Let dry. Double load a no. 12 flat with Fresh Foliage and Thicket and pull light curving stems radiating outward from the center. Stay up on the chisel edge to keep your stems thin and delicate. Re-load your brush, picking up a little Yellow Citron on the lighter green side of the brush. The little feathery leaves are tapped on with the chisel edge, angled upward along the stems.

2. Double load a no. 8 filbert (see page 14 for directions on double loading a filbert brush) with Magenta and Wicker White. Start with the sideview buds at the top of the bouquet. To get the color variations, flip the filbert brush over so the Magenta is on the other side and paint the front petals of the buds. Using the same brush and colors, start with the back petals of the large pink cosmos, pulling each petal toward the center.

3. Finish the pink cosmos petals, pulling each one toward the center and turning your surface as you go to make painting easier. The white cosmos is painted the same way, using Wicker White on a no. 8 filbert. Load a no. 12 flat with Magenta and pull some chisel edge streaks out from the center to shade and detail the petals.

4. Double load a 1/4-inch (6mm) scruffy with School Bus Yellow and Yellow Light, plus a touch of Wicker White. Pounce on the flower centers. Go back and pick up a little more Wicker White on the scruffy and pounce a highlight on one side of the flower centers. Shade the opposite side of the flower centers with Thicket on a no. 2 script liner, as shown at left. To finish your cosmos bouquet, add several more open blossoms and sideview buds here and there, allowing the feathery green leaves and stems to show through. Vary your petal colors by picking up either more Magenta or more Wicker White on your no. 8 filbert. Don't forget to pull streaks out from the flower centers using the chisel edge of your flat brush.

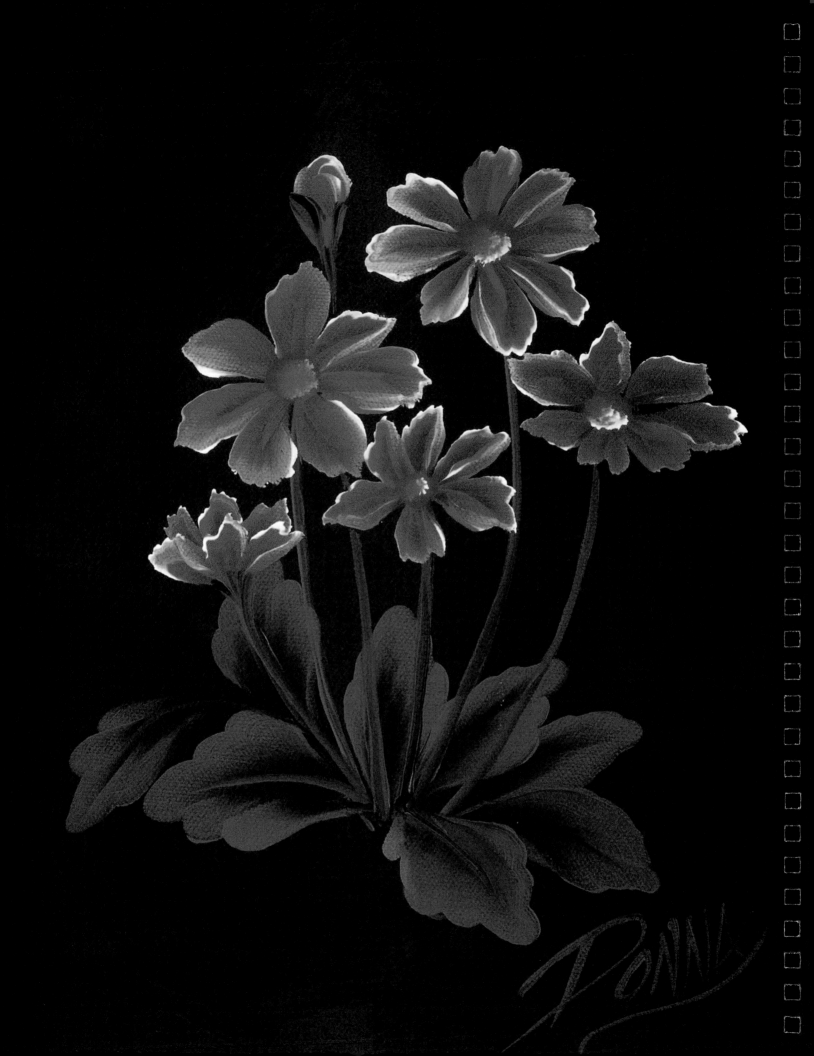

coreopsis

brushes

no. 12 flat • 1/4-inch (6mm) scruffy

colors

Fresh Foliage • Thicket • Yellow Light
Wicker White • Yellow Ochre

1. Create a Faux Leather background following the directions on page 32. Let dry completely. Double load your no. 12 flat with Fresh Foliage and Thicket. Paint the stems for placement using the chisel edge of the brush. Paint a rosette of scalloped-edge leaves at the base of the stems, keeping the Fresh Foliage side of the brush to the outside edges of the leaves. Pull smaller stems partway into the leaves.

2. Load a no. 12 flat with Yellow Light and sideload into Wicker White. Paint the bud at the top with three overlapping chisel edge strokes. For the large open blossom, paint a circle of six or seven jagged-edge petals (see page 16), keeping the Wicker White side of the brush to the outside edges of the petals. With the same brush and colors, paint a sideview blossom below the large one. Start each petal at the same spot in the center above the stem.

3. Add a second, shorter layer of petals to the sideview blossom. Load a 1/4-inch (6mm) scruffy with Yellow Ochre and pounce on the center of the large open blossom. Pick up Yellow Light and Wicker White on the scruffy and highlight the center. Double load a no. 12 flat with Thicket and Fresh Foliage and chisel edge a calyx under the sideview blossom to attach it to the stem. Also add a calyx to the bud. To finish your coreopsis, fill in with several more open blossoms, varying their size and shape for interest.

bellflower

brushes
no. 12 flat • no. 16 flat • no. 2 script liner

colors
Thicket • Fresh Foliage • Wicker White
Violet Pansy • Yellow Light

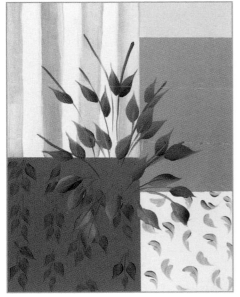

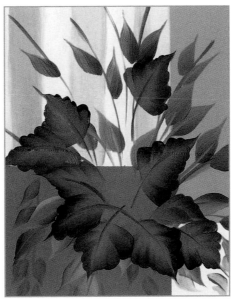

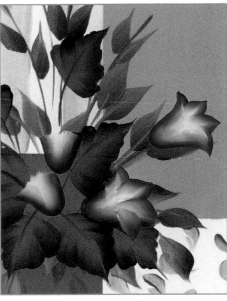

1. Create a Patchwork Squares background following the directions on pages 34-35. The colors for this background are Linen, Wicker White and Basil Green. Let dry. Double load a no. 16 flat with Thicket and Fresh Foliage, plus a little Wicker White occasionally. Paint the stems and the smaller one-stroke leaves.

2. With the same brush and colors, paint the larger wiggle-edge leaves, keeping the Thicket to the outside. Pull stems partway into the centers of the leaves.

3. Double load a no. 12 flat with Violet Pansy and Wicker White. Begin painting the petals of the bellflowers, keeping the Violet Pansy to the outside. Begin with large C-strokes for the base, then added the pointed petal edges.

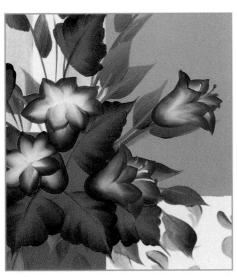

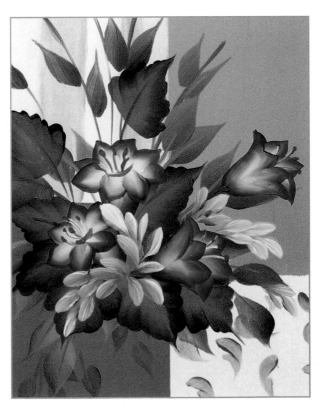

5. Using the same brush and colors, stroke in a lot of little buds to fill in among the bellflowers. Use a daisy-petal touch and pull stroke, leading with the Violet Pansy side of the brush. Finish with stamens of Fresh Foliage and Wicker White on a no. 2 script liner. Dot the ends with Yellow Light.

4. In the sideview blossoms, paint little stamens with Fresh Foliage and Wicker White on a no. 2 script liner. Dot the ends with Yellow Light. Double load a no. 12 flat with Violet Pansy and Wicker White. Paint the top petals of the trumpet shape (see page 19) on each bellflower facing toward you.

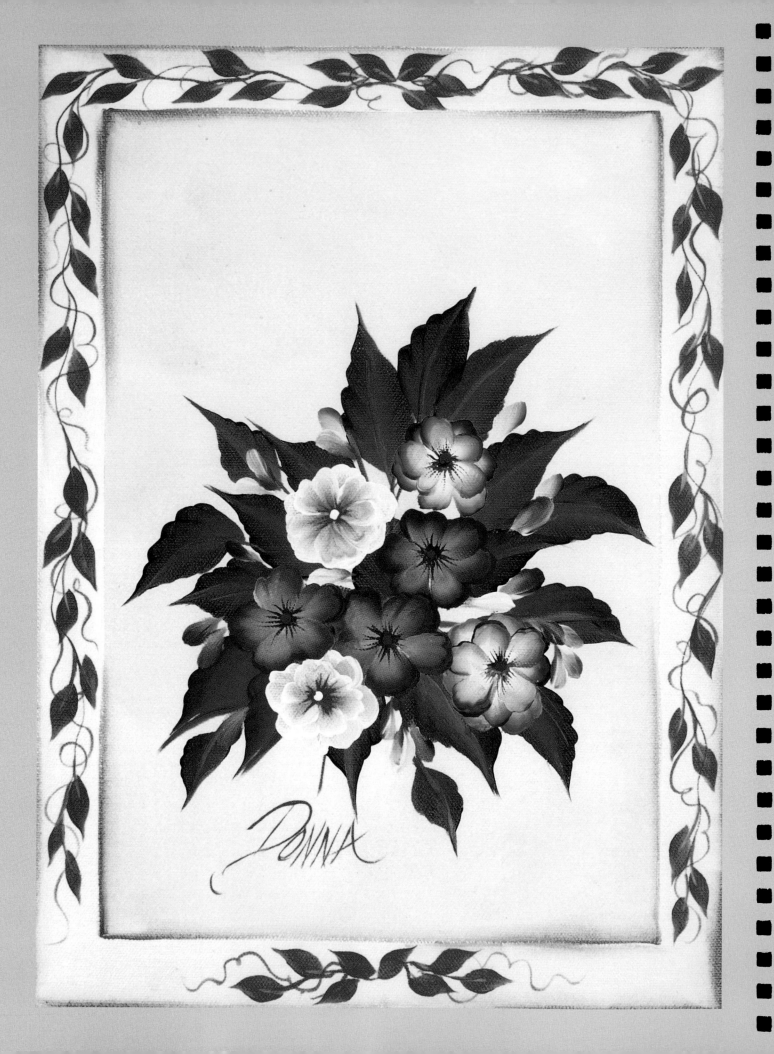

mixed impatiens

brushes

no. 10 flat • no. 12 flat • no. 2 script liner

colors

Thicket • Yellow Citron • Pure Orange • Sunflower
School Bus Yellow • Magenta • Wicker White

1. Tape off a 1-inch (25mm) frame. Sponge on a light blue background using Baby Blue and Wicker White. Remove the tape and let dry. Double load a no. 12 flat with Thicket and Yellow Citron. Paint long slender leaves with slightly ruffled edges. Pull stems partway in.

2. Double load a no. 12 flat with Pure Orange and Sunflower and paint the orange impatiens. Let dry and add a second coat if needed for good coverage. For the white impatiens, load a no. 12 flat with Wicker White and pick up just a touch of Thicket for depth of color in the center. For the pink impatiens, load a no. 12 flat with Wicker White and sideload into Magenta (see page 13 for sideloading tips). Paint the first layer of pink petals, then reload and paint the second, smaller layer of petals. Using a sideloaded brush keeps just the outer tips of the petals pink.

3. Detail and shade the centers by painting tiny lines radiating outward using the no. 2 script liner. Use Magenta for the pink flowers, Pure Orange on the orange flowers, and School Bus Yellow on the white flowers.

4. Using the handle end of the script liner, dot in the centers: Wicker White on the white impatiens, and School Bus Yellow on the pink and orange impatiens. Paint flower buds in all three colors using the chisel edge of a no. 10 flat. Fill in the bouquet with more flowers and buds, keeping the overall shape of the design fairly circular. To paint the frame, load a no. 10 flat with Fresh Foliage and floating medium. Paint shadow leaves starting at the center top and continuing down the right side. Start at the center top again and paint leaves down the left side. Place a small cluster on the center bottom of the frame. Float-shade along the inside and outside edges of the frame with Butter Pecan and floating medium.

wisteria

brushes

no. 12 flat • no. 16 flat

colors

Thicket • Yellow Light • Fresh Foliage
Heather • Violet Pansy • Wicker White

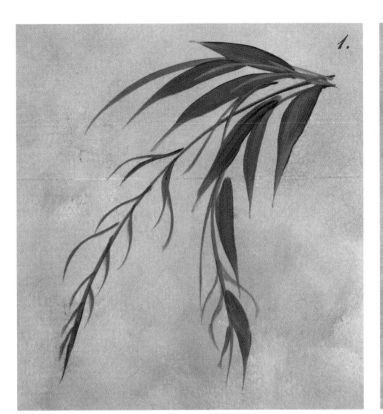

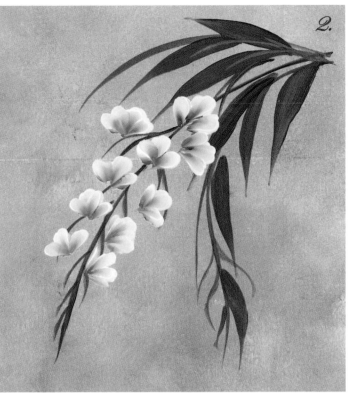

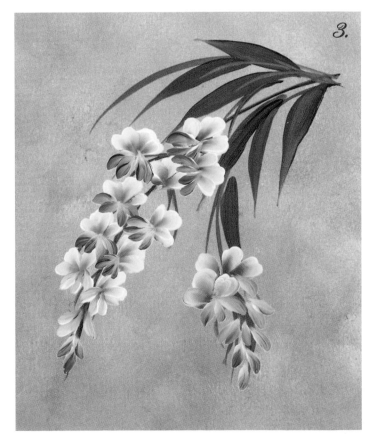

1. Start with an Antiqued background following the directions on page 33. Let dry. Double load a no. 16 flat with Thicket and Fresh Foliage and pick up some floating medium. Paint the long stems originating from the upper right corner, and add some smaller stems coming off the main ones. Paint the long thin leaves starting at the base on the chisel edge. Press down on the bristles to widen, then slide and lift back up to the chisel. Keep the leaves airy—let the background show through among the leaves and stems.

2. Double load a no. 12 flat with Heather and Wicker White and paint all the back petals of the wisteria blossoms, occasionally picking up Violet Pansy. These little petals are made up of three, four or five small comma strokes or daisy petal strokes side by side. Touch, lean the bristles in the directions you're painting, and lift to the tip. Don't turn your brush—make sure the Wicker White side is always to the outside edge of the petals.

3. With the same brush and colors, add the front petals, stroking toward the center. Again, pick up Violet Pansy on the Heather side of the brush every once in a while for color variations in the petals. Add the hanging buds with single comma strokes. To finish, dot in the flower centers with Yellow Light, and chisel edge some small skinny buds with Fresh Foliage. Add a couple more leaves to fill in around the wisteria blossoms if needed.

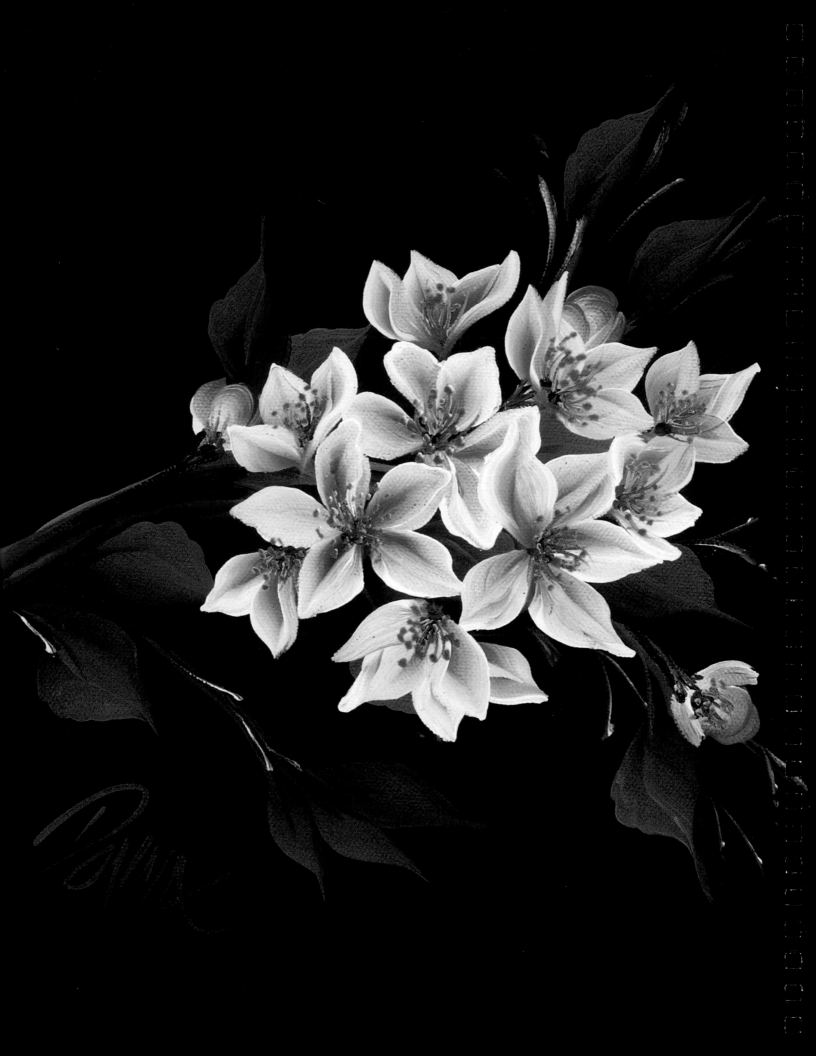

apple tree blossoms

brushes
no. 12 flat • no. 16 flat • no. 2 script liner

colors
Burnt Umber • Thicket
Yellow Light • Wicker White • Magenta
Soft Apple • Fresh Foliage

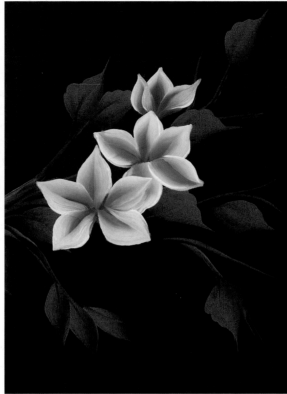

2. Double load a no. 12 flat with Magenta and Wicker White. Begin painting the apple blossom petals. These are all pointed single-stroke petals (see page 17). Keep the Magenta side of the brush toward the center of the petals. With the same brush and colors, paint the three petals of the sideview blossom in back.

1. Begin by creating a Faux Leather background following the directions on page 32. Let dry completely. Double load a no. 16 flat with Burnt Umber and Wicker White and paint the branches of the apple tree. The leaves are painted with Thicket and Fresh Foliage double loaded on a no. 16 flat. The larger leaves have one wiggle side and one smooth side (see page 22). The smaller leaves are one-stroke leaves.

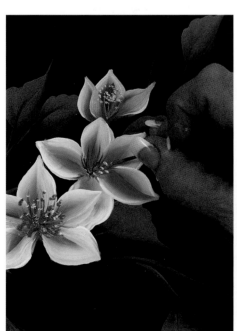

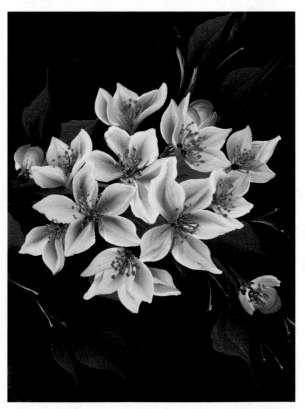

4. Continue painting apple blossoms to fill out the cluster on the branch. Load a no. 2 script liner with inky Burnt Umber, then stroke through Wicker White on your palette. Paint the tiny twigs extending out from the branches, filling in around the leaves as needed.

3. Load a no. 2 script liner with inky Thicket, then stroke through a little Soft Apple on your palette. Paint the stamens, then dot the anthers with Yellow Light and Wicker White.

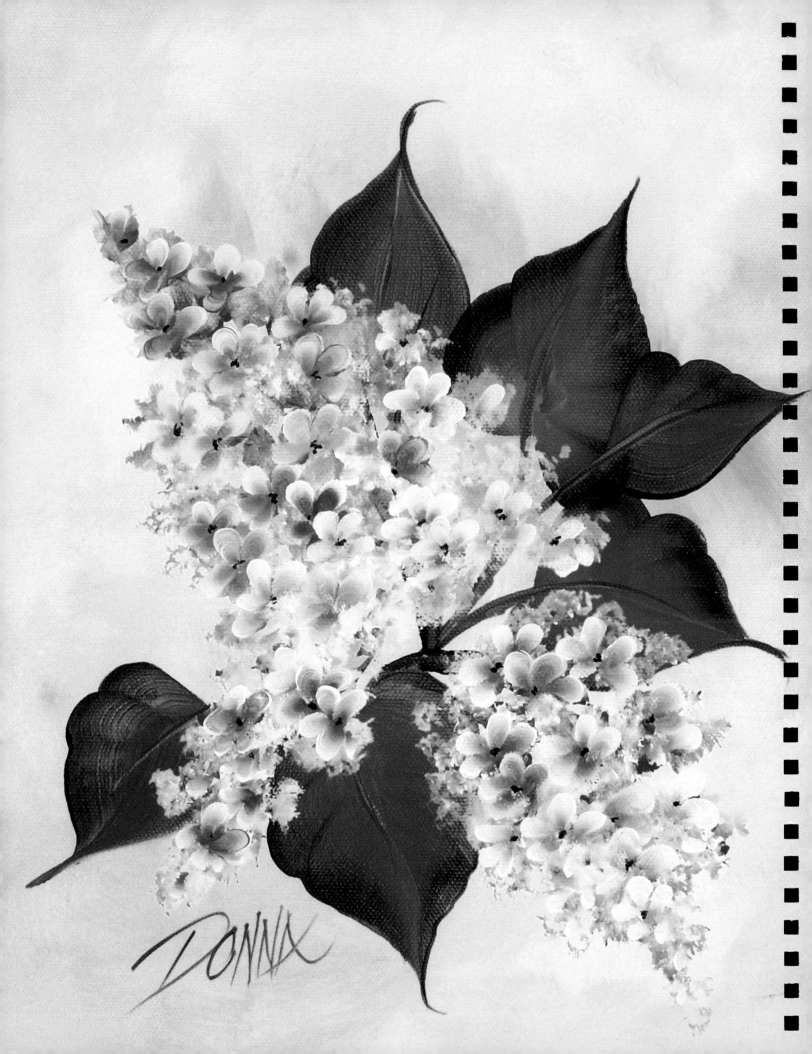

lilac

brushes
no. 10 flat • 3/4-inch (19mm) flat
3/4-inch (19mm) scruffy • no. 2 script liner

colors
Thicket • Wicker White • Fresh Foliage
Burnt Umber • Violet Pansy • Dioxazine Purple

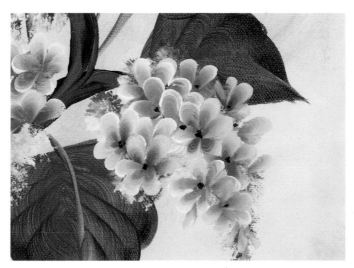

1. Create a Sky & Clouds background following the instructions on page 28. Let dry. Paint the stems and leaves with Thicket and Fresh Foliage double loaded on a 3/4-inch (19mm) flat. Add a few tree branches among the leaves with Burnt Umber and Wicker White on a no. 10 flat.

2. Establish the general shape of the lilacs using a 3/4-inch (19mm) scruffy double loaded with Violet Pansy and Wicker White. Lilac blossoms are wider at the stem and narrow down to a point at the end.

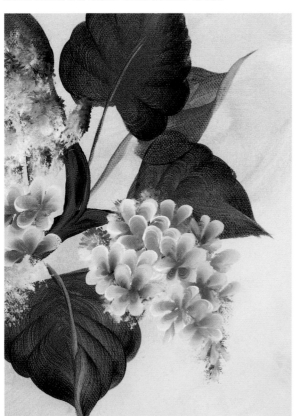

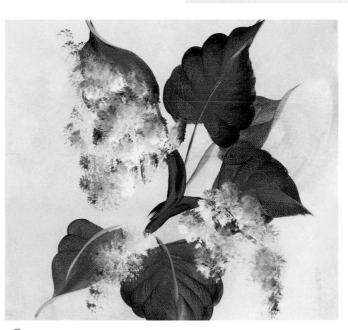

3. (Left) Lilac blossoms are large clusters of individual petals or florets that are painted right over the shapes you pounced on in step 2. Double load a no. 10 flat with Violet Pansy and Wicker White and begin painting the individual five-petal florets, overlapping them as shown. As you approach the bottom tip, load more Wicker White on your brush to make the petals a little lighter in color.

4. (Above) The flower centers are inky Dioxazine Purple dotted on with a no. 2 script liner.

pear tree blossoms

brushes

no. 16 flat • no. 2 script liner

colors

Thicket • Soft Apple

Wicker White • Magenta

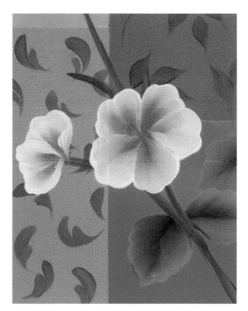

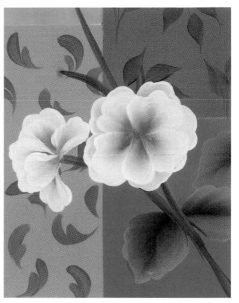

1. Create a Patchwork Squares background following the instructions on pages 34-35, leaving off the stripes. Let dry. Double load a no. 16 flat with Thicket and Soft Apple and paint the stems and leaves. Keep the Soft Apple to the outsides of the leaves.

2. Load a no. 16 flat with Wicker White and sideload into just a touch of Thicket. Pear blossoms are white but you need a bit of color for shading and depth. Paint the sideview blossom and the outer layer of the open blossom.

3. With the same brush and colors, continue painting the next layer of the open blossom, making it a little smaller than the first layer. Add the lower petals to the sideview blossom. Keep the Wicker White to the outside so the green shades the center.

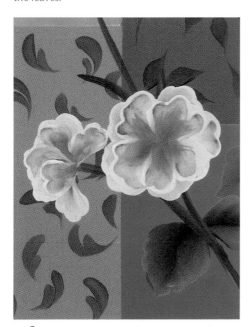

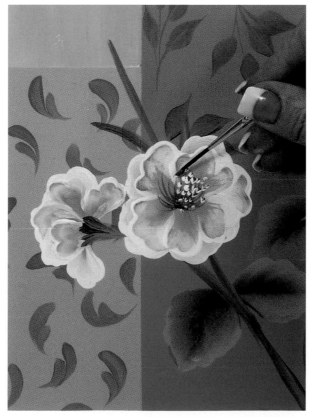

4. To shape the outer edges of the petals and make them seem as if they are curling upward, float shading around the inner edge of each petal by loading a little more Thicket onto your no. 10 flat. See page 20 for complete instructions on how to float-shade a flower petal.

5. Paint the base of the sideview blossom where it connects to the stem with Thicket and Soft Apple on a no. 10 flat. For the centers of the open blossoms, load a no. 2 script liner with inky Thicket and dot the centers, then pull fine curving lines outward for the stamens. Stroke the liner through Wicker White, dip the tip into Magenta, and dot the ends of the stamens. To finish your pear blossom painting, add more open and sideview blossoms and a bud lower down on the branch. Use your brush handle to add Soft Apple polka dots to the lower left patchwork square.

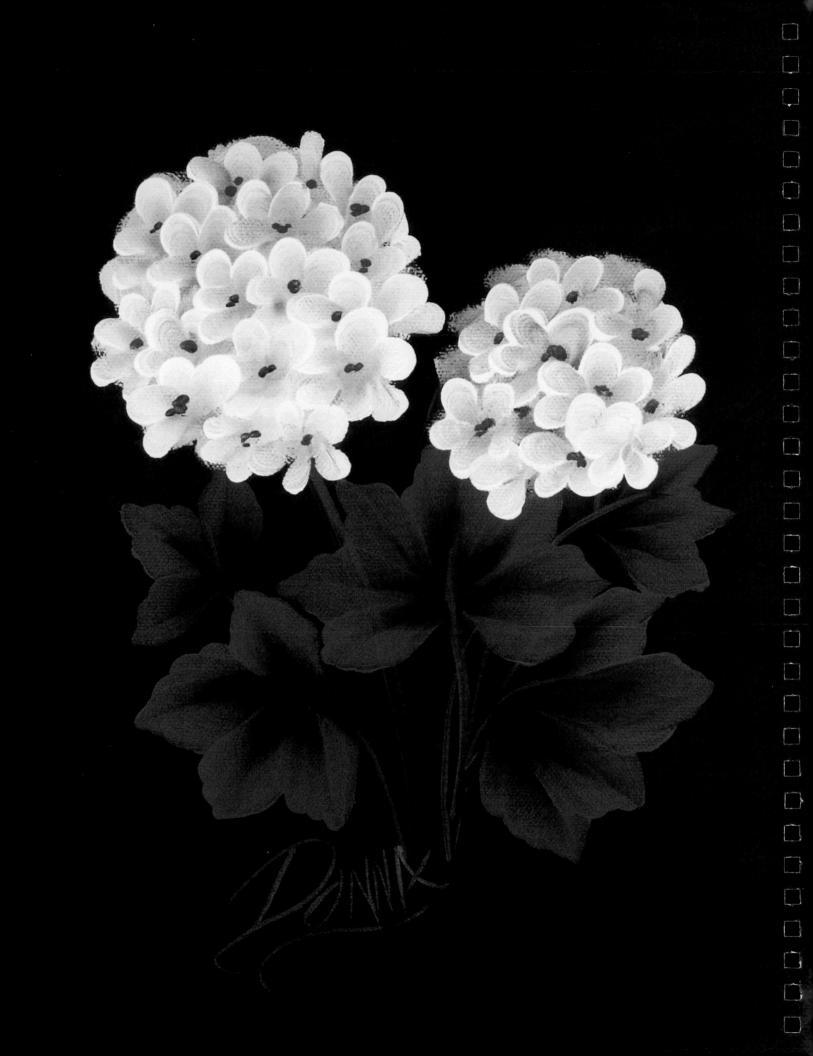

snowball viburnum

brushes
no. 10 flat • 3/4-inch (19mm) flat
3/4-inch (19mm) scruffy

colors
Thicket • Wicker White
Yellow Ochre • Fresh Foliage

1. Create a Faux Leather background following the instructions on page 32. Let the background dry completely. Double load a 3/4-inch (19mm) flat with Thicket and Fresh Foliage. Paint the stems first for placement, then the leaves, keeping the Fresh Foliage to the outside.

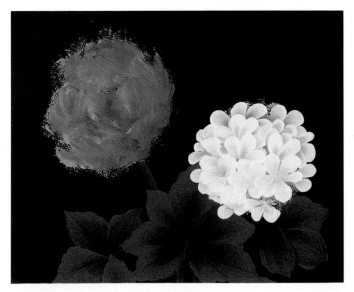

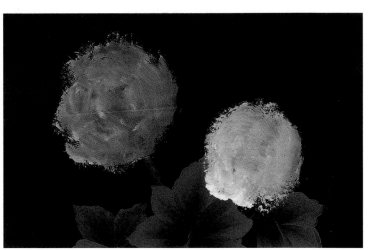

2. Double load Yellow Ochre and Wicker White on a 3/4-inch (19mm) scruffy and pounce on the approximate shape and size of the snowball viburnum flowerheads. These shapes will be overpainted with lots of petals so they don't need to be perfect.

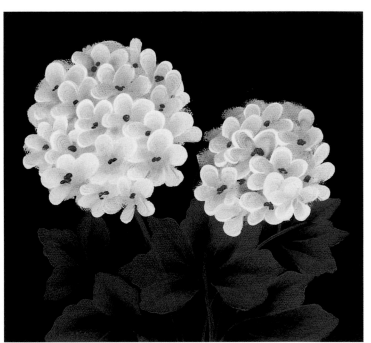

3. (Left) Double load a no. 10 flat with Wicker White and Yellow Ochre. Begin painting the five-petal florets, keeping the Wicker White to the outside edges of the petals. Be sure to layer the five petal flowers by overlapping the florets (see page 17), but don't cover the background color entirely.

4. (Above) To vary the colors and add depth, pick up more or less Wicker White on your brush, or more or less Yellow Ochre. The whiter the petals in the center of the cluster, the more round the flowerhead appears to be. Finish by dotting in the centers with Fresh Foliage plus a little Thicket.

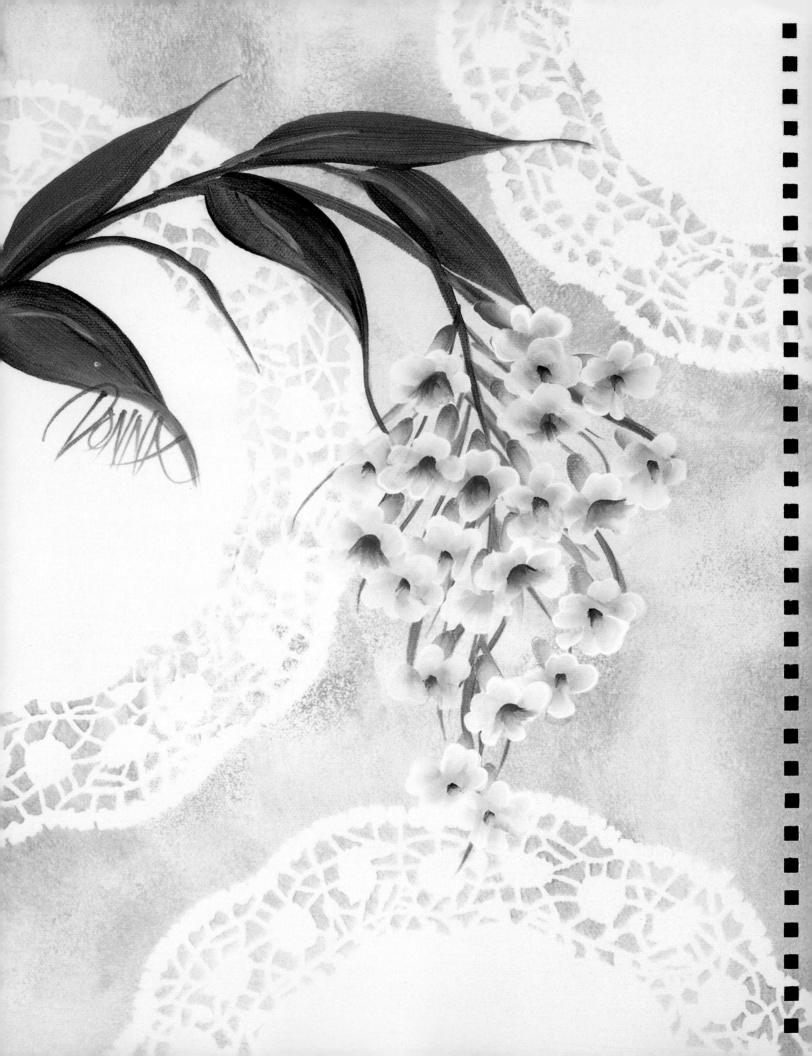

jacaranda tree

brushes
3/4-inch (19mm) flat • no. 10 flat

colors
Fresh Foliage • Burnt Umber • Heather
Dioxazine Purple • Wicker White

1. The background for the jacaranda tree is the Lace Paper Doily. Follow the instructions on page 26, but change the colors to Linen and Wicker White. Let dry. Double load a 3/4-inch (19mm) flat with Fresh Foliage and Burnt Umber. Paint the long, curving main stem and large leaves. Pick up Fresh Foliage on your dirty brush and add the finer hairlike stems at the end.

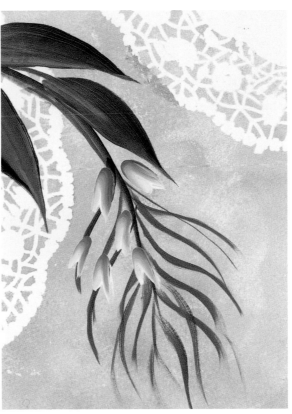

2. Jacaranda blossoms are clusters of little trumpet shaped flowers (see page 19). Double load a no. 10 flat with Heather and Wicker White and paint the trumpet shaped base of each flower using a tight C-stroke.

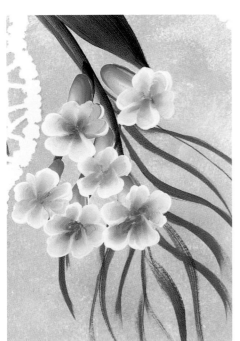

3. With the same brush and colors but picking up a little more Wicker White, paint the ruffled-edge petals that overlay the trumpet shaped base at the top.

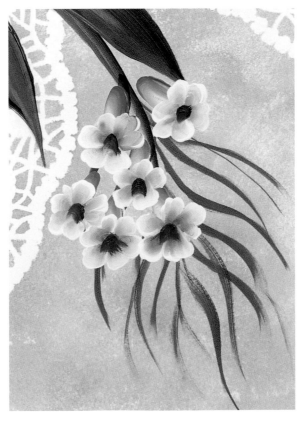

4. Load a no. 10 flat with Dioxazine Purple and shade the throats of the blossoms with a little open C-stroke. Pull out some tiny chisel edge streaks on a few of the petals.

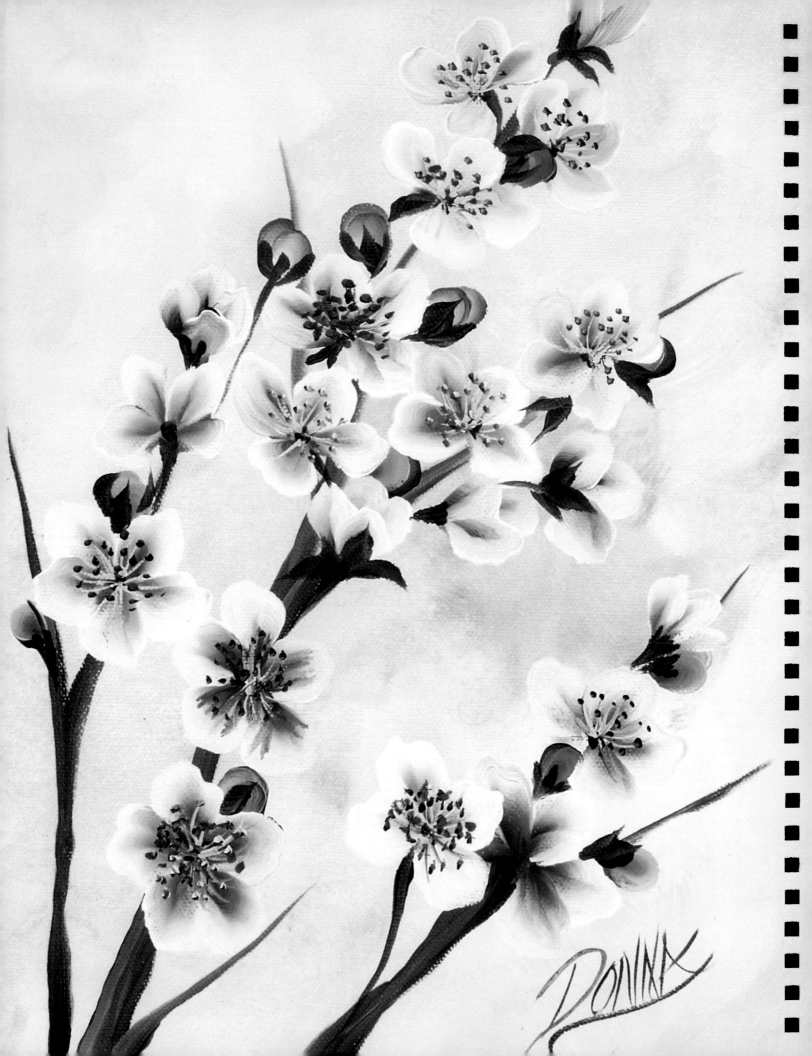

cherry tree blossoms

brushes

no. 8 flat • no. 12 flat • no. 16 flat
no. 2 script liner

colors

Butter Pecan • Burnt Umber • Wicker White
Peony • Yellow Light • Berry Wine

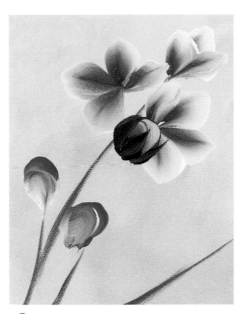

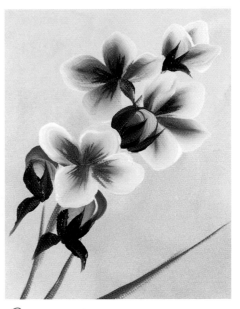

1. Create a Sky & Clouds background following the directions on page 28. Let dry. Double load Burnt Umber and Butter Pecan on a no. 16 flat. Pick up Wicker White to highlight. Paint the main tree branches and the smaller ones branching off, using the chisel edge of the brush. Cherry trees blossom before their leaves come out, so there are no leaves to paint!

2. Double load a no. 12 flat with Peony and Wicker White. Begin with the open petals. These are painted like a pointed single-stroke petal (see page 17), but the tips are rounded instead of pointed. Keep the Wicker White to the outside as you stroke these petals. Stroke in the buds with two or three overlapping comma strokes, turning the brush so the Peony is now on the outside. Load a no. 8 flat with Berry Wine and stroke some calyxes over the bud.

3. Continue painting buds and open blossoms down the branch. Shade the centers using the chisel edge of the no. 8 flat and Peony. Pull the calyxes with Berry Wine.

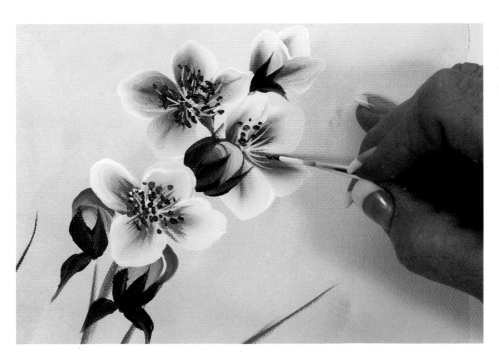

4. Load a no. 2 script liner with Wicker White and pull fine curving lines out from the centers for stamens. Pick up Berry Wine on the liner and dip into Yellow Light. Dot on the anthers and pollen dots.

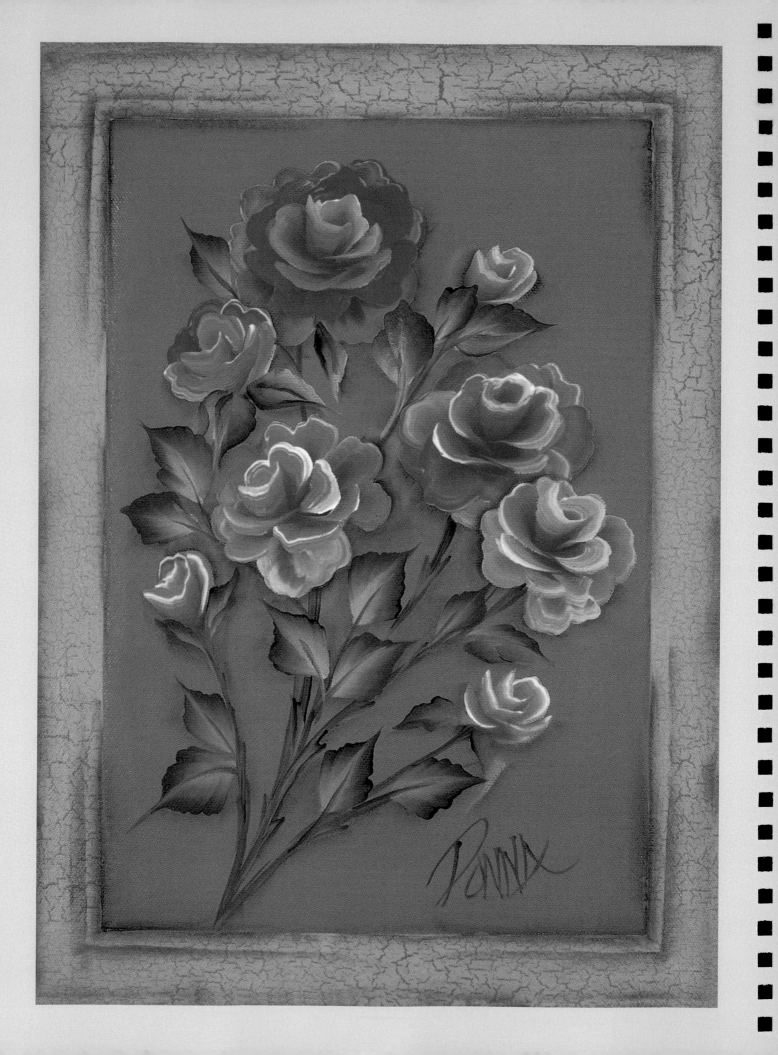

climbing rose

brushes

no. 10 flat • no. 16 flat

colors

Thicket • Sunflower • Wicker White

Yellow Ochre • Yellow Light

1. Create a Crackled Frame background following the directions on page 31. Here, the background center is Basil Green and the crackled frame is Linen. Let dry. Double load a no. 16 flat with Thicket and Sunflower and paint the stems and leaves, keeping the Thicket to the outside. If you prefer lighter leaves, as shown at left, pick up a little Wicker White on the Sunflower side.

2. To begin the roses, double load a no. 16 flat with Yellow Ochre and Wicker White (for lighter roses) or Yellow Ochre and Yellow Light (for bright yellow roses like the ones shown at left). Blend well on your palette. Start with the outer skirt of petals on the open rose and the back petal of the little rosebud (this is a C-stroke).

3. With the same brush and colors, add the side petals to the open rose and the front petal to the bud (this is a U-stroke).

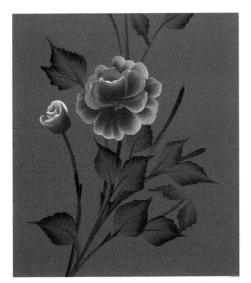

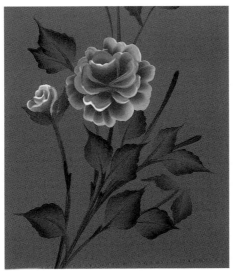

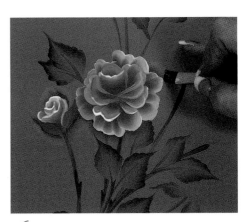

4. Paint the center bud in the open rose, then pull more side petals and petals that are starting to open out from the center. Add another layer of petals to the rosebud.

5. Fill in the rest of the petals on the open rose. Paint a calyx over the base of the rosebud with Thicket and Sunflower on a no. 10 flat.

6. Load a no. 10 flat with floating medium, then sideload into a little Thicket. Float shading underneath and around the roses to separate them from the background. To finish, fill in with more leaves if needed in the spaces between the roses. To add dimension to the crackled frame, float-shade Thicket in the four corners of the frame as shown at left.

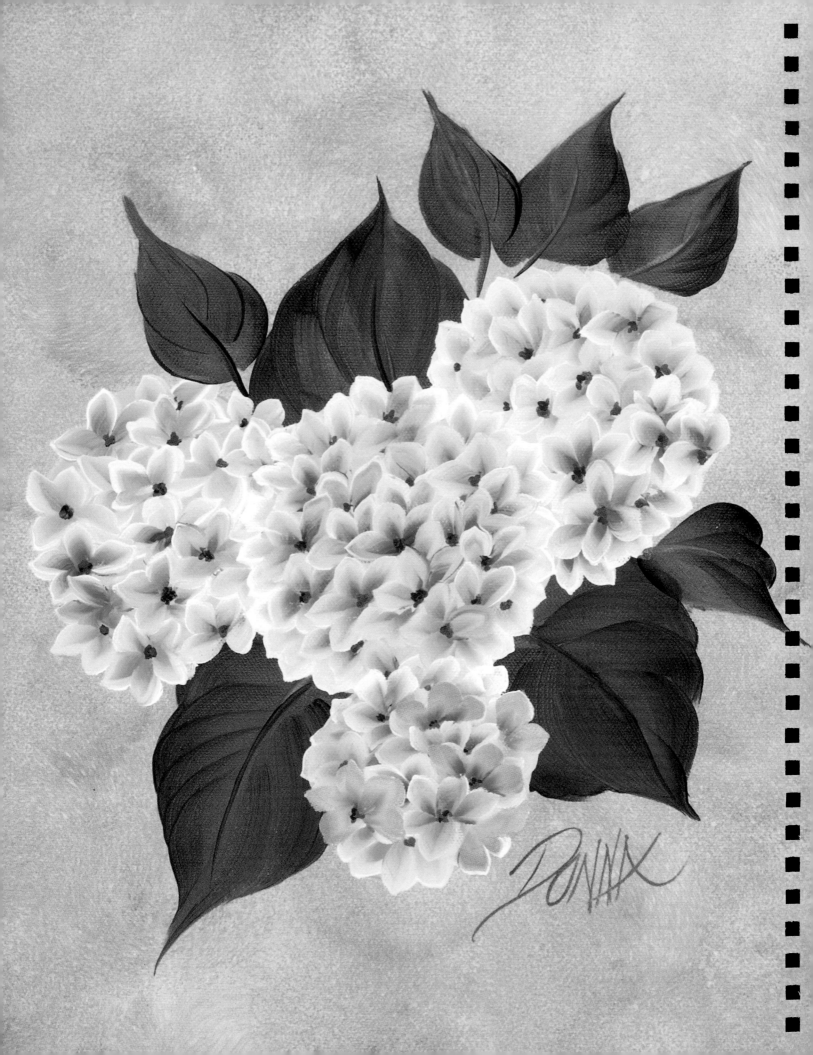

hydrangea

brushes
no. 10 flat • 3/4-inch (19mm) flat
no. 2 script liner

colors
Fresh Foliage • Thicket
Magenta • Wicker White

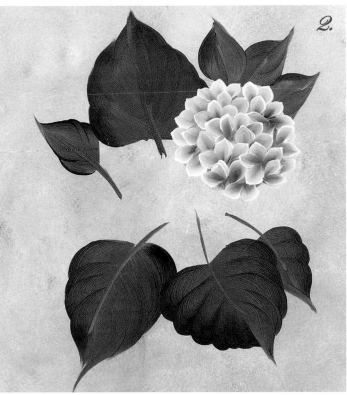

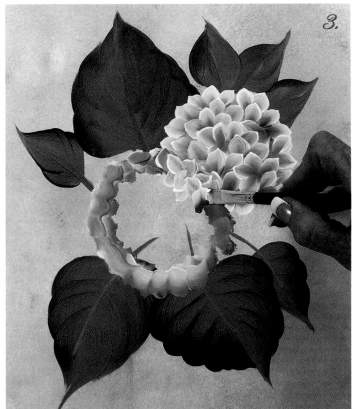

1. Create an Antiqued background following the directions on page 33. Let dry completely. Double load a 3/4-inch (19mm) flat with Fresh Foliage and Thicket. Paint the large ruffled-edge leaves and the smaller smooth-sided leaves in a roughly circular pattern as shown. As you reload your brush with color, dip into floating medium often to smooth out your strokes. Pull stems into the leaves using the chisel edge of the brush.

2. Hydrangeas have large round flowerheads that are clusters of smaller florets. Double load a no. 10 flat with Magenta and Wicker White. Keeping the Wicker White to the outside, paint four-petal florets that have a somewhat pointed tip. Overlap the florets as you go to create a ball-shaped cluster. Vary the petal colors by picking up more Magenta sometimes, and more Wicker White other times.

3. For the foreground cluster, using the same brush and colors, dab in a circular shape for placement. Begin painting individual florets to fill in around the circle, then work inward toward the center. To finish, add a couple more clusters to fill out the design. Vary the sizes of your flowerheads for interest. In the finished painting at left, the lower cluster has a few florets that are tinged green with a little bit of Fresh Foliage; as hydrangea blossoms age, their petals turn more green. Dot in the centers of the florets with Fresh Foliage on a no. 2 script liner, picking up a little Magenta for some of them.

butterfly bush

brushes

no. 10 flat • no. 16 flat • no. 2 script liner
3/4-inch (19mm) scruffy

colors

Thicket • Fresh Foliage • Wicker White
Burnt Umber • Violet Pansy • Dioxazine Purple

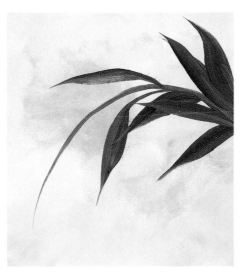

1. Create a Sky & Clouds background following the directions on page 28. Let dry. Double load a no. 16 flat with Thicket and Fresh Foliage, plus a little Burnt Umber. Paint the stems and the long, slender leaves.

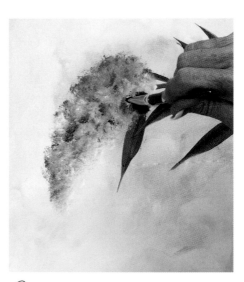

2. Pounce on the general shape of the blossom with a 3/4-inch (19mm) scruffy double loaded with Dioxazine Purple and Wicker White. Pick up a little Violet Pansy occasionally on the purple side of the scruffy for color variation. Don't overblend—leave some areas dark and some almost white.

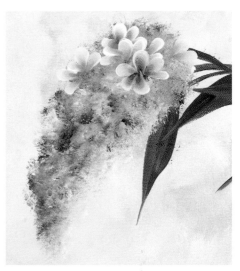

3. Double load a no. 10 flat with Violet Pansy and Wicker White. Begin painting the individual florets, keeping the Wicker White to the outside. Leave some open spaces between the florets so the background colors show through. To vary the colors of the florets, pick up some Dioxazine Purple sometimes, and more Wicker White other times.

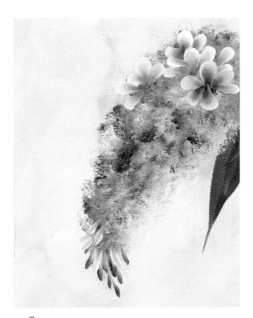

4. The blossoms of the butterfly bush come to a point at the bottom where the buds are forming. To paint the buds, chisel edge little teardrop strokes extending downward from the main part, using a no. 10 flat double loaded with Dioxazine Purple and Wicker White.

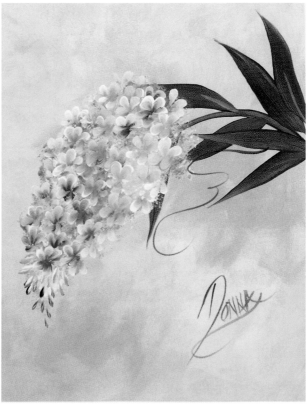

5. Using the same brush and colors, stroke in a lot of little five-petal florets to fill in the blossom. Remember to vary the colors you pick up on your brush as you did in step 3. Finish with a couple of curlicues or tendrils using inky Fresh Foliage on a no. 2 script liner.

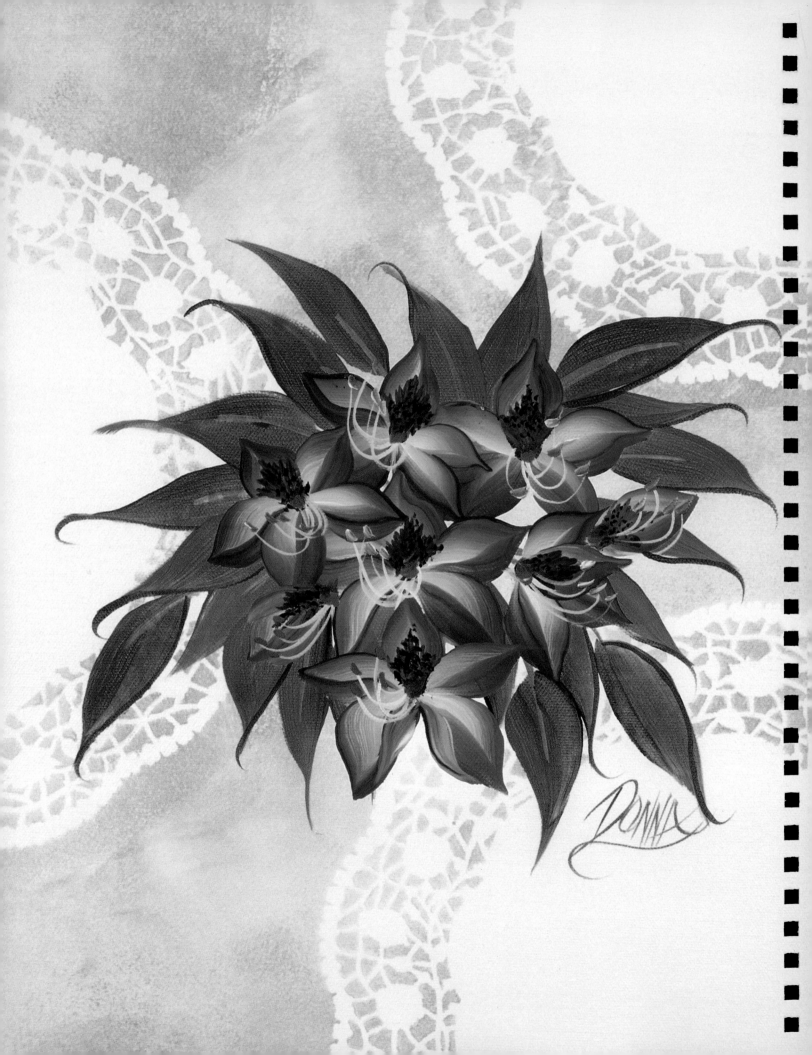

rhododendron

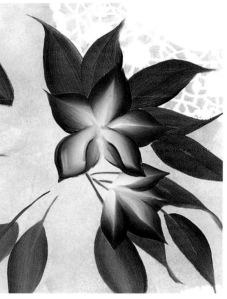

1. Create a Lace Paper Doily background following the directions on page 26, but using Linen and Wicker White. Let dry. Double load a no. 16 flat with Thicket and Yellow Citron. The long slender leaves are placed in a somewhat circular design to echo the roundness of the doilies. To paint these leaves, start at the base, push down on the bristles, slide and turn the brush to make half the leaf with a long tip. Then push, slide and turn to connect the second half of the leaf to the first.

2. Double load a no. 16 flat with Magenta and Wicker White and begin to paint the rhododendron petals. Start at the base of the petal on the chisel, lay the bristles down, slide out and then lift to the pointed tip. Without lifting your brush off the surface, slide back down to the base. Keep the Magenta side of the brush to the outside of the petals. Make some of your petals wider, and some a little narrower.

3. Add the two front petals on the open blossom. Note that the edges of these petals are rolled on one side. As you slide your brush back down to the base, turn it so the Magenta side curves inward toward the center.

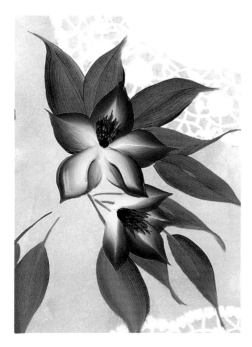

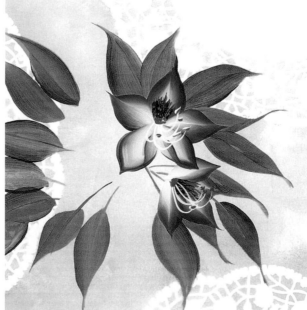

4. Darken the throat with little chisel edge strokes pulled upward from the center, using a no. 10 flat and Magenta. Pick up Dioxazine Purple and dot over the centers.

5. Load a no. 2 script liner with inky Wicker White and pull long curving stamens outward from the center. Dot on anthers with Yellow Light.

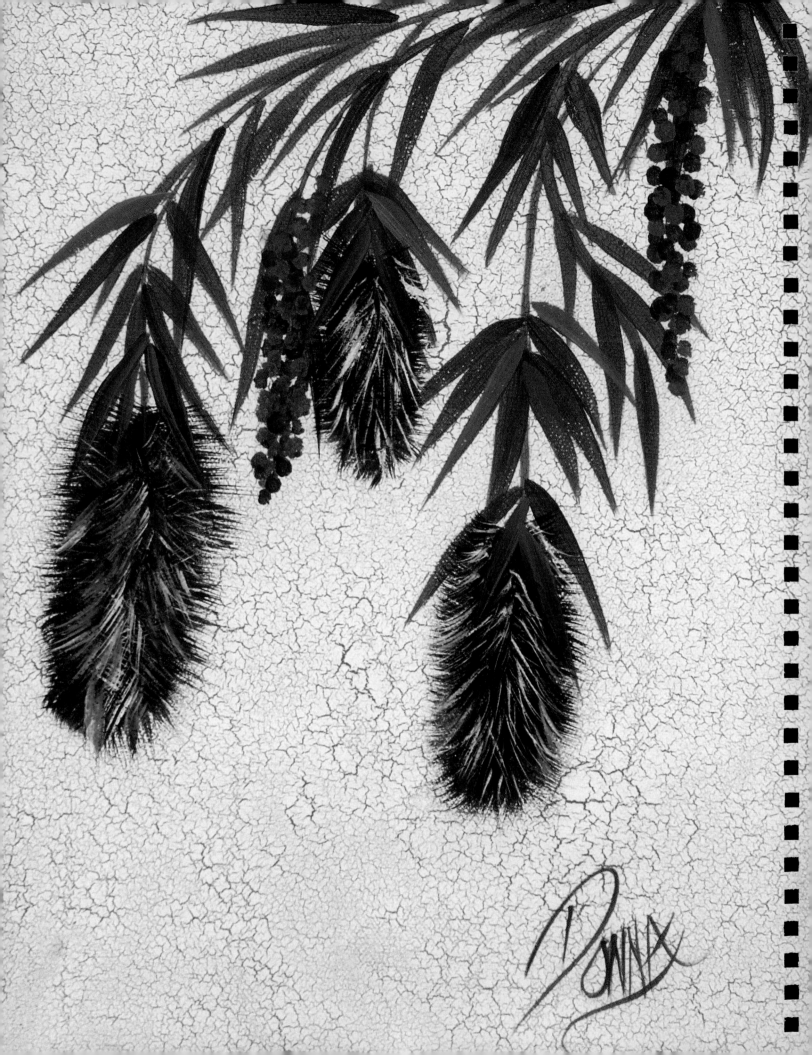

bottlebrush tree

brushes
no. 6 flat • no. 12 flat
1/2-inch (12mm) feather brush

colors
Thicket • Fresh Foliage
Engine Red • Wicker White

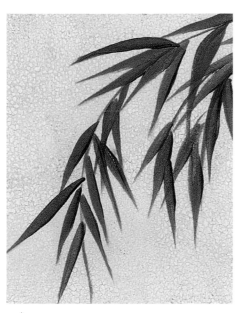

1. Create an Allover Crackled background following the directions on page 30. Let dry. Double load a no. 12 flat with Thicket and Fresh Foliage and dip into floating medium. Paint the stems and the long, slender bamboo-like leaves, staying mostly on the chisel edge.

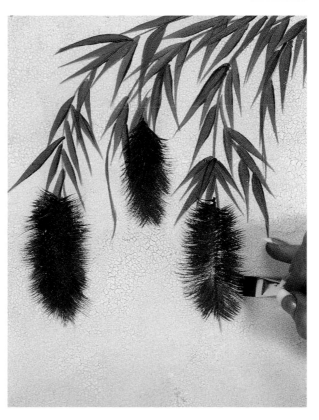

2. Using a 1/2-inch (12mm) feather brush loaded with thick Engine Red, pull short horizontal strokes outward from the stem to form the bottlebrush shapes. Pick up a little Thicket on your red brush and shade the blossoms, pulling shorter strokes outward from the center on both sides.

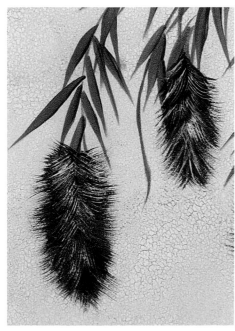

3. Pick up Wicker White on the same feather brush and pull a few lighter lines outward from the center to highlight. These should be much sparser than the shading lines.

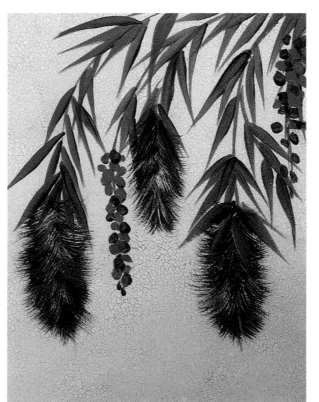

4. Double load a no. 12 flat with Thicket and Fresh Foliage and pull some more long, slender leaves downward to overlap the blossoms at the top. To paint the little seedpods, load a no. 6 flat with Thicket and dab on some circular pod shapes. Pick up some Fresh Foliage on your brush and add a few lighter pods here and there.

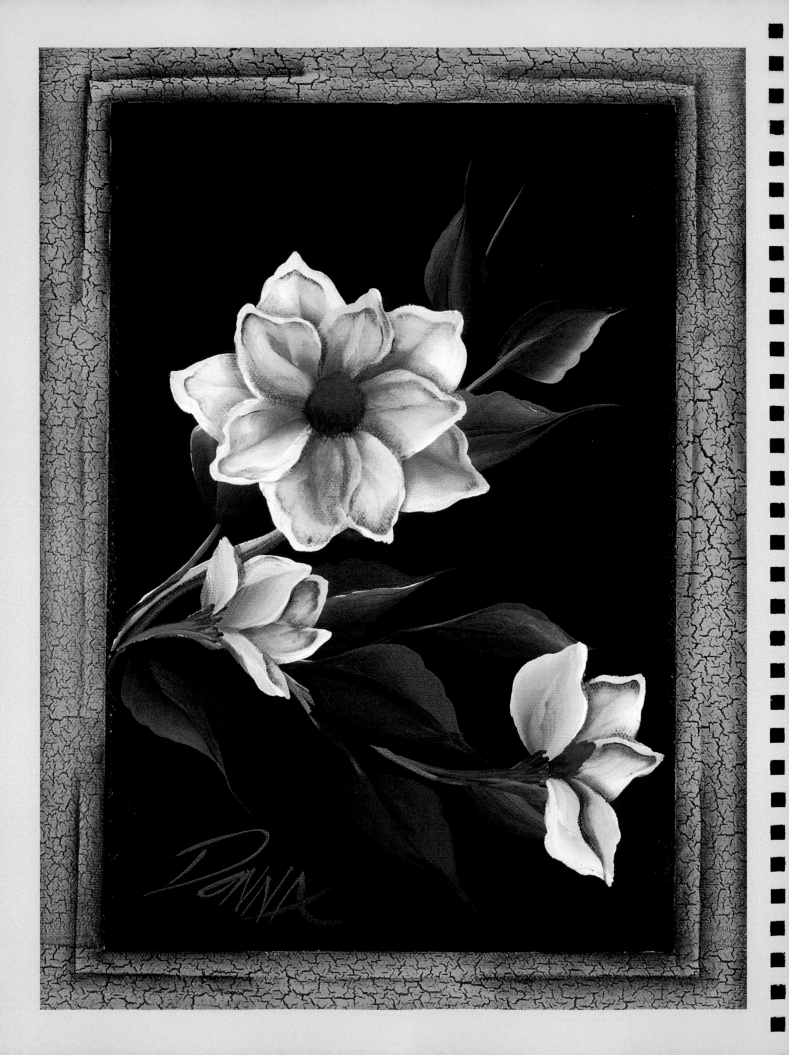

magnolia

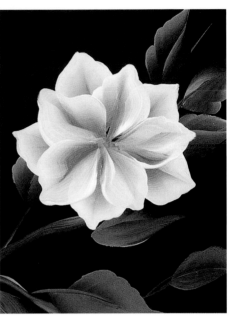

brushes
no. 10 flat • no. 12 flat • 3/4-inch (19mm) flat

colors
Burnt Umber • Wicker White
Fresh Foliage • Thicket • Butter Pecan
Yellow Ochre • Yellow Light

1. Create a Crackled Frame background following the directions on page 31. Here, the center color is Maple Syrup; the crackled frame is Linen. Let dry. Paint the branches with Burnt Umber and Wicker White on a 3/4-inch (19mm) flat. Double load the same flat with Thicket and Fresh Foliage, and work in some Burnt Umber on the Thicket side. Paint the leaves, keeping the Fresh Foliage to the outside.

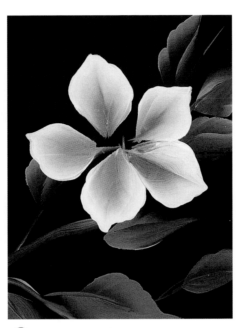

2. Load a 3/4-inch (19mm) flat with Wicker White, sideload into a little Butter Pecan and dip the brush into floating medium. Begin the magnolia blossom with the outer layer of five large petals. Keep the Wicker White to the outside.

3. Using the same brush and colors, paint the second, slightly smaller layer of five petals, offsetting them from the first layer as shown.

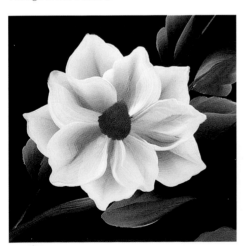

4. Double load a no. 10 flat with Yellow Ochre and Yellow Light and tap in the cone-shaped center with the chisel edge of the brush.

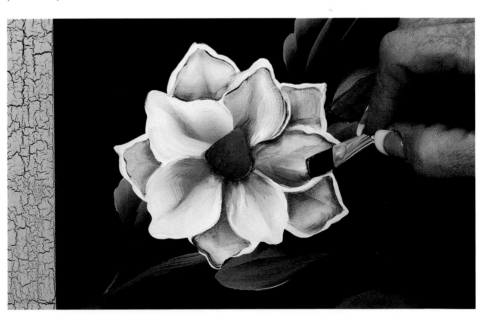

5. Load a no. 12 flat with floating medium, then sideload ever so slightly into Burnt Umber. Float shading around the center cone to separate it from the petals. Then float shading just inside the outer edges of the petals. To separate the lower layer of petals from the upper layer, float shading on the lower petals. To add shape and dimension to the crackled frame, load a 3/4-inch (19mm) flat with floating medium and sideload into Burnt Umber. Float shading along the inside edge of the frame on all four sides, then float shading on the corners of the crackled frame itself.

brushes
no. 10 flat • no. 16 flat

colors
Thicket • Yellow Citron • Wicker White

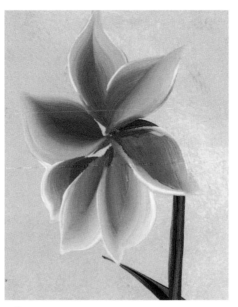

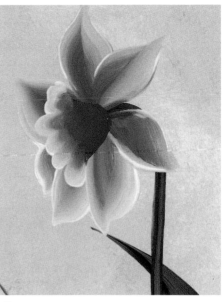

1. Begin by creating a Tone-on-Tone background following the directions on page 27. Let dry completely. Double load a no. 16 flat with Thicket and Yellow Citron and paint the leaves first, then the long straight stems. At the tops of the stems, curve them over where they will connect to the base of the blossom.

2. Double load a no. 16 flat with Yellow Citron and Wicker White. Paint the petals of the skirt, keeping the Wicker White to the outside. Begin each petal at the base, push down on the bristles, slide up to the tip lifting back up to the chisel, then slide back down again to the base.

3. Re-load the brush with the same colors, but pick up more Yellow Citron this time. Paint the back part of the center trumpet. This is a petal with a ruffled top edge (see page 18). Keep the Wicker White side of the brush to the top ruffled edge of the petal.

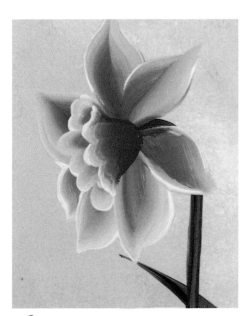

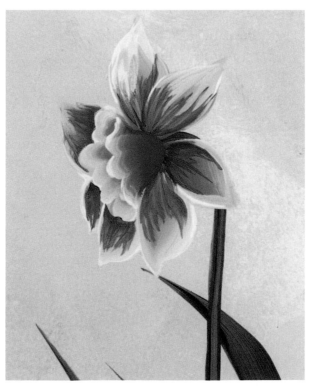

5. Load a no. 10 flat with Thicket and chisel-edge some shading lines coming out from the base of the skirt petals. Work around the shape of the center trumpet. To finish, paint the second jonquil as more of a sideview blossom, using a no. 16 flat double loaded with Yellow Citron and Wicker White. Again, keep the Wicker White to the outside edge of the petals and trumpet. Load a no. 10 flat with floating medium and sideload into Thicket. Float shading around the trumpet of the open blossom to separate it from the skirt petals. Also float shading in the inner part of the trumpet on the sideview blossom if needed.

4. Paint the front part of the trumpet with the same colors. This is a smaller petal with a ruffled top edge.

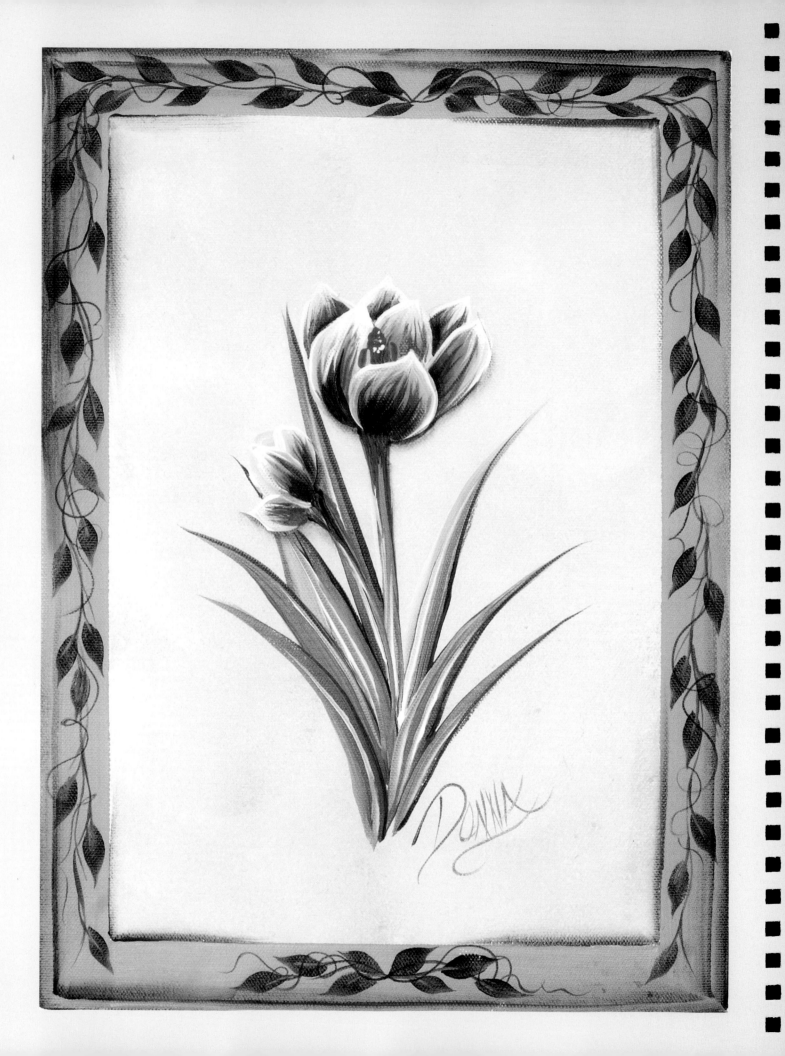

crocus

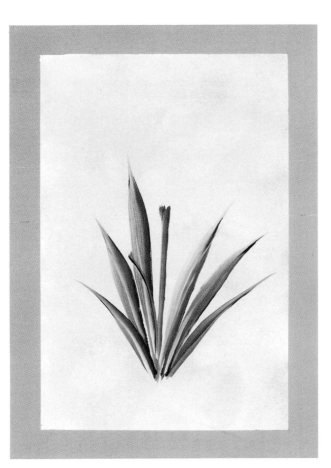

1. For the background, tape off the outer edges with 1-inch (25mm) painter's tape. Sponge on a soft blue in the center with Baby Blue and Wicker White. Remove the tape and let dry. Paint the frame with Butter Pecan. Let dry. Load a no. 16 flat with Thicket and Fresh Foliage on one side and Wicker White on the other. Paint the long pointed leaves first, then the stem. For variegated leaf colors, pick up more Wicker White for some of your strokes.

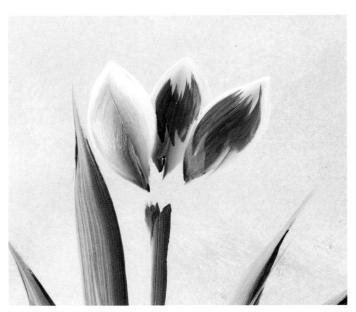

2. Double load a no. 16 flat with Violet Pansy and Wicker White. To paint the back three crocus petals, begin at the base of the petal, stroke up to the pointed tip, then slide back down to the base. Load the brush with inky Violet Pansy and add streaks using the chisel edge of the brush.

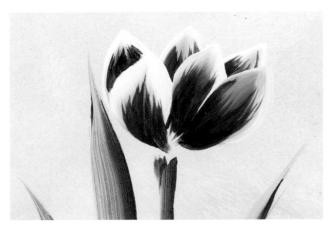

3. The next three petals are painted the same way as the step 2 petals, with Violet Pansy and Wicker White on a no. 16 flat. Chisel edge the streaky lines with inky Violet Pansy.

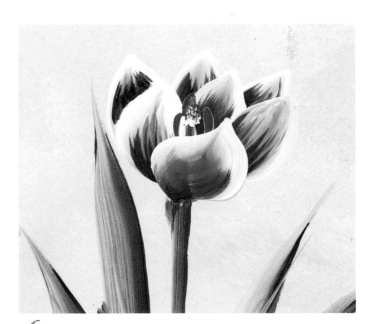

4. The center stamens are tapped on with Yellow Light and School Bus Yellow on a no. 2 flat. Let these dry, then paint the final front petal. To finish the frame, float shading in the four corners using floating medium and Maple Syrup. With the same brush, paint shadow leaves starting at the top center and coming down both sides. Finish with Maple Syrup tendrils using a no. 2 script liner.

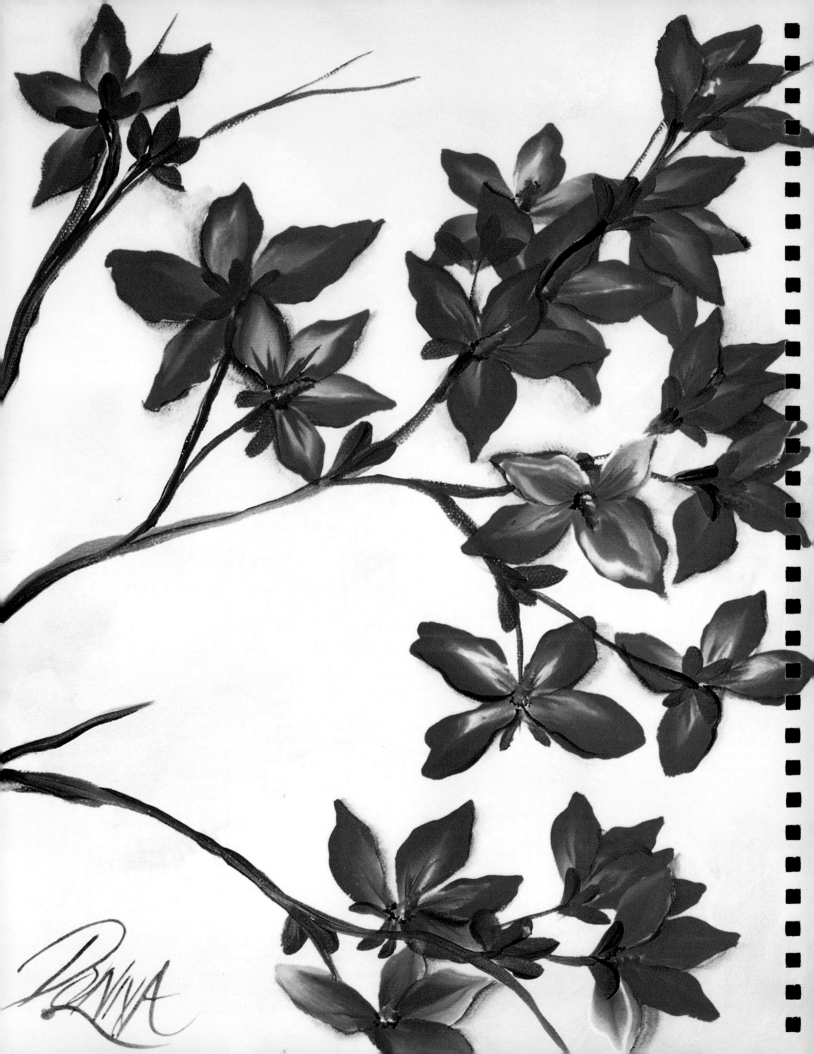

forsythia

brushes

no. 2 flat • no. 10 flat • no. 12 flat

colors

Burnt Umber • Thicket • School Bus Yellow
Wicker White • Yellow Light • Yellow Citron
Yellow Ochre

1. Create a Sky & Clouds background following the instructions on page 28. Let dry. Double load a no. 12 flat with Burnt Umber and Wicker White and paint the main forsythia branches, then the smaller branches coming off. Stay up on the chisel edge of the brush.

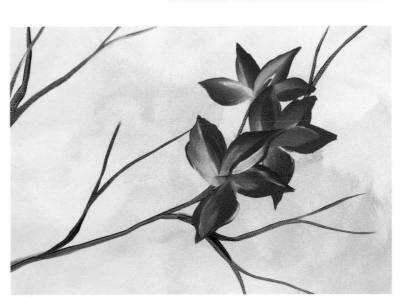

2. Forsythia shrubs blossom in the spring before their leaves come out. The little yellow blossoms are made up of tiny petals that open from buds that are all around and up and down each branch. Begin painting the pointed petals with a no. 12 flat multi-loaded with School Bus Yellow, Yellow Light and Wicker White.

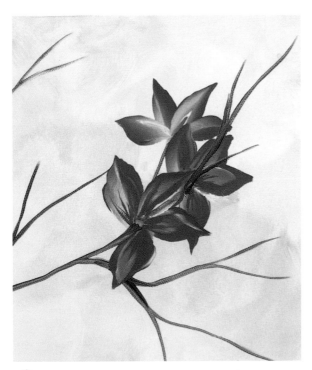

3. Re-establish some of the small branches on top of a few of the blossoms. Chisel-edge some Yellow Citron shading in the centers of the petals.

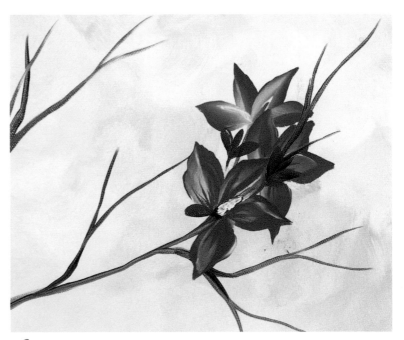

4. Paint the little green sepals at the base of the petals with Thicket and Yellow Citron on a no. 10 flat. The little stamens in the centers are tapped on with a no. 2 flat using Yellow Light, Wicker White and a touch of Yellow Ochre. Shade the base of the stamen with Burnt Umber. To finish, continue adding blossoms all along the smaller branches. Vary them so some are fully open, some are seen from the side, and some are seen from the back. When all petals are painted, load a no. 10 flat with floating medium and sideload into Burnt Umber. Float shading all around each petal to separate it from other petals and from the background.

primrose

brushes

no. 12 flat • 3/4-inch (19mm) flat
no. 2 script liner

colors

Thicket • Wicker White • Engine Red
School Bus Yellow • Fresh Foliage

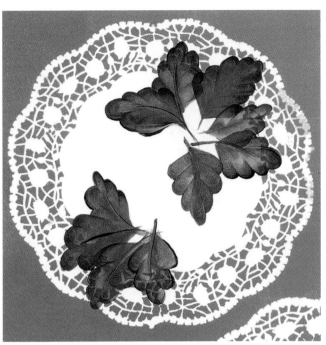

1. Create a Lace Paper Doily background following the instructions on page 26. Let the background dry completely. Double load a 3/4-inch (19mm) flat with Thicket and Fresh Foliage. Paint a couple of clusters of large scalloped-edge leaves, keeping the Thicket to the outside. Pull chisel-edge stems partway into the leaves.

2. Double load Engine Red and School Bus Yellow on a no. 12 flat. Paint five-petal, ruffled-edge flowers. Each segment of the petal is a teardrop stroke with a slight wiggle of the brush at the outside edge. If the paint is not covering well, add a little Wicker White to the School Bus Yellow side of the brush. Overlap the petals and tuck a few in among the leaves.

3. Tap in a little circle of dots for the centers using Thicket and the tip of a no. 2 script liner. To finish, add more flowers to the other set of leaves following the directions in steps 1 through 3. Primroses come in many bright colors, so try these same flowers using Dioxazine Purple with Yellow Light centers, or Magenta with Yellow Light centers.

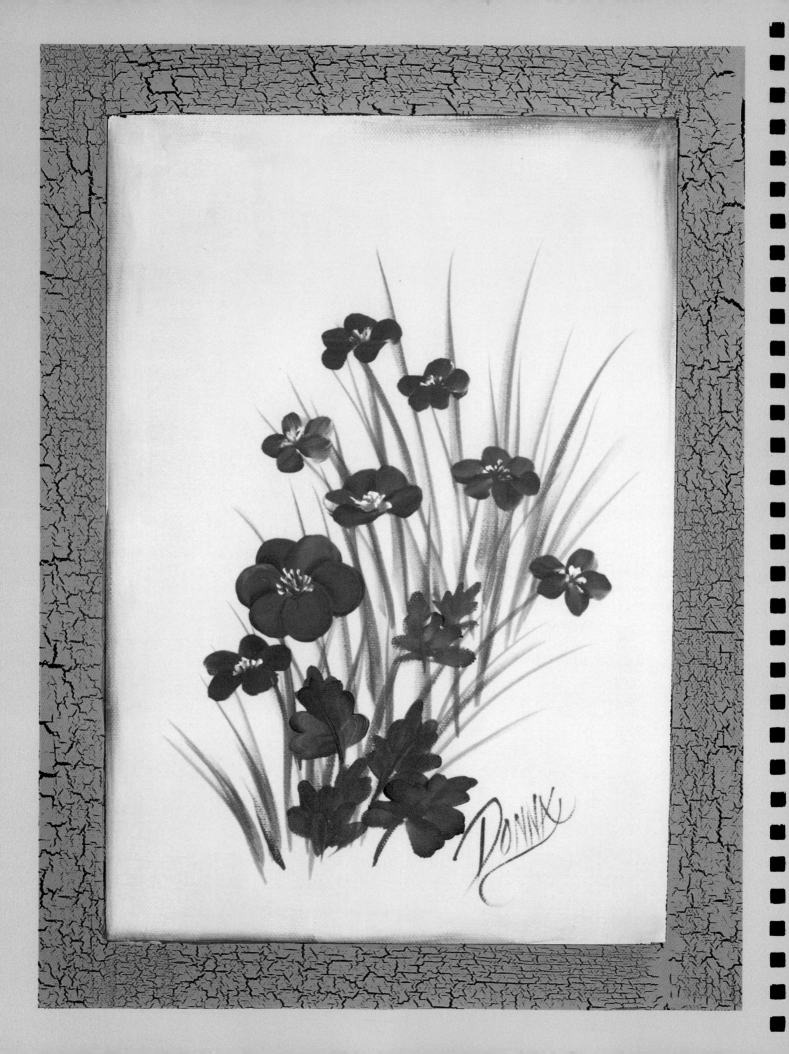

buttercups

brushes

no. 12 flat • no. 10 filbert

colors

Thicket • Yellow Citron • Yellow Light
Yellow Ochre • School Bus Yellow
Wicker White • Periwinkle

95

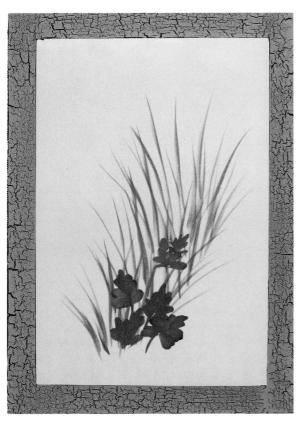

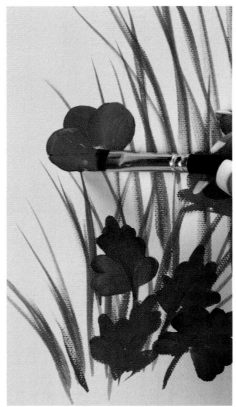

1. The background for the buttercups is the Crackled Frame. Follow the instructions on page 31, but change the colors to Baby Blue for the center, Maple Syrup for the frame's basecoat, and Linen for the crackled topcoat. Let dry. Double load a no. 12 flat with Yellow Citron and Thicket, and pick up a little Wicker White on the yellow side. Paint the grass blades and leaves.

2. Double load a no. 10 filbert with School Bus Yellow and Yellow Light, picking up some Wicker White on the Yellow Light side. (See page 14 for directions on double loading a filbert brush.) Paint the back petals of the buttercup, keeping the School Bus Yellow to the outside.

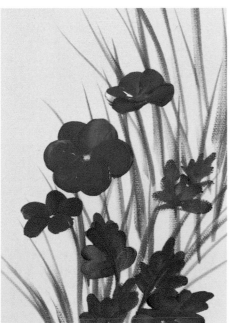

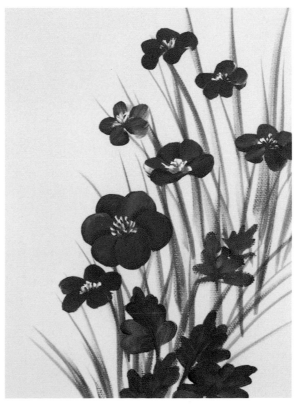

4. Load a no. 12 flat with floating medium and sideload into Yellow Ochre. Float shading around the petals to separate them. Pick up School Bus Yellow and Wicker White and tap in the center stamens using the chisel edge of the no. 12 flat. To finish, load a no. 12 flat with floating medium and sideload into a tiny bit of Periwinkle. Shade around the inner edge of the crackled frame on the blue background to separate the frame from the painting and create a cast shadow.

3. With the same brush and colors, paint the front petals. Buttercups face upwards from the grass in spring, so paint the petals in the back a little longer than the ones in front.

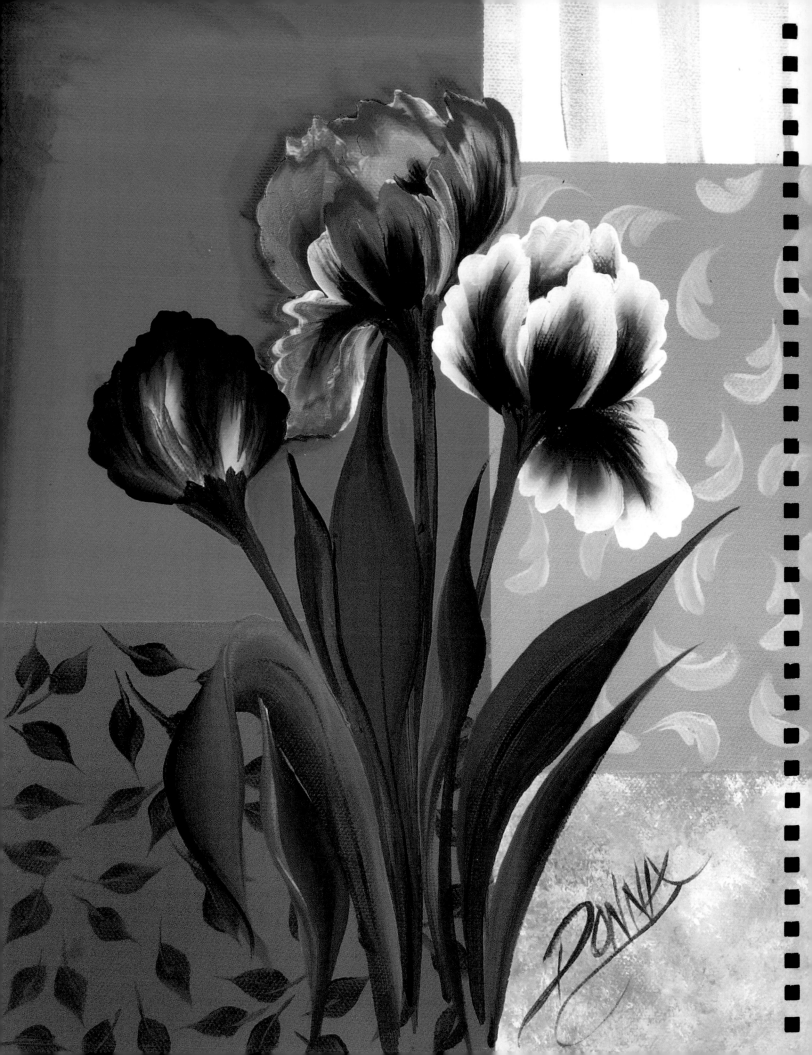

parrot tulips

brushes

3/4-inch (19mm) flat • 5/8-inch (16mm) angular

colors

Thicket • Fresh Foliage • Wicker White • Magenta
School Bus Yellow • Yellow Citron • Berry Wine

1. Create a Patchwork Squares background following the directions on pages 34-35. For this painting, the shadow leaves in the green square are single leaves, not clusters, and are painted with Thicket and floating medium. Let dry. Double load a 3/4-inch (19mm) flat with Thicket and Fresh Foliage, plus a little Yellow Citron. Dip into lots of floating medium. Paint a thick cluster of long, spiky leaves and sturdy looking stems. For a natural look, paint a folded tulip leaf following the directions on page 23. At the tops of the stems, paint the bases where the tulips connect to the stems.

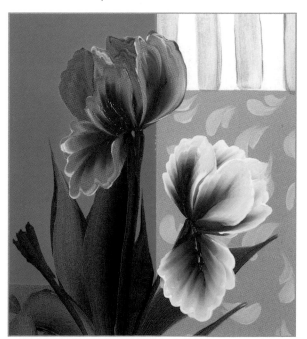

2. Double load a 3/4-inch (19mm) flat with Magenta and School Bus Yellow plus a touch of Wicker White. Begin with the tallest tulip in the middle. Paint the back petals first. Since these are parrot tulips, the edges are ruffled (see page 18 for directions on painting ruffled-edge petals). The pink and white tulip petals are painted with Magenta and Wicker White. Keep the Wicker White to the outside as you stroke these petals.

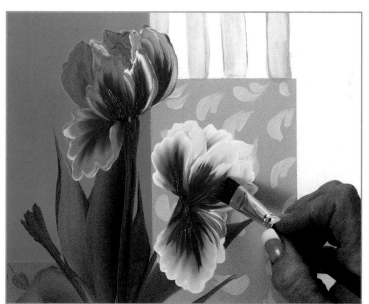

3. (Left) Using the same brush and colors, paint another layer of front petals and add a drooping petal to each of the open tulips. Turn your surface to make painting these easier.

4. (Above) Load Magenta onto a 5/8-inch (16mm) angular brush and chisel-edge some streaky lines on a few of the petals. To finish, paint a closed tulip blossom with Magenta and Berry Wine on a 3/4-inch (19mm) flat, picking up a little Wicker White on one side. Float shading around the outside of each tulip and between the petals with floating medium and Magenta.

glory of the snow

brushes
3/4-inch (19mm) flat • no. 12 flat
no. 2 script liner

colors
Thicket • Fresh Foliage • Wicker White
Brilliant Ultramarine • Yellow Light

1. Create an Antiqued background following the directions on page 33. Let dry. Double load a 3/4-inch (19mm) flat with Thicket and Fresh Foliage and paint the stems and long slender leaves, keeping the Thicket to the outside. Extend the tips of the leaves into long points. If your brush starts to drag or feel dry, dip into floating medium after you've loaded your colors.

2. To begin the petals, double load a no. 12 flat with Brilliant Ultramarine and Wicker White. Work a lot of the white into the blue before you start painting. Glory-of-the-Snow flowers are a light sky blue, not a deep blue. Paint the long, pointed single-stroke petals (see directions on page 17).

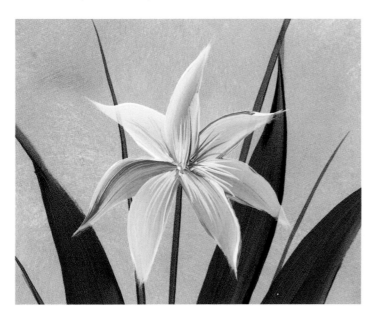

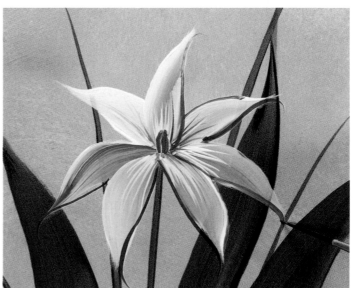

3. Pick up Wicker White on a no. 2 script liner and pull little white streaks out from the center on some of the petals. Pick up Brilliant Ultramarine on the liner and accent the streaks here and there.

4. Stroke in the center stamens with Yellow Light and Wicker White on a no. 12 flat. Load a no. 2 script liner with inky Brilliant Ultramarine and accent some of the edges of the blue petals, pulling the line to a curved, extended point.

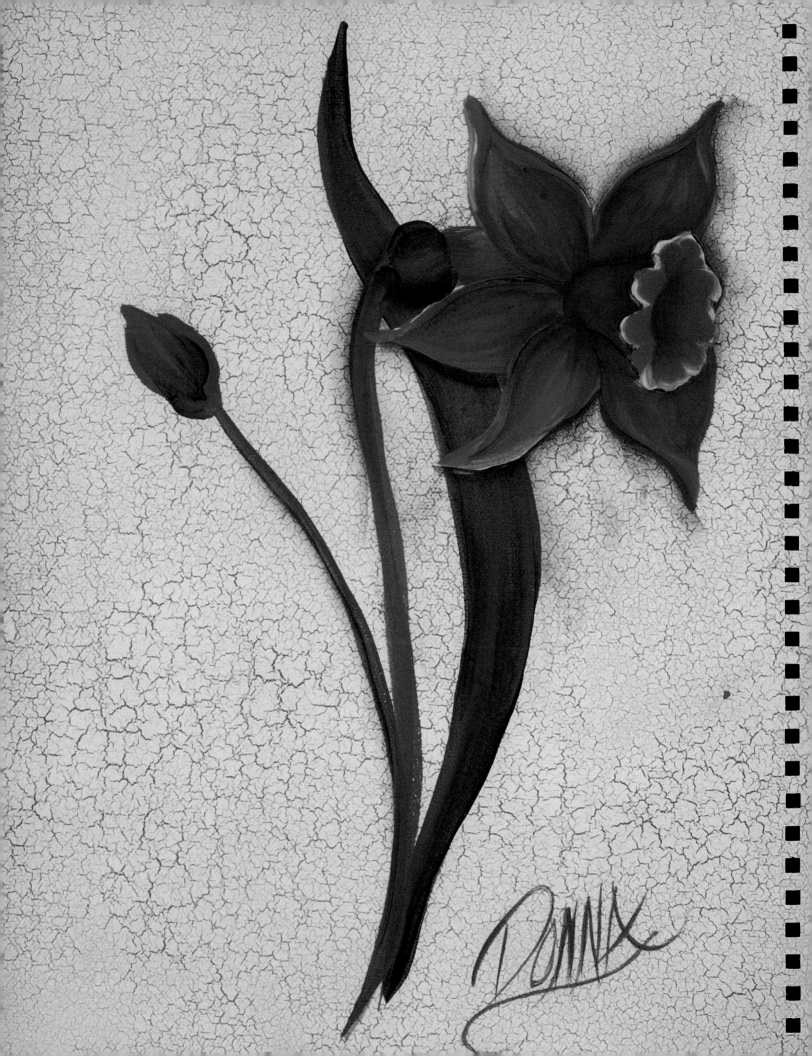

daffodil

brushes
3/4-inch (19mm) flat • no. 12 flat

colors
Yellow Citron • Thicket • Yellow Light
Wicker White • Yellow Ochre • Burnt Umber

1. Create an Allover Crackled background following the directions on page 30. Let dry completely. Double load a 3/4-inch (19mm) flat with Yellow Citron and Thicket. Dip the brush into floating medium to make it easier to paint over the crackled background. Paint a large leaf and pull a couple of stems upward from the base using the chisel edge of the brush.

2. Double load a 3/4-inch (19mm) flat with Yellow Light and Yellow Ochre and paint the base of the daffodil blossom with a tight C-stroke.

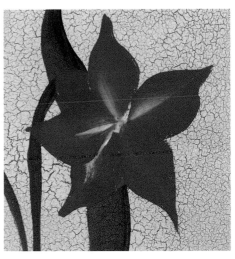

3. With the same brush and colors, paint the open petals, picking up Wicker White as needed on the Yellow Light side of the brush. Keep the Yellow Ochre side to the outside of the petals. Start each petal at the base, push down on the bristles, slide up and lift to the tip, slide back down to the base.

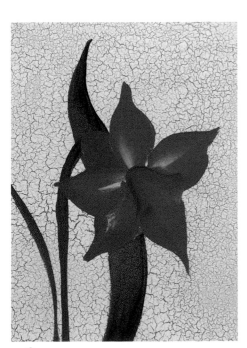

4. Double load a 3/4-inch (19mm) flat with Yellow Light and Yellow Ochre and paint the trumpet, keeping the Yellow Ochre to the outside to separate the base of the trumpet from the outside petals.

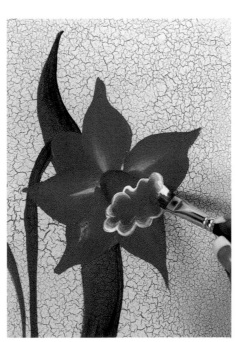

5. Double load a no. 12 flat with Yellow Light and Wicker White and paint a ruffly circle for the opening of the trumpet.

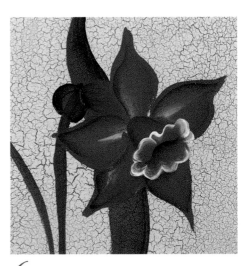

6. Load a no. 12 flat with floating medium and sideload into Burnt Umber. Float shade the inside edges of the petals and the throat of the trumpet (see page 20 for directions on float shading). The pod at the base is Thicket and Yellow Citron. To finish, deepen the shading on the petals and trumpet base with Yellow Ochre and floating medium on a no. 12 flat. Add the closed bud on the other stem with the same colors: Yellow Light, Yellow Ochre and Burnt Umber.

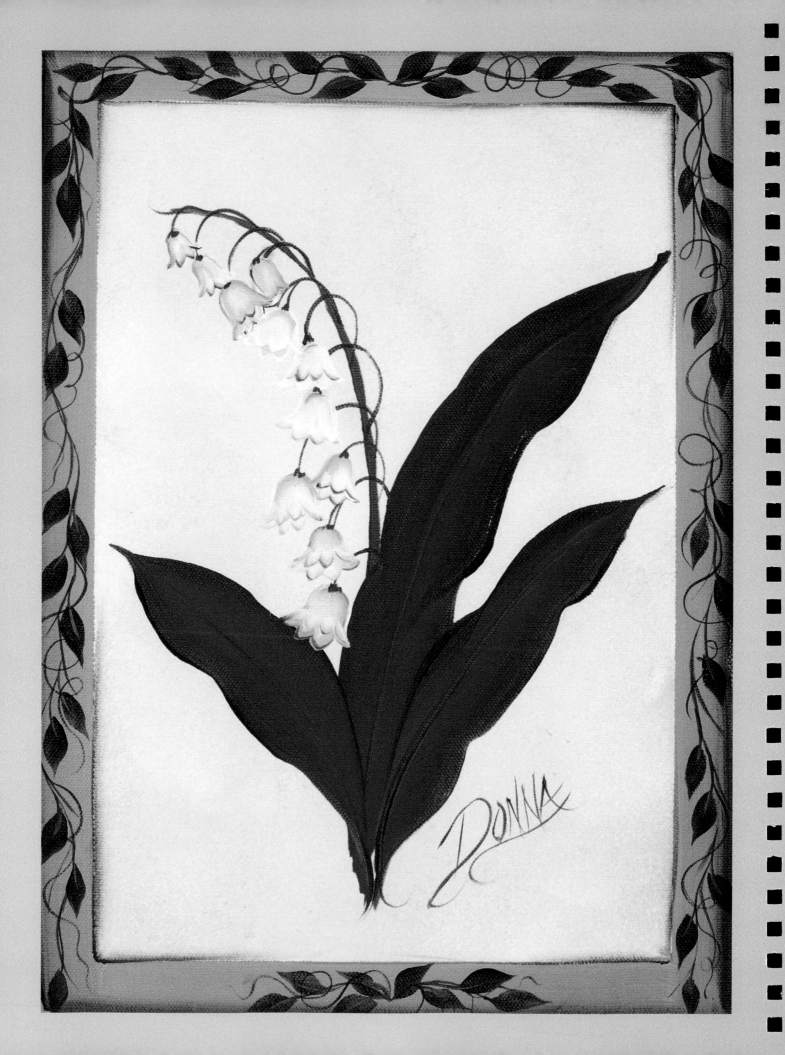

brushes
no. 10 flat • no. 2 script liner
3/4-inch (19mm) flat

colors
Thicket • Fresh Foliage
Wicker White • Yellow Citron

1. For the background, tape off the outer edges with 1-inch (25mm) painter's tape. Sponge on a soft blue in the center with Baby Blue and Wicker White. Remove the tape and let dry. Paint the frame with Butter Pecan. Let dry. Double load a 3/4-inch (19mm) flat with Thicket and Yellow Citron. Paint the stem and the long, slender leaves with scalloped edges.

2. Mix Thicket and Yellow Citron on your palette and use a no. 2 script liner to paint a series of curving stemlets coming off the main stem.

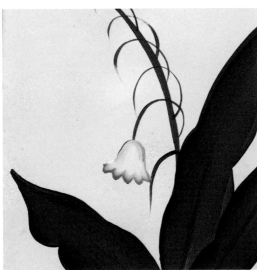

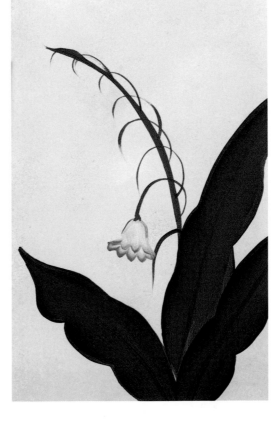

3. To paint the little white bell-shaped blossoms, choose a no. 6, 8 or 10 flat, depending on the size of your painting and the size of the bell. Load the brush with Wicker White, then sideload ever so slightly into Fresh Foliage. Stroke the back part of the bell. This is painted like a petal with a ruffled top edge (see page 18 for directions). Keep the green side of the brush to the outside.

4. The front part of the bell is painted the same way as the back part, only just a little shorter. Dot on the base of the bell where it connects to the stem with Fresh Foliage. To finish, paint a series of bells connecting to the little stemlets. For a natural look, don't paint them all hanging straight down. Let them hang at different angles and overlap sometimes. Also, vary the amount of Fresh Foliage you sideload onto your Wicker White brush—sometimes your bells will be whiter and sometimes they'll have more green around the edges. To finish the frame, float shading in the four corners using floating medium and Maple Syrup. With the same brush, paint shadow leaves starting at the top center and coming down both sides. Finish with Maple Syrup tendrils using a no. 2 script liner.

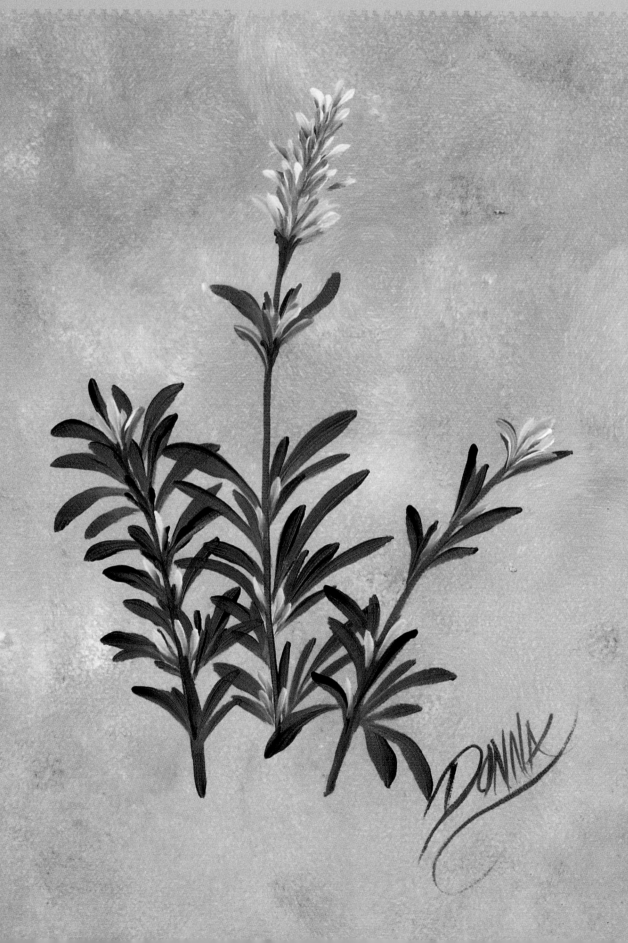

brushes
no. 8 flat • no. 12 flat

colors
Thicket • Fresh Foliage
Wicker White • Lilac Love

105

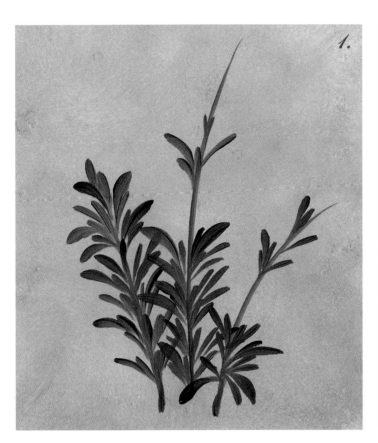

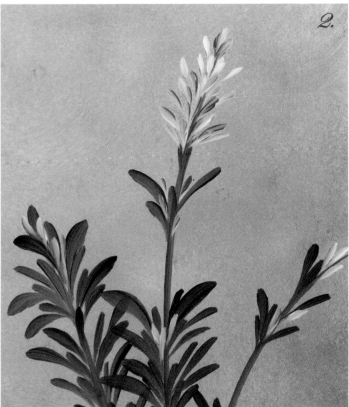

1. Begin by creating an Antiqued background following the directions on page 33. Let dry completely. Double load a no. 12 flat with Thicket and Fresh Foliage and place the stems using the chisel edge of the brush and stroking upward from the base. The leaves are made with little chisel-edge petal strokes (see page 16) pulled inward at an angle toward the stems. For a natural look, vary the leaf colors by picking up more Thicket sometimes and more Fresh Foliage other times. Also, leave some empty spaces along the stems as shown.

2. Double load a no. 8 flat with Lilac Love and Wicker White. The lavender blossoms are made up of lots of tiny petals. Use a chisel edge petal stroke for each petal and angle them toward the stem, just as you did for the leaves. Lead with the Wicker White side of the brush for the older petals, and with the Lilac Love side for the newer petals. Add single or double strokes of petal color here and there along the stem tucked in among the leaves.

3. Double load a no. 8 flat with Fresh Foliage and Wicker White and add little green buds in among the petals of the upper blossom. To finish, add a few lavender petals lower on the stems closer to the base.

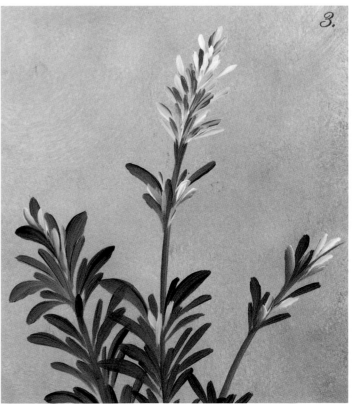

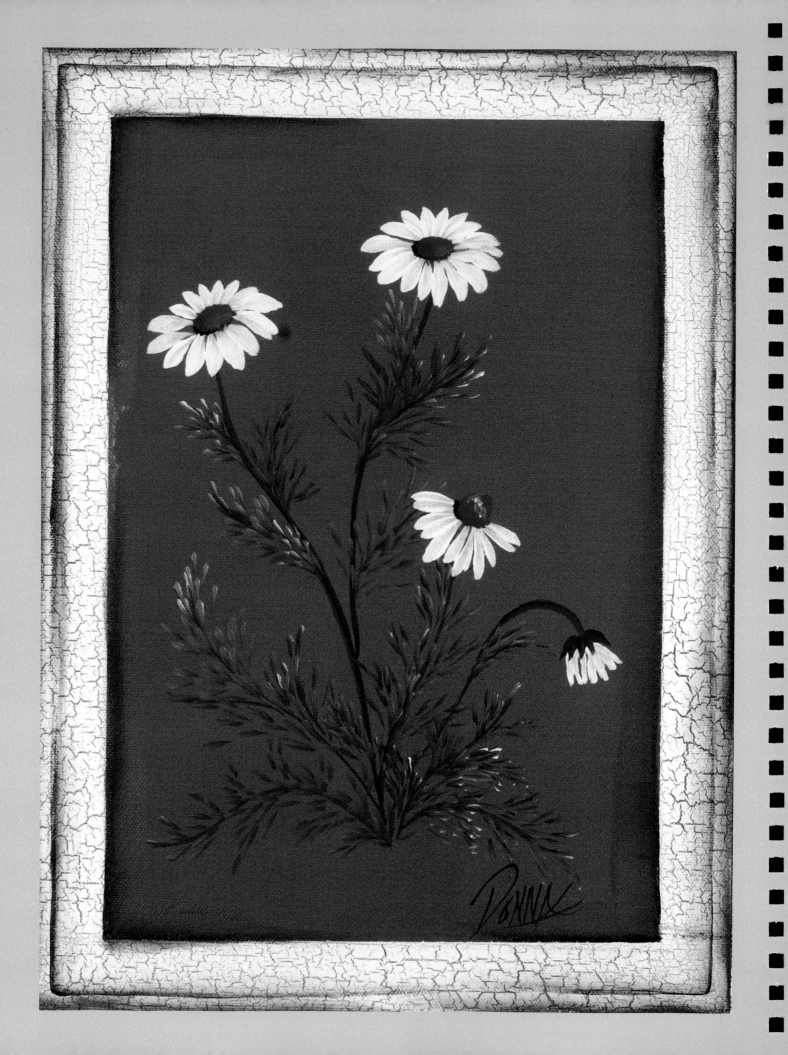

chamomile

brushes
no. 10 flat • 1/4-inch (6mm) scruffy
no. 2 script liner

colors
Thicket • Wicker White • Fresh Foliage
Yellow Light • Yellow Ochre • Burnt Umber

1. Create a Crackled Frame background following the directions on page 31. In this painting, the basecoat color is Butter Pecan and the crackled frame topcoat is Wicker White. Let dry. Double load a no. 10 flat with Thicket and Fresh Foliage, and paint the stems for placement. With the same colors and brush, paint the little feathery leaves with tiny chisel-edge strokes, angling them in toward the stem. For variegated leaf colors, pick up Wicker White on the Fresh Foliage side of your brush for some of your strokes.

2. Load a no. 10 flat with pure Wicker White. Paint the chamomile petals with chisel edge petal strokes and comma strokes (see page 16). Start at the outside and stroke each petal inward toward the center. The back petals are shortest and they get longer as they come around the sides. The front petals are longest.

3. The centers are pounced on with a 1/4-inch (6mm) scruffy double loaded with Yellow Light and a little Yellow Ochre. Highlight with a little Wicker White. Shade around one side with dots of Burnt Umber on a no. 2 script liner. To finish the frame, float shading in the four corners using floating medium and Burnt Umber to separate the frame from the painting. The illusion of molding on the frame is created with float shading twice around all four sides of the frame, once along the outside edge, and again 1/4-inch (6mm) inward.

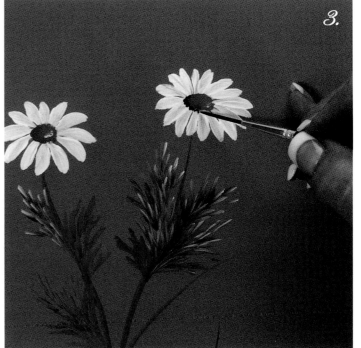

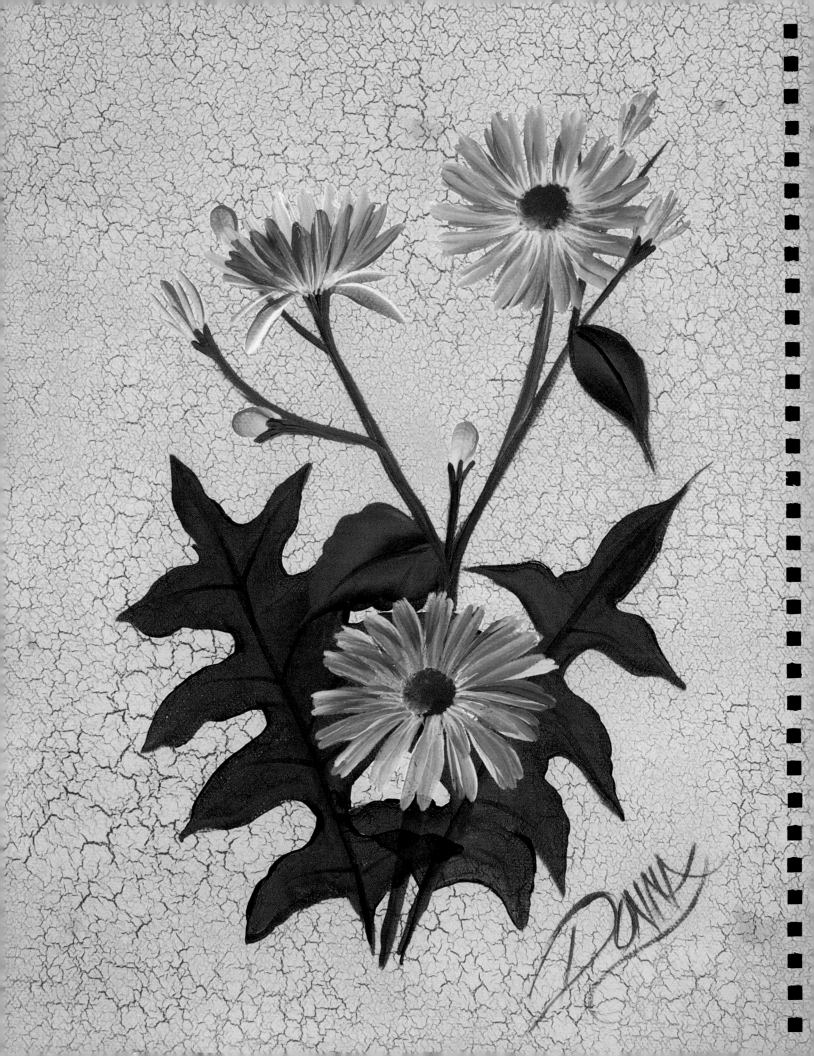

chicory

brushes
no. 12 flat • no. 16 flat • no. 2 script liner
1/4-inch (6mm) scruffy

colors
Thicket • Yellow Citron • Wicker White
Navy Blue • Yellow Light • Yellow Ochre

1. Create an Allover Crackled background following the instructions on page 30. Let dry. Double load a no. 16 flat with Thicket and Yellow Citron and paint the main stems, then the smaller stems coming off. With the same colors, paint the lobed leaves and the small one-stroke leaf. Dip your brush into floating medium if it drags on the crackled background.

2. Begin painting the chicory blossoms with Navy Blue and Wicker White on a no. 12 flat. Stroke the back petals of the sideview blossom first, and lay out the open blossom with a circular pattern of chisel-edge strokes pulled inward toward the center.

3. Pick up more Navy Blue on your brush and paint the front petals of the sideview blossom. Fill in with lots of chisel-edge petal strokes on the open blossoms. To get the jagged tips on these petals, pull a couple of side-by-side strokes for each petal.

4. Load a no. 2 script liner with inky Wicker White and pull streaks from the center to highlight.

5. Load a 1/4-inch (6mm) scruffy with Yellow Ochre and Wicker White and pounce in the centers. Highlight with Yellow Light.

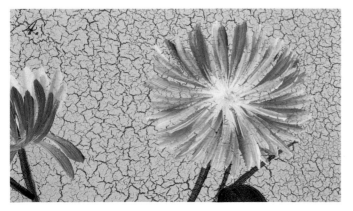

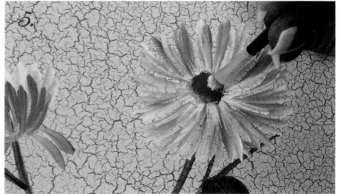

sedum

brushes
no. 8 flat • no. 10 flat • no. 16 flat

colors
Thicket • Wicker White • Magenta
Berry Wine • Fresh Foliage

111

1. Create a Crackled Frame background following the instructions on page 31. The basecoat is Basil Green and the crackled frame topcoat is Linen. Let dry. Double load a no. 16 flat with Thicket and Fresh Foliage. Place the stems and paint clusters of three leaves with teardrop petal strokes (see page 17), keeping the Thicket to the outside.

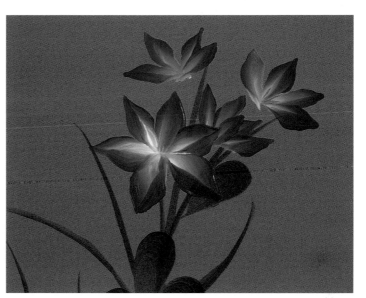

2. Double load Magenta and Wicker White on a no. 10 flat. Paint small, very pointed petals for the sideview blossoms, and a star-shaped cluster of five or six pointed petals for the open blossoms. Start at the base of the petal, push down on the bristles, slide up to the point as you lift to the chisel, then slide back down to the base. Keep the Magenta to the outside on all the petals.

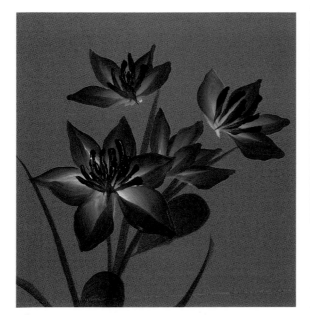

3. The centers are painted with Berry Wine and Magenta on a no. 8 flat. Use the chisel edge to pull little curving strokes for the stamens. Pull them inward toward the center.

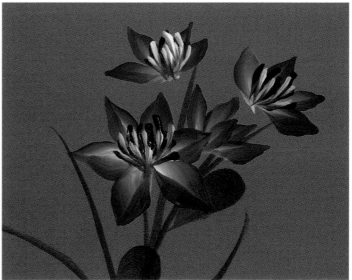

4. Pick up Wicker White on the same brush and paint a few lighter stamens among the darker ones. To complete the painting, add many more blossoms and make sure there are plenty of sideview blossoms. When the flowers are finished, float shading around the inner edge of the crackled frame to separate it from the background. Load a no. 16 flat with floating medium and sideload into a little bit of Thicket. Shade the corners and let it fade out along the sides.

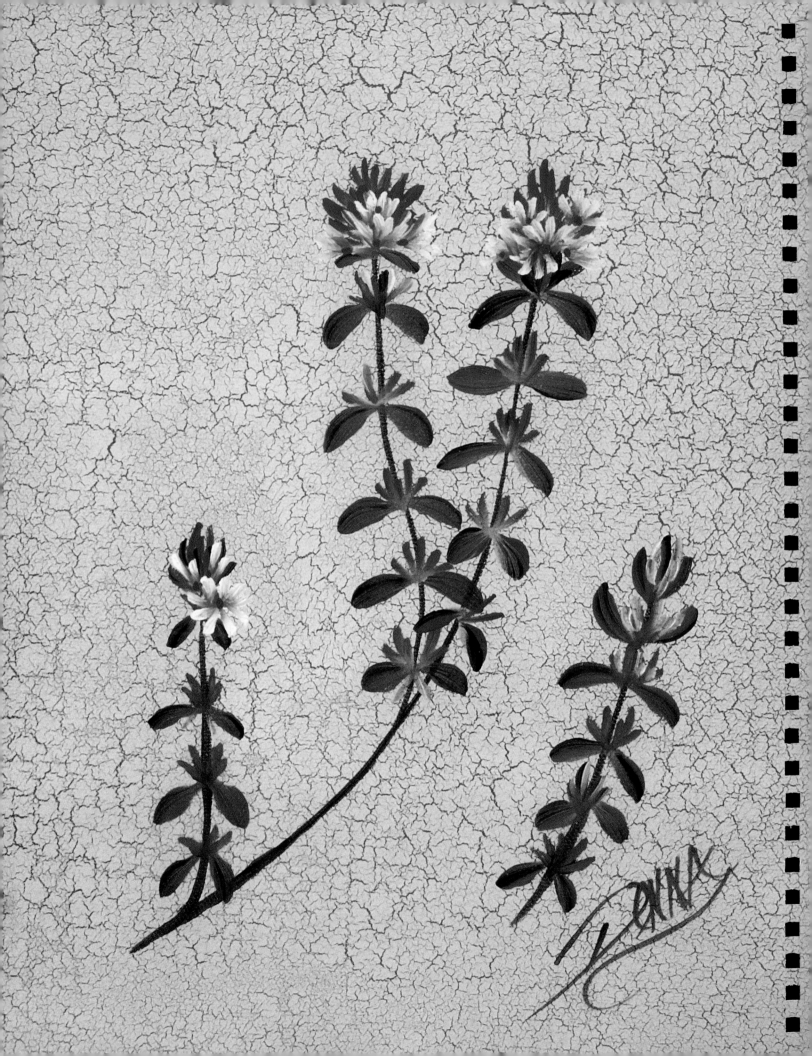

thyme

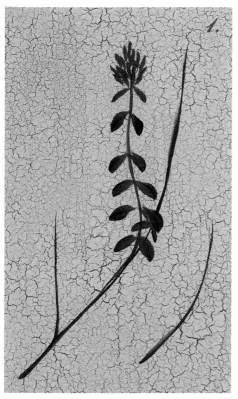

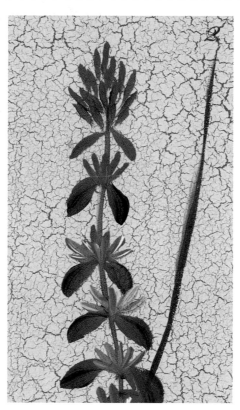

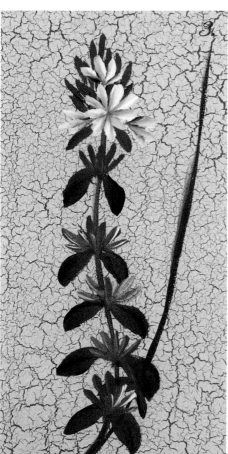

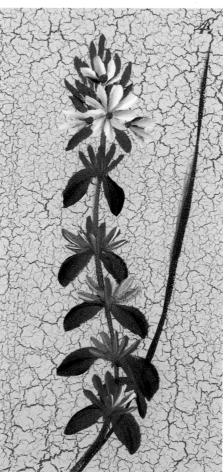

brushes

no. 8 flat • no. 12 flat

colors

Thicket • Yellow Citron • Violet Pansy
School Bus Yellow • Wicker White • Burnt Umber

1. This painting of flowering thyme begins with an Allover Crackled background. Follow the instructions on page 30. Let dry. Double load a no. 12 flat with Burnt Umber and Wicker White and place a few sparse stems. The leaves and new-growth buds at the top are painted with Thicket and Yellow Citron on a no. 8 flat. The leaves are little comma strokes that start at the tip and pull upward toward the stem.

2. Double load a no. 8 flat with Yellow Citron and Wicker White. Paint more new-growth buds by pulling little upward strokes angled outward from the stem—longer in the middle, shorter on the outside. These buds are placed along the stem where the leaves connect.

3. Double load Violet Pansy and Wicker White on a no. 8 flat. The thyme blossoms are painted with little chisel edge petal strokes pulled inward toward the center. Add some sideview blossoms around the open blossom.

4. Dot the centers with School Bus Yellow on the tip end of your brush handle.

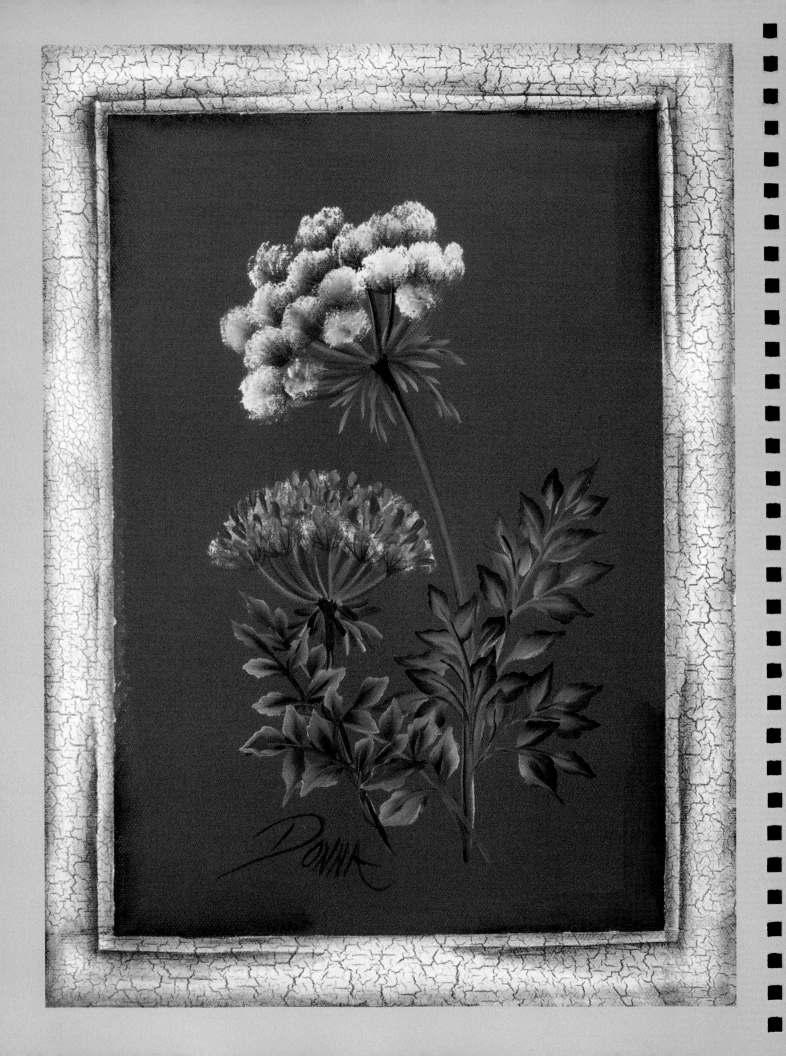

queen anne's lace

brushes

no. 8 flat • no. 10 flat • no. 12 flat
no. 2 script liner • 1/4-inch (6mm) scruffy

colors

Thicket • Fresh Foliage
Wicker White • Yellow Light

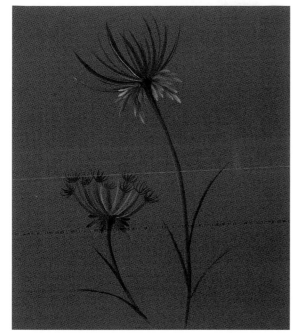

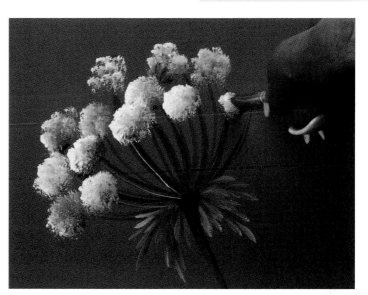

1. Create a Crackled Frame background following the directions on page 31. For this painting, the basecoat color is Butter Pecan and the crackled frame topcoat is Wicker White. Let dry. Double load a no. 12 flat with Thicket and Fresh Foliage and chisel-edge the stems for placement. At the tops of the stems, add clusters of the little curving stemlets that support the white blossoms. Double load a no. 10 flat with Thicket and Fresh Foliage and pick up a little Wicker White. Paint the little leaves that fall away from the blossoms using chisel edge strokes. Paint the bases where the stems connect to the blossoms with Thicket.

2. Double load a 1/4-inch (6mm) scruffy with Wicker White and Fresh Foliage plus a tiny bit of Thicket. Begin pouncing on the puffy white florets, layering them so the background shows through and they have an airy, lacy look.

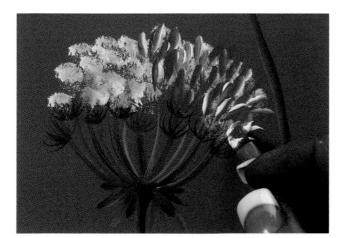

3. Using a no. 8 flat with Fresh Foliage and Wicker White, stroke in the buds on the lower blossom that are just opening up. Stroke these right over the puffy white florets but don't cover the little clusters of tiny stemlets underneath.

4. Paint the leaves lower down on the stems with Thicket, Fresh Foliage and Wicker White on a no. 8 flat. The leaves are in clusters of three. Pull little chisel-edge stems to connect the leaves to the main stem. To finish, float shading around and on the frame with floating medium and Burnt Umber.

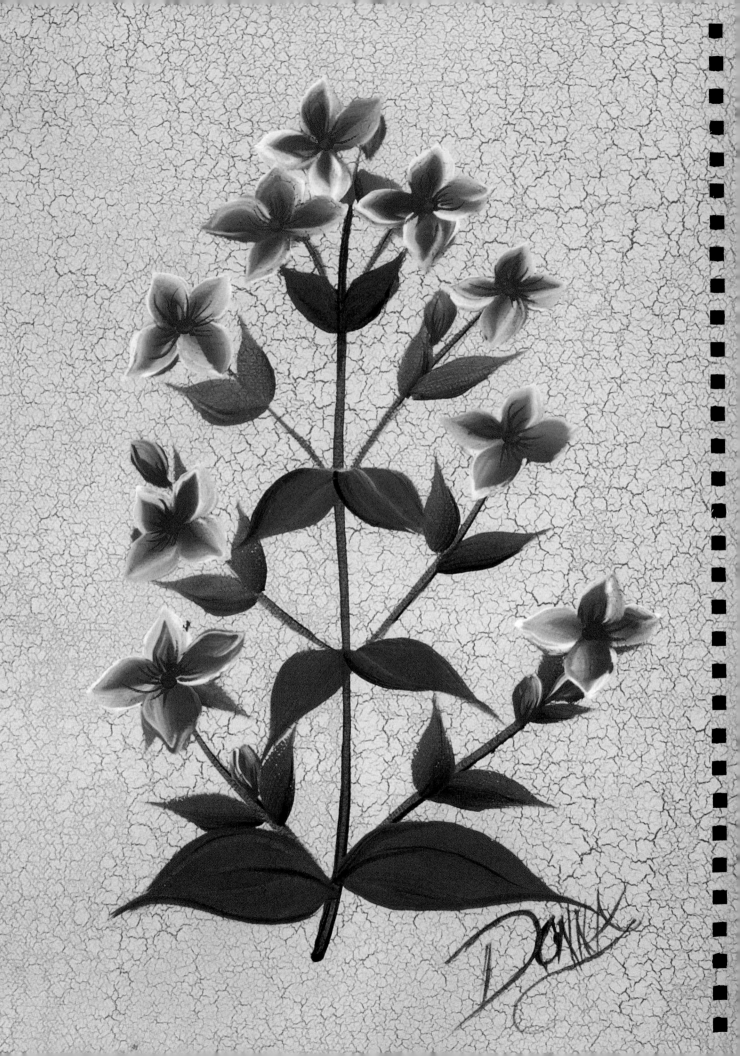

st. john's wort

brushes
no. 10 flat • no. 12 flat • no. 2 script liner

colors
Thicket • Yellow Citron • Wicker White
Sunflower • Yellow Ochre • Yellow Light

1. Create an Allover Crackled background following the directions on page 30. Let dry. Double load a no. 12 flat with Thicket and Yellow Citron, and pick up a little Sunflower on the lighter green side of the brush. Dip into floating medium to make painting easier on the crackled background. Paint the long main stem and the smaller stems coming off at an angle. These stems are straight and evenly placed along the main stem. With the same brush and colors, paint the pairs of one-stroke leaves, keeping them evenly spaced along the stems. If your brush starts to drag or feel dry, dip into floating medium after you've loaded your colors.

2. To begin the petals, double load a no. 10 flat with Yellow Ochre and Wicker White. Pick up Yellow Light on the Yellow Ochre side of the brush. Stroke in the four-petal flowers, picking up fresh Wicker White every time you stroke to keep the white edges distinct.

3. Continue painting four-petal flowers at the top of every stem, and include a few buds tucked in here and there. To paint the centers, load a no. 2 script liner with Yelllow Ochre and pull little lines out from the center. Repeat with inky Yellow Citron. Dot the very center with Yellow Citron and highlight with a smaller dot of Yellow Light.

lotus blossom

brushes
no. 8 flat • no. 12 flat • no. 16 flat
3/4-inch (19mm) flat

colors
Thicket • Fresh Foliage • Yellow Light
Wicker White • School Bus Yellow • Burnt Umber

1. Begin by creating a Tone-on-Tone background following the directions on page 27. Let dry completely. Double load a ¾-inch (19mm) flat with Thicket and Fresh Foliage and pick up lots of floating medium to make painting easier. Use the chisel edge of your brush to make a V-shape guideline where the notch of the leaf will be. Start on one side of the V and draw the outside shape of the leaf. Fill in the center, then use the chisel edge to paint the veins.

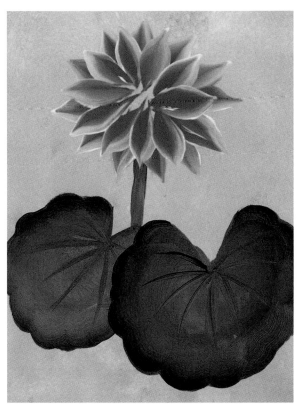

2. Paint a thick straight stem coming up from behind the leaves. Double load a no. 16 flat with Yellow Light and Wicker White and paint the outermost two layers of petals, keeping the white to the outside. If you want a bright yellow lotus blossom, pick up more Yellow Light. If you want lighter-colored blossoms such as the ones on the facing page, pick up more Wicker White. Paint the outermost layer of petals first, then the next, inner layer, offsetting the petals from the first layer.

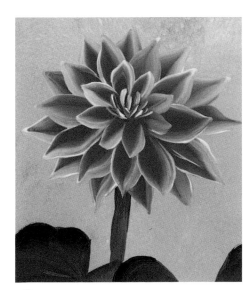

3. Paint the final, smaller layer of petals using the same brush and colors. Offset these petals from the second layer. To paint the center stamens, double load a no. 8 flat with School Bus Yellow and Wicker White and pull some tiny, curving chisel-edge strokes downward toward the center.

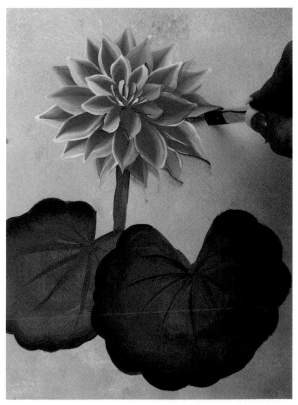

4. Load a no. 12 flat with lots of floating medium and sideload into a little bit of Burnt Umber. Float shading under and around the outermost petals to separate them from the background and to accent the pointed tips of the petals. Shade beween the petal layers here and there to separate them as well. To finish, paint the smaller lotus blossom the same way. Allow some of the stem to peek through between the blossoms.

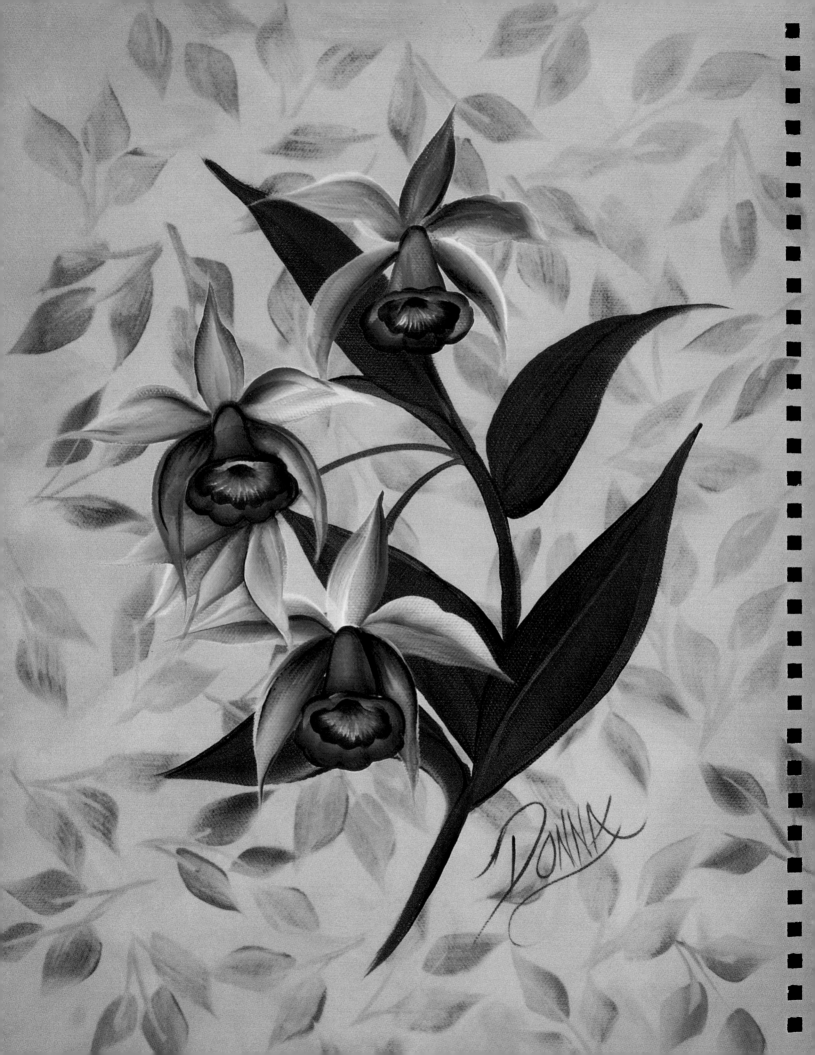

orchid

brushes
no. 8 flat • no. 12 flat • no. 16 flat
3/4-inch (19mm) flat

colors
Thicket • Wicker White • Yellow Citron
Violet Pansy • Dioxazine Purple • Magenta

1. Create a Shadow Leaves background following the directions on page 29. In this painting, the basecoat color is Sunflower and Wicker White, and the shadow leaves are Yellow Ochre and Wicker White. Let dry. Double load a 3/4-inch (19mm) flat with Thicket and Yellow Citron and dip your brush into lots of floating medium. Paint the stems and leaves that attach directly to the main stem.

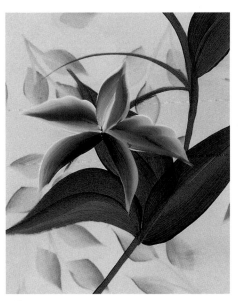

2. Double load a no. 16 flat with Violet Pansy and Wicker White. Paint the top and two side petals with two strokes: slide up to a sharp point and slide back down to the base. The two drooping front petals are painted in one stroke from base to tip.

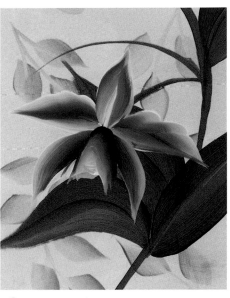

3. The base of the trumpet is painted with Violet Pansy and Wicker White double loaded on a no. 12 flat. Stroke upward in a very tight, upside down U-stroke, keeping the Violet Pansy to the outside.

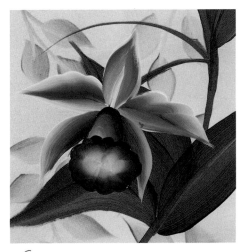

4. The opening of the trumpet is a ruffled circle painted with Violet Pansy and Wicker White, keeping the Violet Pansy to the outside edge (see page 18 for directions on painting petals with a ruffled top edge).

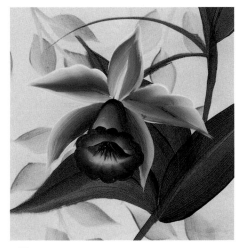

5. Sideload more Violet Pansy on your no. 12 flat and paint the throat of the trumpet with a stroke that is pointed on both ends and wider in the middle. Use the chisel edge to pull little hairlines downward and outward from the throat.

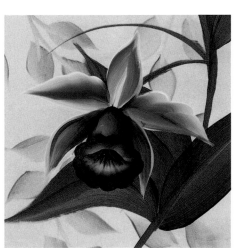

6. Load a no. 8 flat with floating medium and Magenta and detail the inside of the ruffled edges. With the same brush, pick up more floating medium and sideload into Dioxazine Purple. Define the outer edges of some of the petals better. Finish with a couple more orchid blossoms.

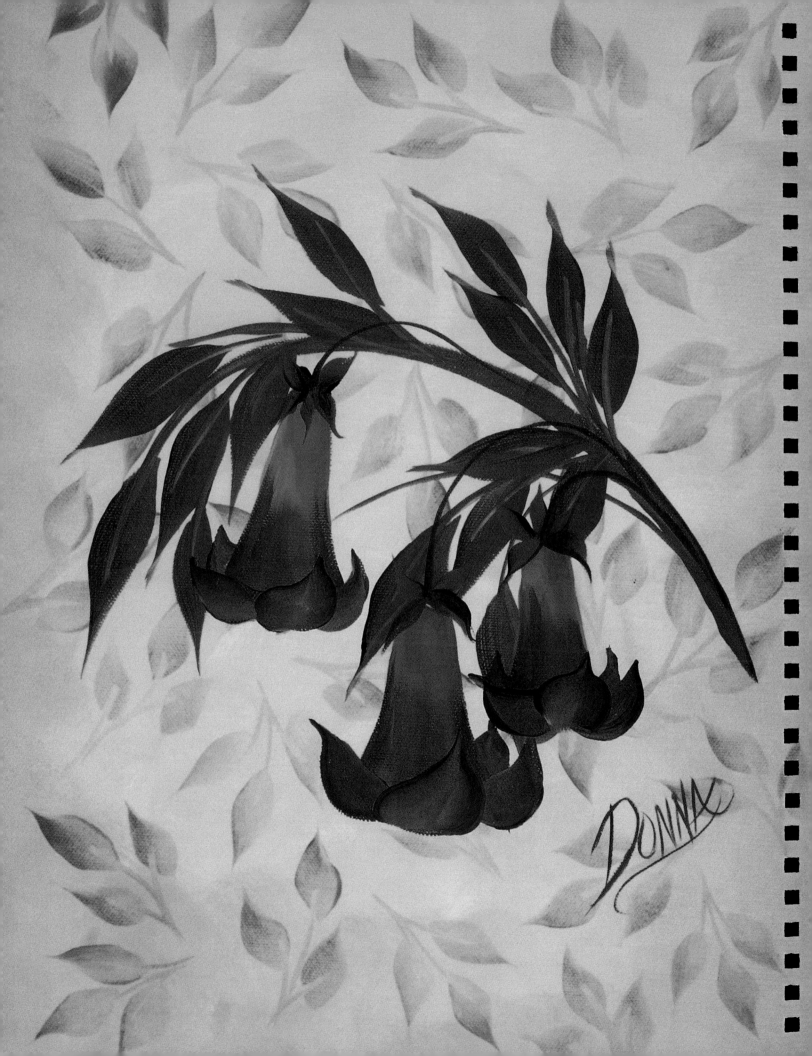

angel's trumpet

brushes
no. 12 flat • no. 16 flat

colors
Thicket • Yellow Citron • Wicker White
Fresh Foliage • Yellow Light • Engine Red
School Bus Yellow

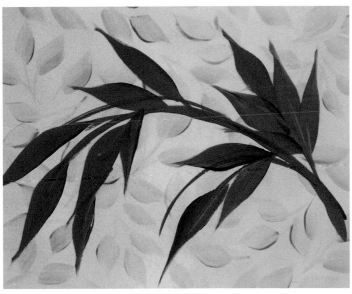

1. Create a Shadow Leaves background following the instructions on page 29. Let dry. Double load a no. 16 flat with Thicket and Yellow Citron and pick up lots of floating medium. Paint the main stems. With the same colors, paint the leaves in clusters at the base and single towards the ends of the stems.

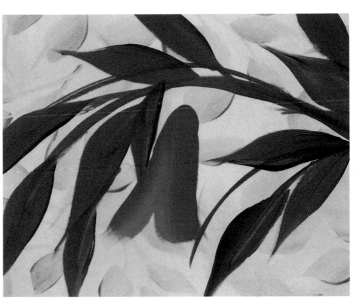

2. Double load a no. 16 flat with Yellow Ochre and Wicker White, picking up a little Fresh Foliage on the white side of the brush. Paint the base of the trumpet by starting at one side of the outside edge, sliding up to the base, curving your brush around, and sliding back to the other outside edge. This is like a very elongated upside-down U-stroke.

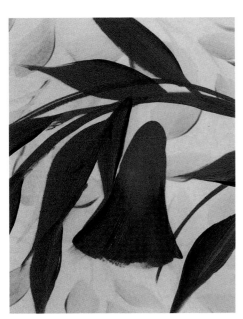

3. Pick up some School Bus Yellow and Engine Red on the same brush and dip into floating medium. Stroke the red upward onto the yellow trumpet.

4. Double load a no. 12 flat with School Bus Yellow and Wicker White and sideload into Engine Red. Paint the two turned outer edges of the trumpet where it opens up.

5. Pull the front two turned outer edges by starting at the point of each one and pulling downward on both sides. Finish with a calyx where the base of the trumpet connects to the stem, using Thicket and Yellow Citron on a no. 12 flat.

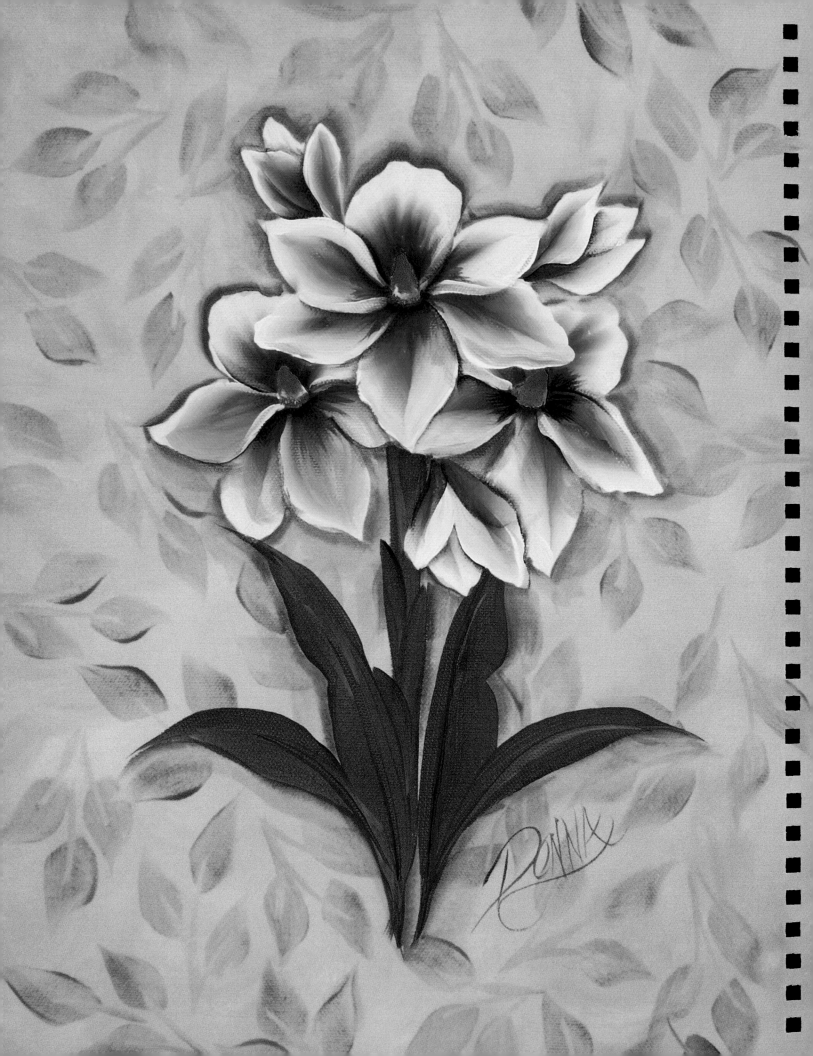

water hyacinth

brushes
no. 10 flat • no. 16 flat

colors
Thicket • Wicker White • Yellow Citron
Violet Pansy • Yellow Light • Yellow Ochre

1. Create a Shadow Leaves background following the directions on page 29. In this painting, the basecoat color is Sunflower and Wicker White, and the shadow leaves are Yellow Ochre and Wicker White. Let dry. Double load a no. 16 flat with Thicket and Yellow Citron and dip your brush into lots of floating medium. Paint the center stalk first, starting with the topmost segment and working down, then add the leaves.

2. Double load Violet Pansy and Wicker White on a no. 16 flat. Paint the back three petals of the open blossom, then the bud. Start at the base of the petal, push down on the bristles, slide up to the point as you lift to the chisel, then slide back down to the base. Keep the Wicker White to the outside on all the petals.

3. With the same brush and colors, add the next three petals to the open blossom, offsetting them from the first three.

4. Load a no. 10 flat with floating medium and Violet Pansy. Using the chisel edge of the brush, shade the center of the open blossom by pulling little streaks outward from the center onto most of the petals.

5. Double load a no. 10 flat with Yellow Light and Yellow Citron and tap on the cone-shaped stamen using the chisel edge of the brush. To finish, load a no. 10 flat with floating medium and sideload into Violet Pansy. Paint the shading between the petals and where the petals turn. Load a no. 16 flat with floating medium and Yellow Ochre and float shade around all the flowers and leaves to separate them from the background.

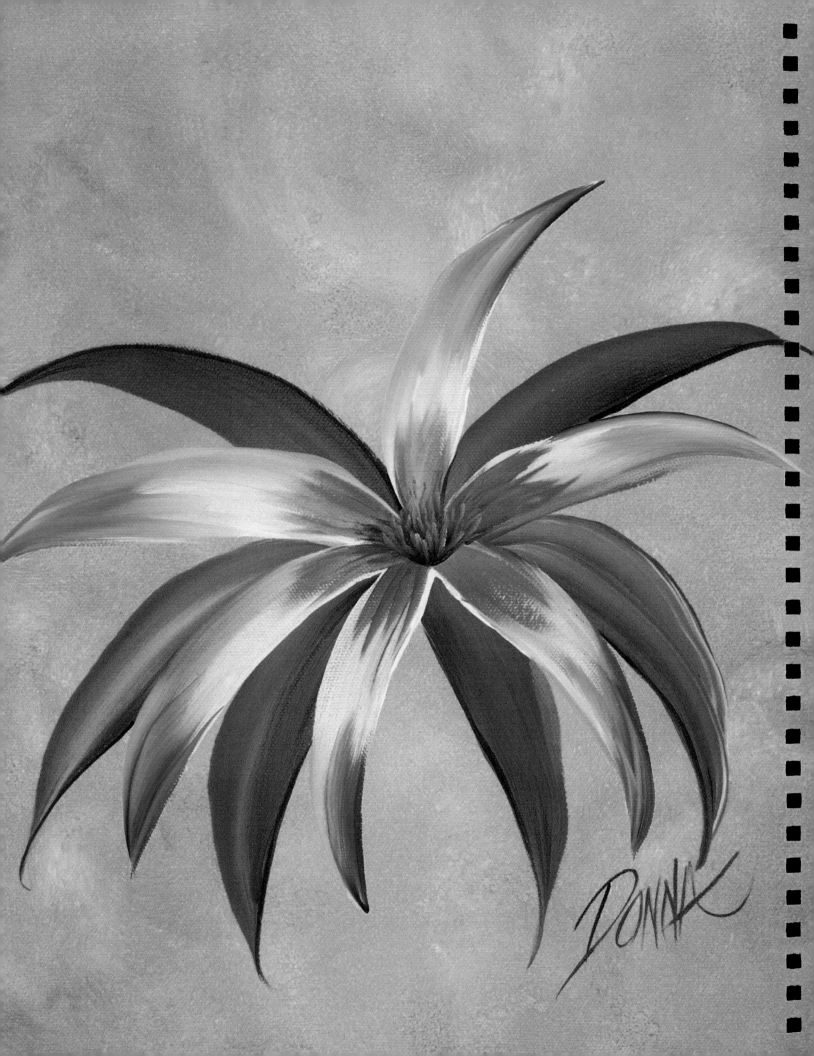

bromeliad

brushes

3/4-inch (19mm) flat

colors

Thicket • Fresh Foliage • Wicker White
Magenta • Sunflower

1. This painting begins with an Antiqued background. Follow the instructions on page 33. Let dry. Double load a 3/4-inch (19mm) flat with Fresh Foliage and Wicker White and pick up a little Thicket. Dip into floating medium to make painting smoother. Start with the six curving, blade-like outer leaves. Begin at the center and pull upwards, extending the tips into sharp points. Keep the Thicket to the outside edges.

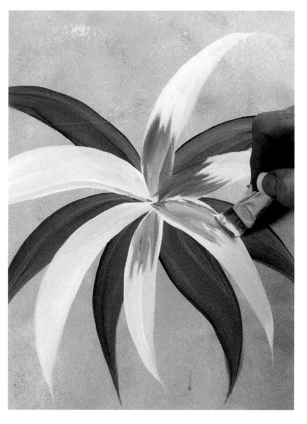

2. The next layer of six blade-like leaves are stroked in first with Wicker White on your 3/4-inch (19mm) flat. Offset these six leaves from the first set. Pick up Fresh Foliage on your brush and shade the inner portions of these white leaves while the paint is still wet. Don't overblend where the green meets the white—let the streakiness show..

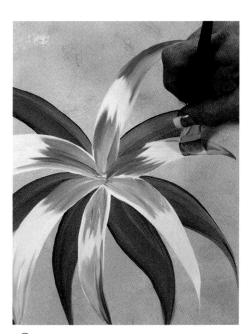

3. For the pink areas of the leaves, double load the same brush with Magenta and Wicker White and start at the outer tip. Stroke downward toward the green, but don't cover all the white. Again, let the streakiness of the pink show.

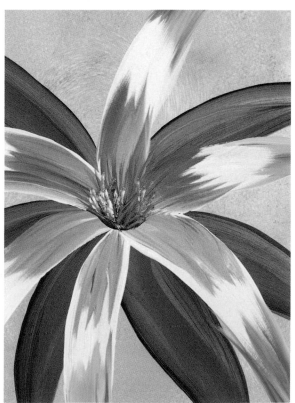

4. To paint the center throat, pick up Thicket on your 3/4-inch (19mm) flat and paint a curved shape that is pointed on both ends and wider in the middle. Then use the chisel edge to continue little lines out onto the leaves along the top of the throat. Pick up Sunflower and Wicker White and tap little chisel-edge stamens extending out from the throat.

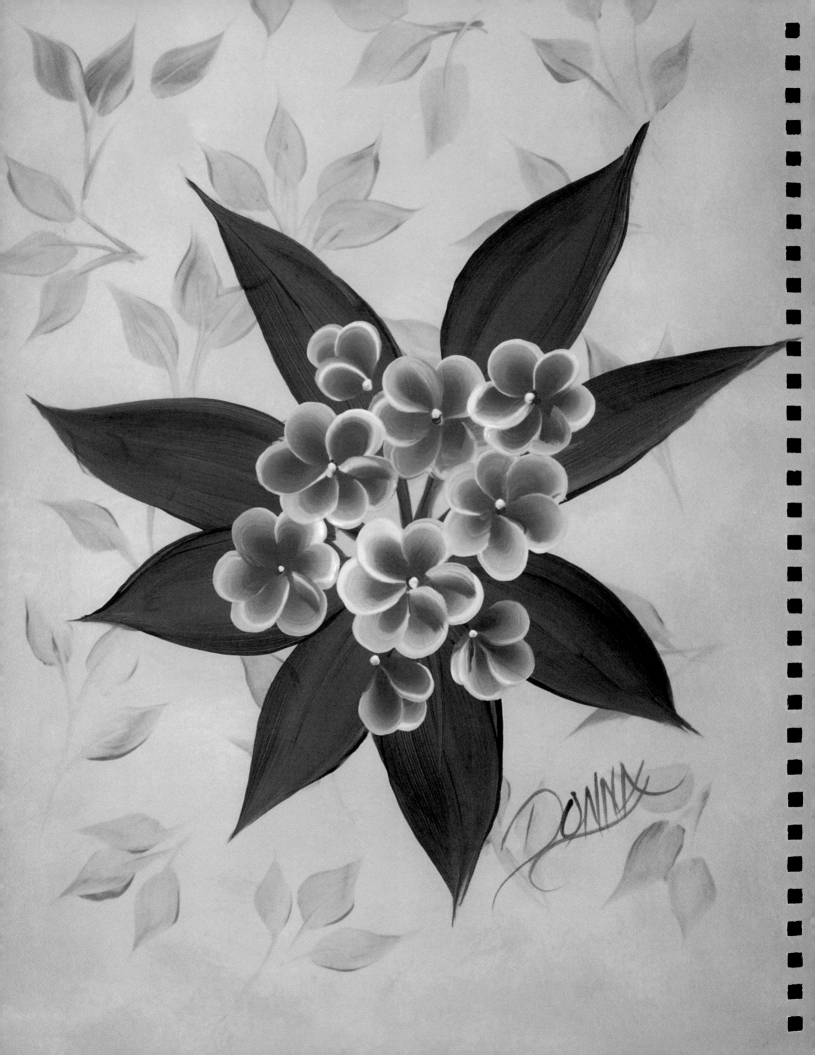

plumeria

brushes

no. 10 flat • no. 16 flat

colors

Thicket • Yellow Citron • Wicker White
Yellow Light • Yellow Ochre

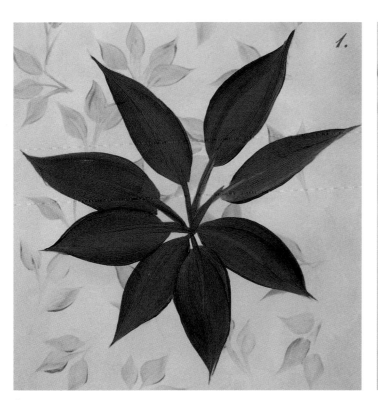

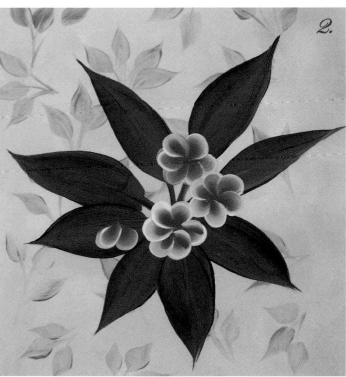

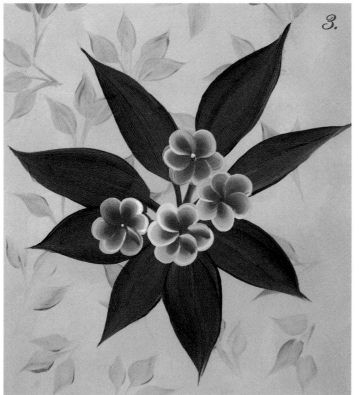

1. Create a Shadow Leaves background following the directions on page 29. Let dry. Double load a no. 16 flat with Thicket and Yellow Citron and dip into lots of floating medium to smooth out your strokes. Paint stems and leaves in a rosette that radiates outwards from a center stem.

2. Double load a no. 10 flat with Wicker White and Yellow Ochre plus a bit of Yellow Light. The petals of a plumeria blossom spiral around so you will need to turn your surface as you paint each petal. Make sure the Wicker White side of the brush starts in the center, comes up and over, and finishes back down in the center (see the teardrop petal stroke on page 17). After you paint your first petal, the second one should slightly overlap the first one; the third petal should slightly overlap the second one, and so on around the entire circle of six petals.

3. Keep picking up Wicker White on your brush to keep the white parts of the petals bright. After the last petal is painted on each blossom, go back in and clean up the first petal so it looks tucked in underneath. Dot the centers of each blossom with Yellow Ochre and highlight with Yellow Light. To complete the painting, add more blossoms to fill out the circular design, with a few sideview petals around the outside edge.

diagonal wildflowers

brushes
no. 6 flat • no. 12 flat

colors
Thicket • Fresh Foliage
Yellow Light • Wicker White • Yellow Ochre
Burnt Umber • Violet Pansy

In this section, you will see how easy it is to create several all-over repeating floral patterns that are well-designed and attractive to look at. Floral patterns are used everywhere, from chairs and sofas upholstered in flowered chintz, to wallpapers, draperies, carpets and area rugs, even clothing, linens and fabrics. Here you'll learn how to lay out simple patterns, then paint repeating floral motifs that flow gracefully and elegantly across your surface. We'll begin with a diagonal design of wildflowers.

1. Begin by creating a Tone-on-Tone background following the directions on page 27. Let dry completely. Meanwhile, work out your diagonal pattern lines on a sheet of white paper with a pencil. Using a straight-edge or ruler, lightly pencil in evenly spaced diagonal lines to establish the overall design.

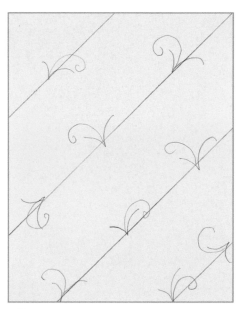

2. Place the repeating design elements along the diagonal lines with simple diagrams like these. Don't include any details at this point; just indicate the basic shape and direction. Here I have two V-shaped lines and a long curving line. I can turn this simple shape in three different directions as long as the size remains pretty consistent.

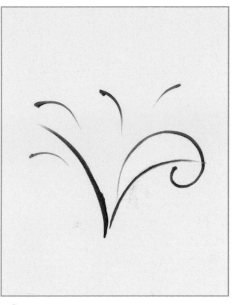

3. Begin painting the basic shape of the little wildflower bouquet using the chisel edge of a no. 12 flat double loaded with Thicket, Fresh Foliage and a little Burnt Umber.

4. With the same brush and colors, use the chisel edge to tap on feathery fern leaves along the V-shaped stem lines. Occasionally pick up a tiny bit of Wicker White on your brush for variety.

5. Load a no. 6 flat with Yellow Ochre and Yellow Light and stroke the daisy petals. Dot in centers of Wicker White and Fresh Foliage. The lavender blossoms are chisel-edge strokes of Violet Pansy and Wicker White. As you paint each wildflower bouquet, don't try to make them all look the same. It's the little differences that help give this design freshness and charm.

freeform curves

brushes

no. 6 flat • no. 8 flat • no. 12 flat

no. 2 script liner

colors

Thicket • Wicker White • Yellow Citron

Yellow Light • Brilliant Blue

1. Using a pencil and a sheet of white paper, create a series of S-curves and wavy lines. Let some of them continue off the edges. This pattern seems random, but notice how the curving lines are spaced fairly evenly. In the finished design at left, you can see that the white rosebuds are dotted around in ones, twos and threes, but the spacing between them is pretty consistent. They aren't all bunched up in a few areas.

2. Pencil in some shorter curving lines that come off the main lines you drew in step 1. In the lower right corner, I have pencilled in a little pattern that suggests placement of the white rosebuds, blue daisies, large leaves, small leaves and twigs. These patterns can vary in their shape, length, and number of blossoms, but the colors must remain consistent. This gives order and cohesiveness to the overall design.

3. Basecoat your surface with black and let dry. You may need two or three coats for complete coverage. Double load a no. 12 flat with Yellow Citron and Thicket and paint the main vines, the larger leaves, and a few curving stems. Allow open space for the flowers to nestle in among the leaves.

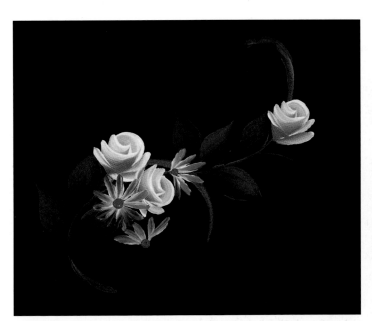

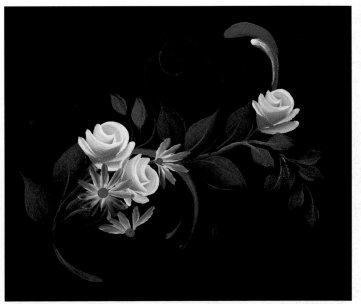

4. The white rosebuds are painted with Yellow Light and Wicker White on a no. 8 flat. Every time you stroke, pick up more white on the corner of the brush. The blue daisies are Brilliant Blue and Wicker White on a no. 8 flat, and the centers are dotted in with Yellow Light.

5. Finish with more leaves, stems and tendrils using Thicket and Yellow Citron. Paint the littlest leaves with a no. 6 flat, the stems and tendrils with a no. 2 script liner. The little new-growth twigs are touch-and-pull strokes of inky Yellow Citron on the script liner.

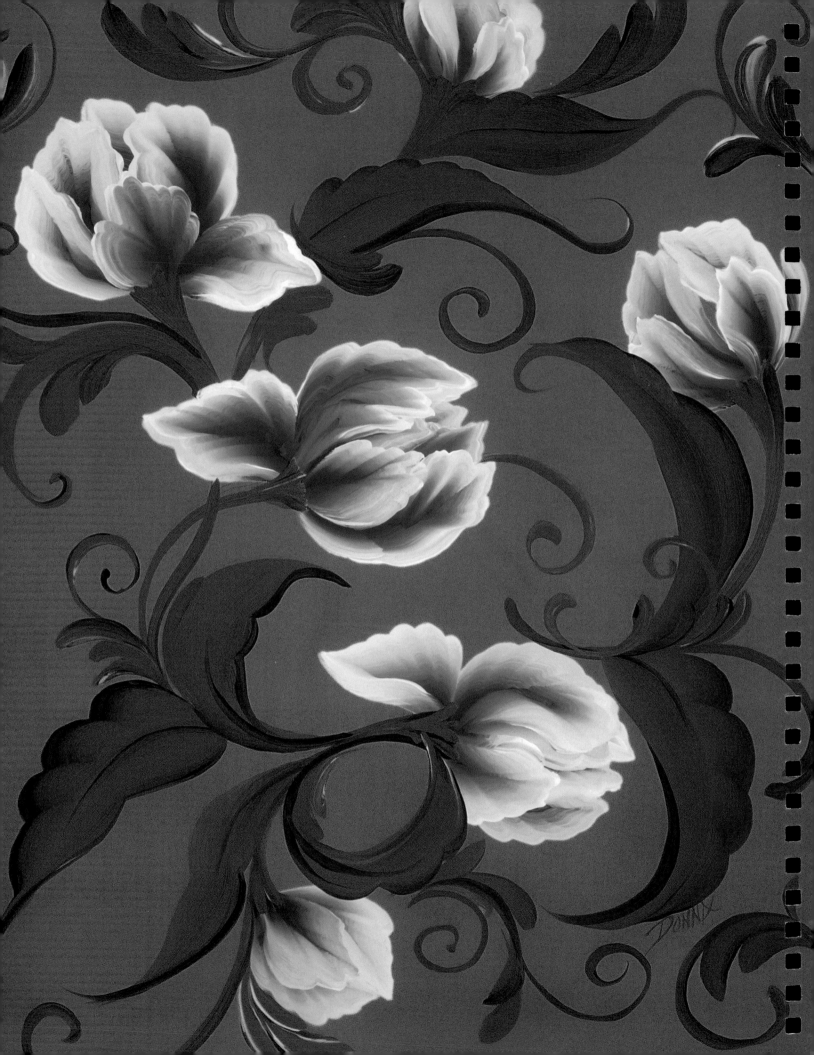

brushes
3/4-inch (19mm) flat • no. 16 flat

colors
Thicket • Yellow Citron
Wicker White • Magenta

137

1. Pencil in a variety of scrolling lines on a piece of white paper to establish the placement of the main design. Allow some of the lines to continue off the edges of the design.

2. Add secondary lines curving off of the first ones. Always begin your secondary lines somewhere along the main lines—don't start them out in space and then try to connect them.

3. Pick out one of your designs and begin to pencil in a diagram of the tulip outlines and the leaves. Here I've darkened the main design lines so you can see them more easily. I also added another set of smaller curving lines coming off the left side. Compare this to the same area in step 2. Pencil in some comma strokes as well.

4. The background color for the design shown at left is Sunflower. Choose a background color for your design that works well with your tulip and scroll colors. Load a 3/4-inch (19mm) flat with Yellow Citron and paint the basic curving shapes using the chisel edge of the brush.

5. Double load the same brush with Thicket and Yellow Citron and paint the large, scalloped-edge leaves. Paint the scrolls and comma strokes with Yellow Citron and Wicker White. If your design is smaller than mine, switch to a no. 16 flat for the commas and scrolls.

6. Paint the pink parrot tulips with Magenta and Wicker White on a 3/4-inch (19mm) flat. (See page 97 for directions on painting parrot tulips.) Paint the base where the tulip attaches to the stem with short, chisel edge strokes of Thicket and Yellow Citron.

hanging swag

In this section, I have created ten glorious floral compositions for you that gather together many of the flowers you've just learned to paint! There are many different compositional shapes you can use for your floral paintings, from vertical to circular, from triangular to heart-shaped. Follow the instructions presented earlier in the book for painting the individual flowers and leaves. In this section I'll show you the order in which to paint your design elements and how to arrange them to create a variety of beautiful finished paintings .

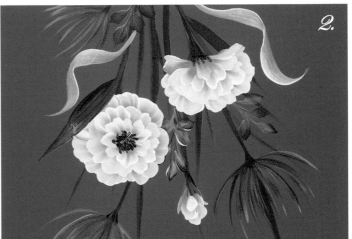

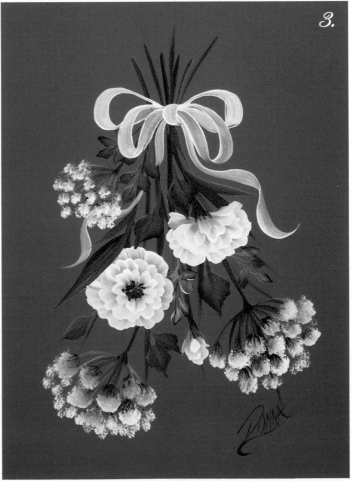

1. Begin by basecoating your background with Heather. Let dry. Paint the stems and some small leaves in a shape that looks like they're gathered together at the top. Turn your surface upside down if it's easier for you to stroke the stems from the bottom up. When these are dry, load a no. 8 flat with floating medium and pick up Wicker White. Paint a simple white ribbon and bow. The center loop is a C-stroke.

2. Place three English roses on the stems, but vary them by having a fully open blossom facing outward, a sideview rose, and a bud. Re-stroke one of the leaves over the open rose so it looks tucked into the bouquet.

3. Fill out the design and give it shape by adding three light and airy Queen Anne's Lace. These delicate blossoms contrast nicely with the layered petals of the roses. Finish by filling in any empty areas with a few more small rose leaves.

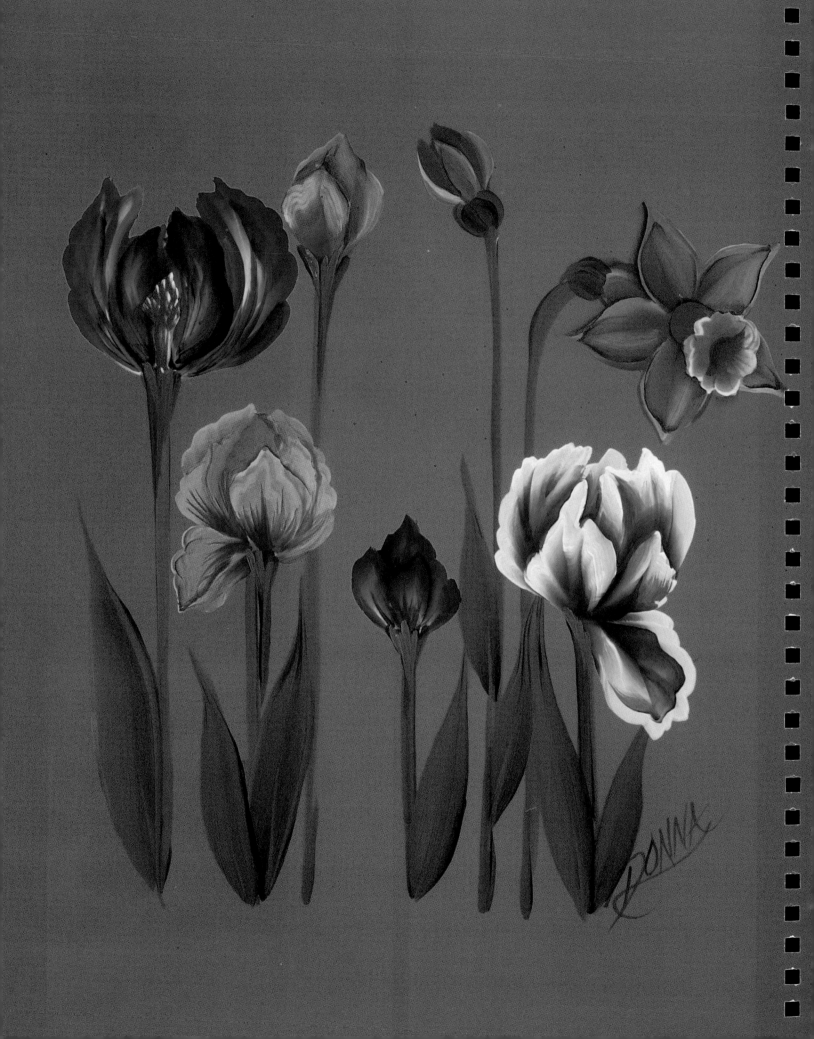

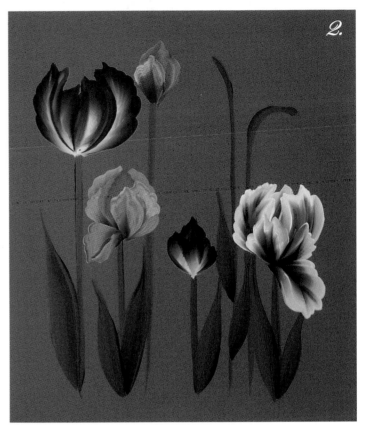

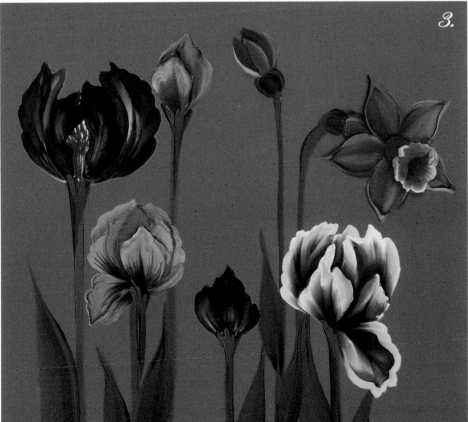

1. Basecoat your surface with two coats of Basil Green. Let dry. Establish the overall shape of the design with vertical stems for the tulips and daffodils. The tops of the daffodil stems should curve over. Soften the stems with some graceful leaves.

2. As you paint the parrot tulips, add interest to the design by letting a couple of the petals droop as they naturally would on fully open tulips. This will help relieve some of the stiffness of the vertical stems and prevent the flowers from looking frozen in place. Add a couple of buds in different stages of opening.

3. Finish with the daffodil blossoms—one fully open and nodding on its stem, and one opening bud. Detail the tulips with stamens that are in the same yellow color family as the daffodils to help tie the composition together.

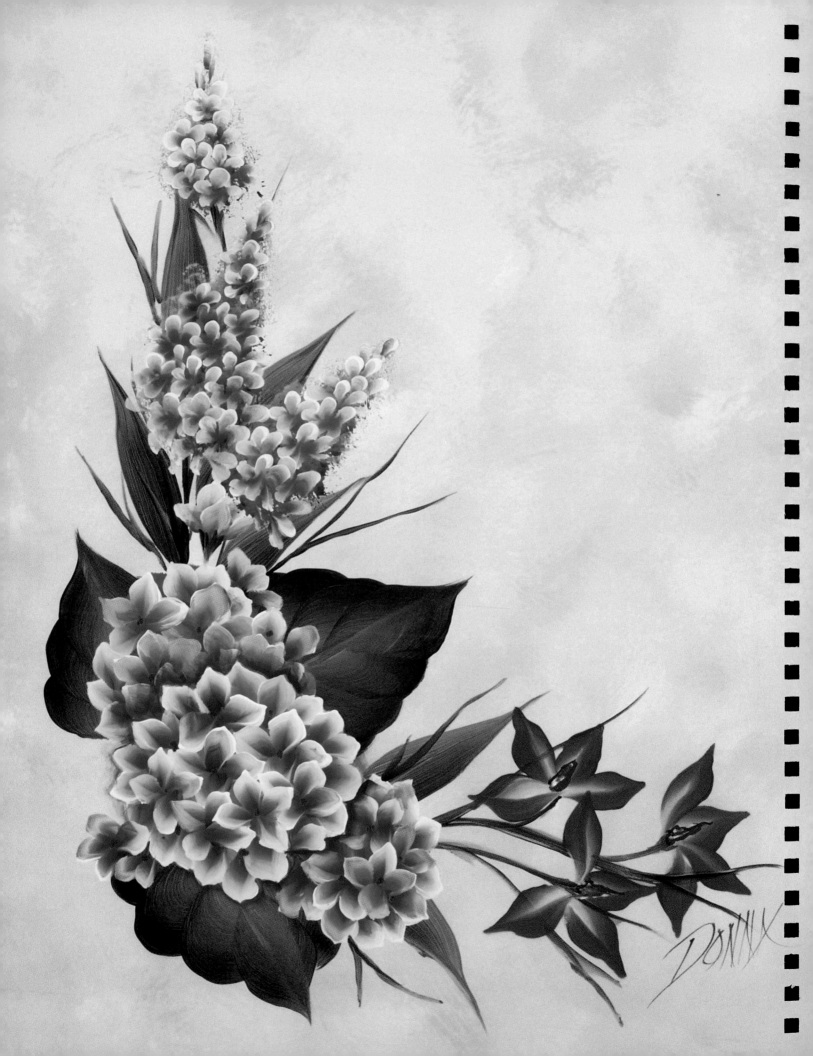

L-shape composition

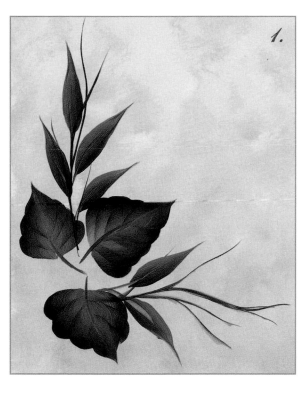

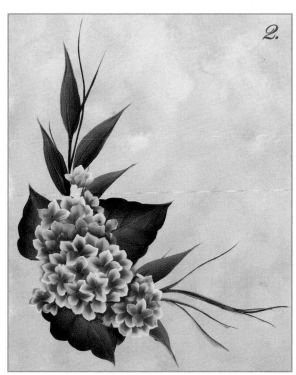

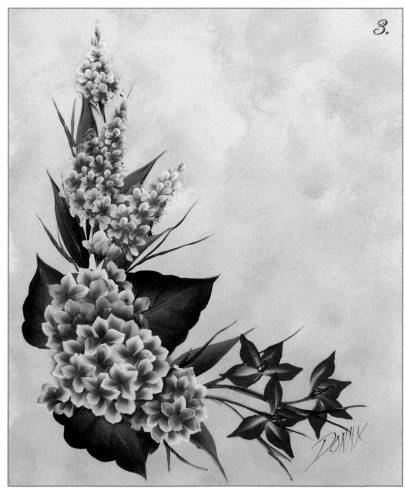

1. Begin with a Tone-on-Tone sponged background of Sunflower and Wicker White. Let dry. Establish the L-shape of the design with vertical and horizontal branches that begin at the lower left corner. Add your large leaves first, then fill in with smaller ones. Pull stems into all the leaves.

2. The flowers in this design are pink hydrangeas, lavender butterfly bush, and yellow forsythia. Place the main flower cluster—the largest, most important one—in the focal point of the composition, which is the corner where the two legs of the L-shape meet. The hydrangeas have the most weight and are the right shape for this area. I arranged the three clusters of pink florets in a slight curve to mimic the corner of the L-shape. Don't forget to float shading around the center cluster to separate it from the other two.

3. Finish with the butterfly bush blossoms extending upward and the forsythia coming out to the right. Add a few more little branches or twigs here and there to overlap the flowers and help set them back into the design. It's always a good idea to vary the textures and petal shapes of the flowers in your compositions so they don't all look the same.

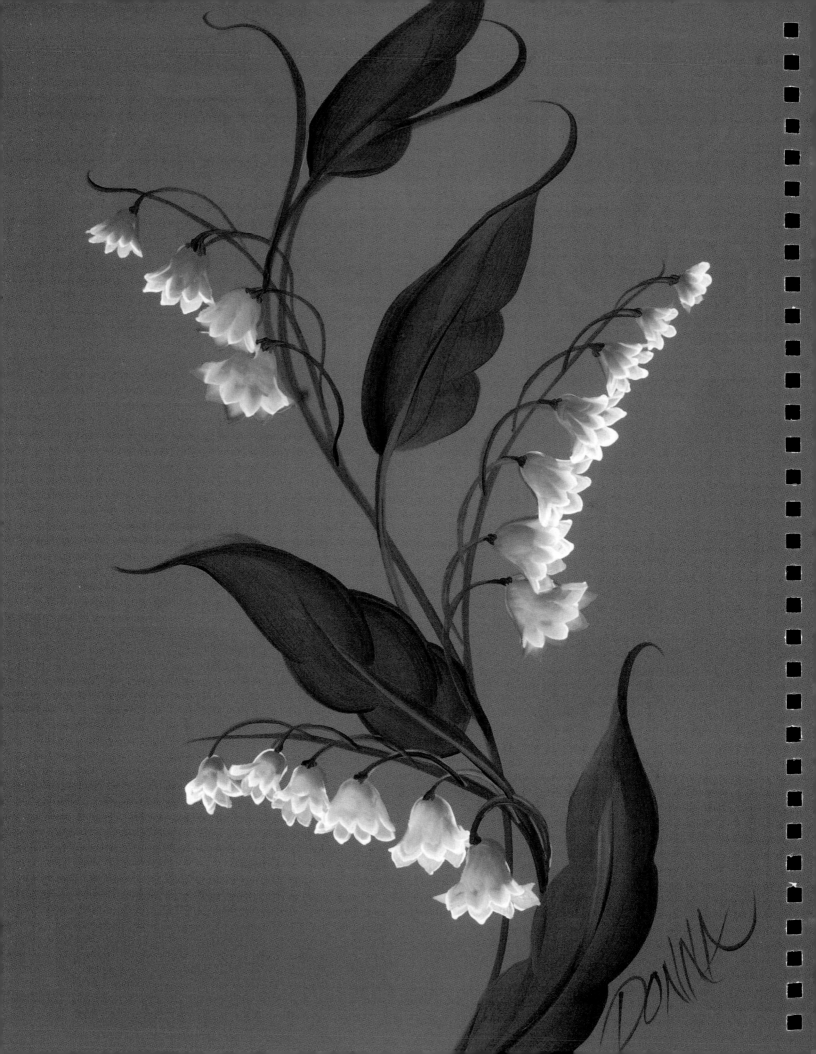

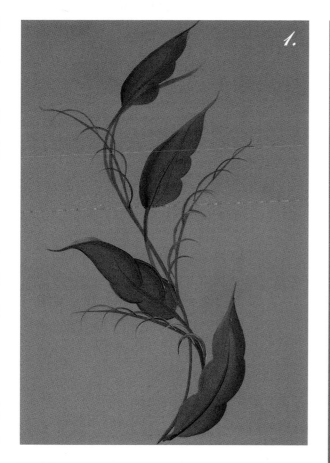

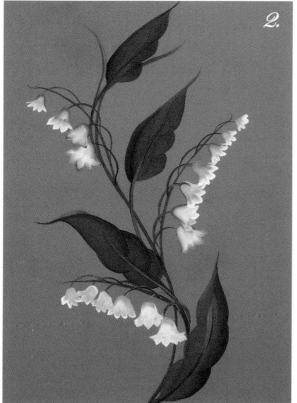

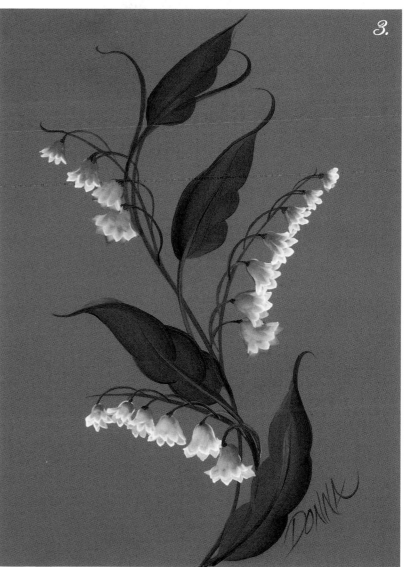

1. Here's an unusual way to use lily-of-the-valley in a design—as a vertical border! Begin with a basecoat of Basil Green. Let dry. Place the long curving vine and pull shorter stems off the main vine using the chisel edge of your brush. Paint the large leaves, then use a script liner to paint the little stemlets for the blossoms.

2. Paint the backs of all the lily-of-the-valley bells using white with a touch of light green. Vary the number of blossoms and their direction.

3. Finish each little bell by painting the fronts. Pick up more white on the brush and keep the white side to the ruffly edge of the bell and the light green side to the base. This vertical border would look lovely alongside a window frame or doorway. For a long border, keep repeating the design shown here, curving the main vine back and forth in a graceful wave.

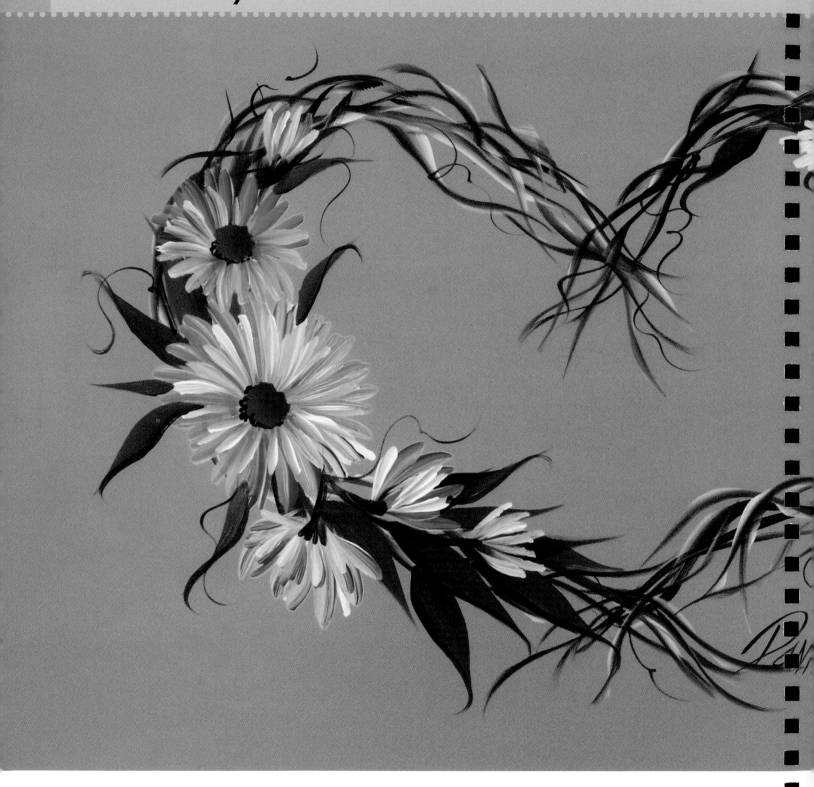

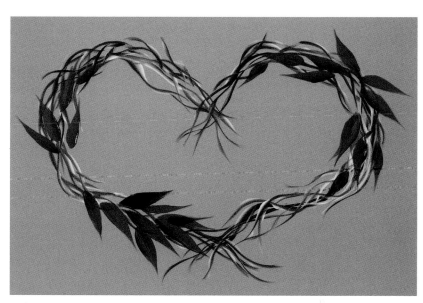

1. This heart-shaped wreath is actually a fairly horizontal design in that it's wider than it is tall. However, heart shapes can vary a lot; they can be as tall as they are wide, or they can be very tall and narrow. Begin by basecoating your surface with Linen and let dry. Establish the basic heart shape of the wreath with chisel-edge grapevines. Add long, slender leaves along the lower left curve and the upper right curve.

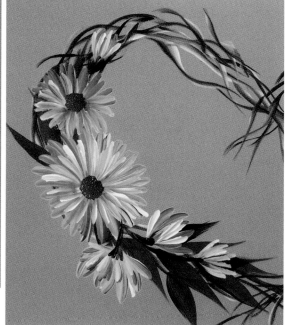

2. Place some blue daisies on the left side. These are the largest, heaviest blossoms so they should be placed along a lower curve to provide weight and stability to the design. Keep the largest daisy in the middle of the cluster and add smaller ones plus some sideview blossoms on either side.

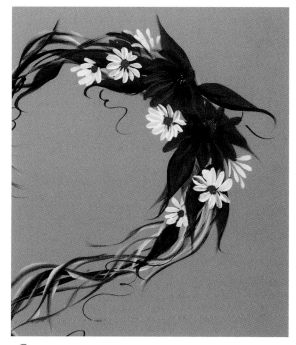

3. On the other side of the wreath, balance the design with smaller daisies in dark yellow and fresh white. Finish with tendrils and curlicues using inky paint and a no. 2 script liner. These final touches will always add airiness and lightness to any composition.

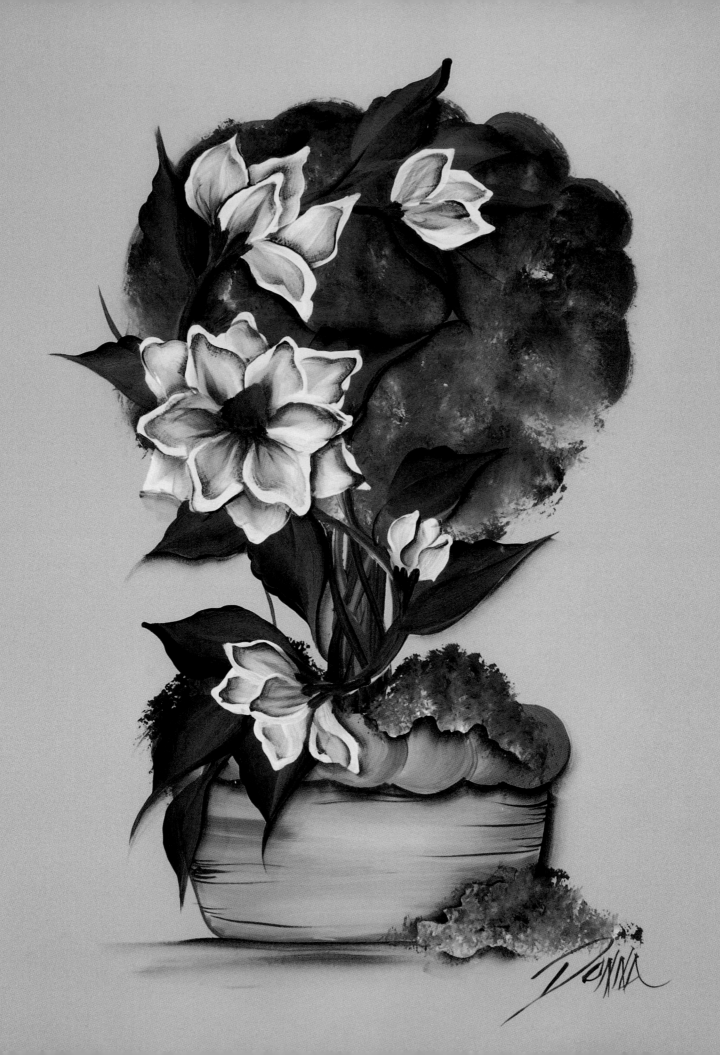

1. Topiaries are fun to paint and make a great foundation for any number of floral designs. Basecoat the background with Georgia Peach and let dry. Place the shape of the planter, the stem and the topiary ball. Use a large scruffy brush to pounce on the greenery. Here I used Thicket and Wicker White, plus a touch of Burnt Umber.

2. Pounce on moss in the top of the planter and at one side underneath. Add stems winding up into the topiary ball using the chisel edge of your flat brush. Place some large wiggle-edge leaves along the branches and pull stems into them.

3. The magnolia blossoms are painted with Wicker White and floating medium. Float shading around the inside edges of the petals and between the petals with Burnt Umber and lots of floating medium. Float shading around the outside of all the magnolias to separate them from the topiary ball. Float shading under the rim of the planter and under the mossy areas, and add roundness to the planter with curving lines coming in from both sides.

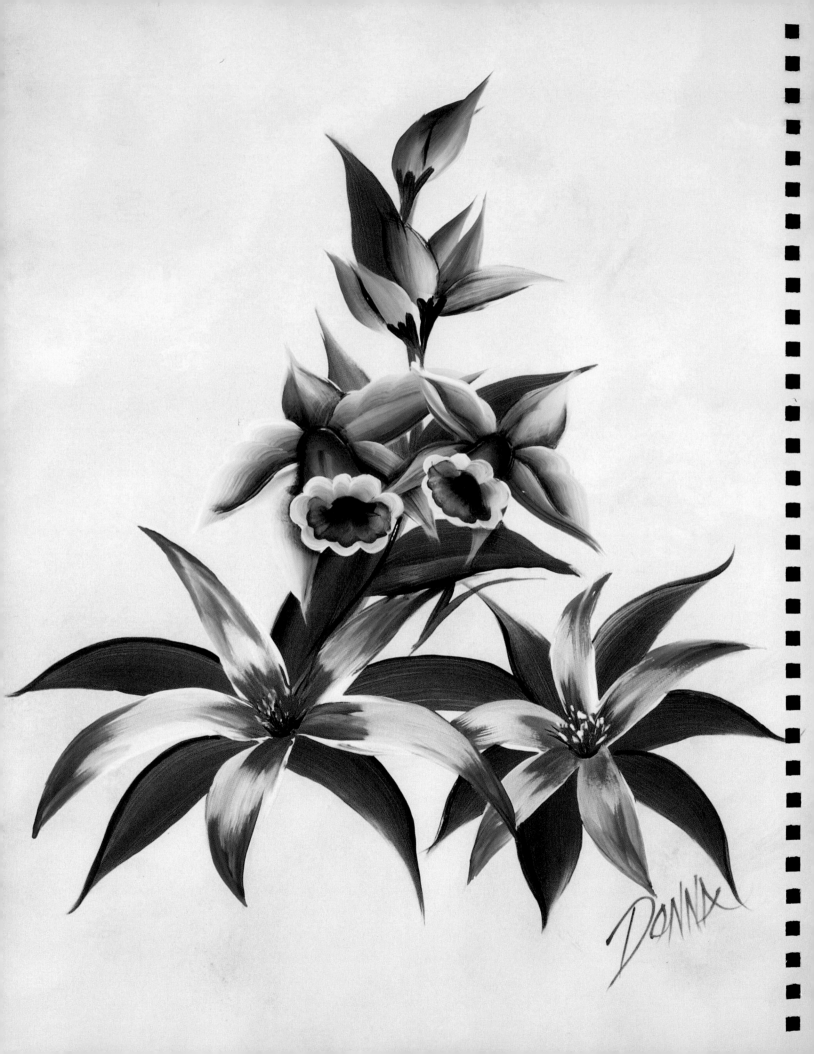

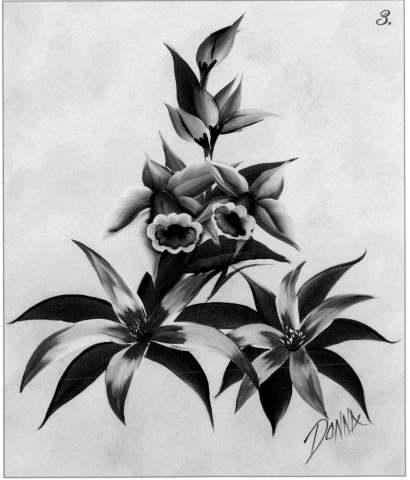

1. Triangle shapes are easy to design and look wonderfully natural—that's why you see them in so many floral arrangements of silk or live flowers. Begin with a sponged-on background of Wicker White with a touch of Basil Green. Place some wide plants at the base of the triangle, such as these bromeliads, and create the tall center with stems and elongated leaves. These leaf shapes echo the shapes of the bromeliad leaves.

2. Finish the coloration of the bromeliads and add the center stamens.

3. Fill in the top of the triangle with orchids and buds. The open blossoms go in the middle where they provide some width to the triangle. The buds extend upward at the top to carry the line to a point. Notice that you do not have to have your topmost bud pointing straight upward. That would be boring and predictable. Instead, let it lean slightly to one side just as it would in nature.

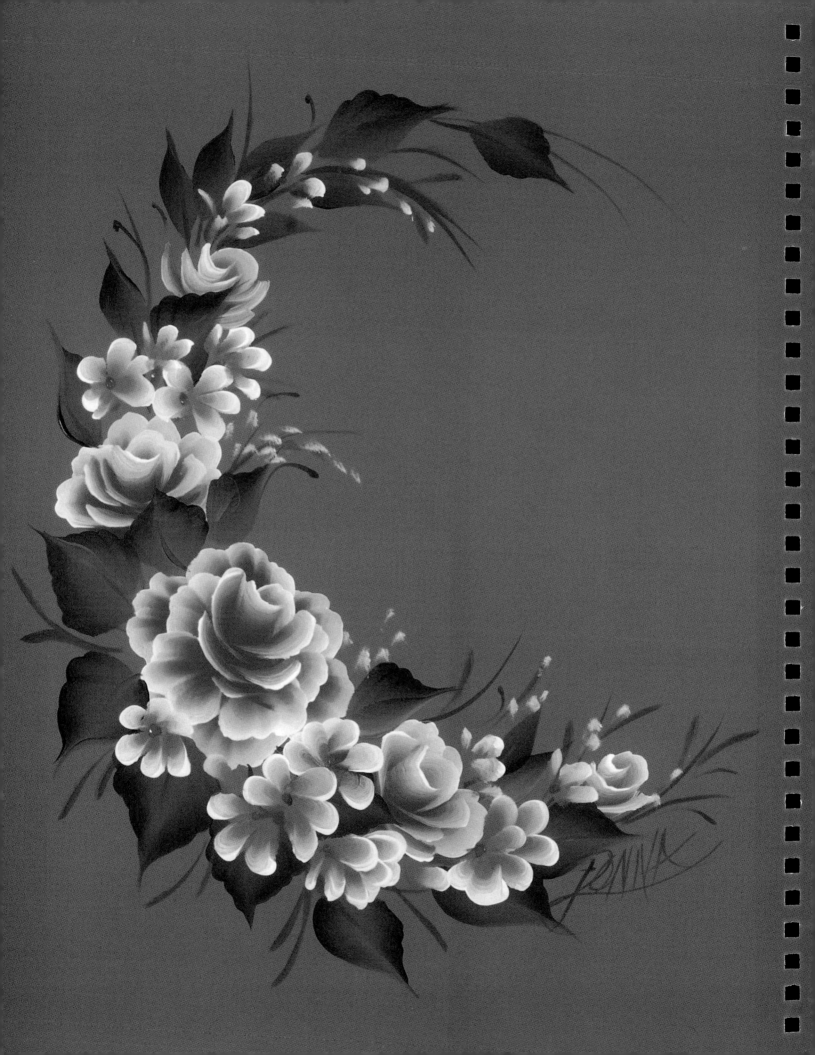

c-shape composition

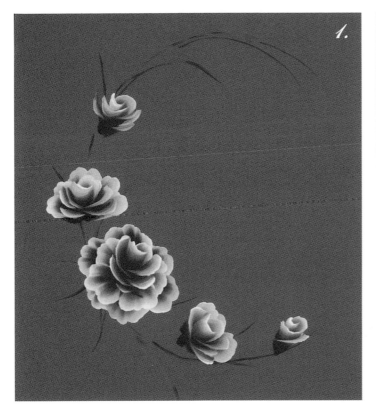

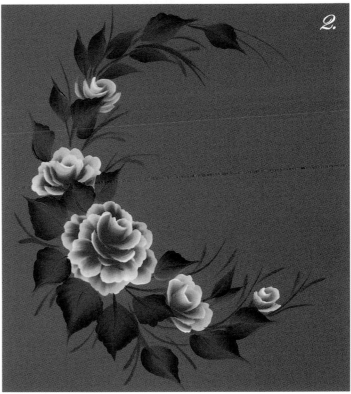

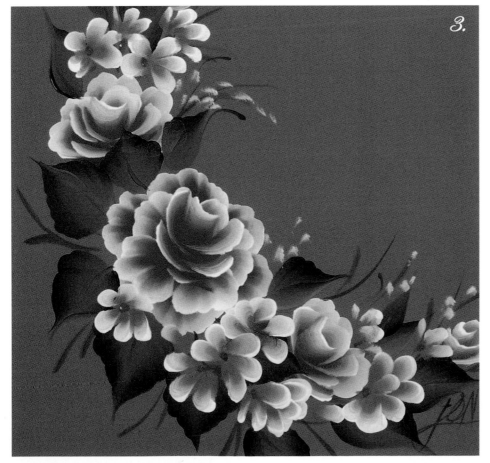

1. The C-shape is a very graceful design and can be used in many applications. Begin with a basecoat of Butter Pecan and let dry. Lightly chisel edge some curving stems to establish the basic C-shape, then pull smaller stems off the main ones. Place an odd number of yellow roses (3 or 5) along the stems, with larger ones in the middle, tapering off to buds on the ends.

2. Fill in with lots of leaves and pull stems into the leaves. To break up the space and add a feeling of airiness, extra stems and green twigs can be pulled out from the main grouping of flowers and leaves.

3. For sparkle, paint little five-petal flowers among the roses with white, and dot on yellow centers. Finish your composition by lightly dabbing on little white buds extending out into the center area, and from the top and bottom arcs of the C-shape.

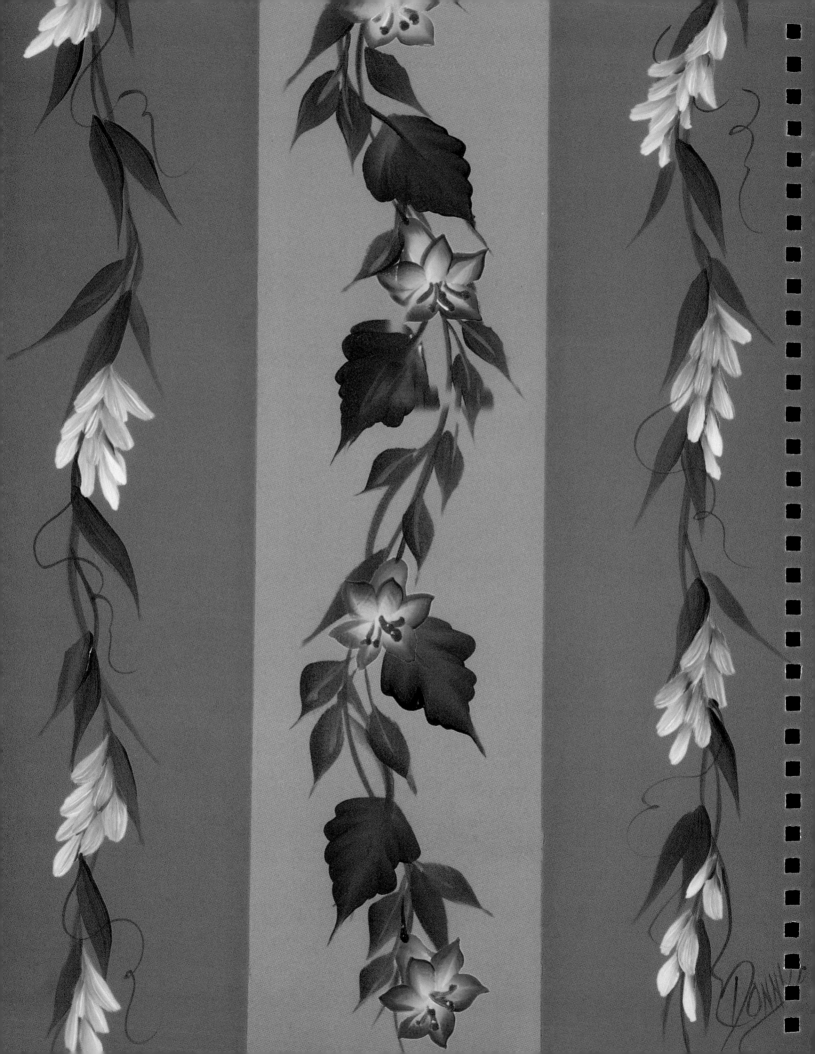

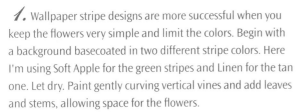

1. Wallpaper stripe designs are more successful when you keep the flowers very simple and limit the colors. Begin with a background basecoated in two different stripe colors. Here I'm using Soft Apple for the green stripes and Linen for the tan one. Let dry. Paint gently curving vertical vines and add leaves and stems, allowing space for the flowers.

2. On the two green stripes, paint some simple lavender-like flower buds that all face downward. Finish these stripes with tendrils and curlicues using inky green paint on a no. 2 script liner.

3. The center stripe looks best with a differently shaped flower but in the same colors to bring consistency to the design. Detail the purple trumpet flowers with green stamens. Fill in the empty places between the flowers with little one-stroke leaves.

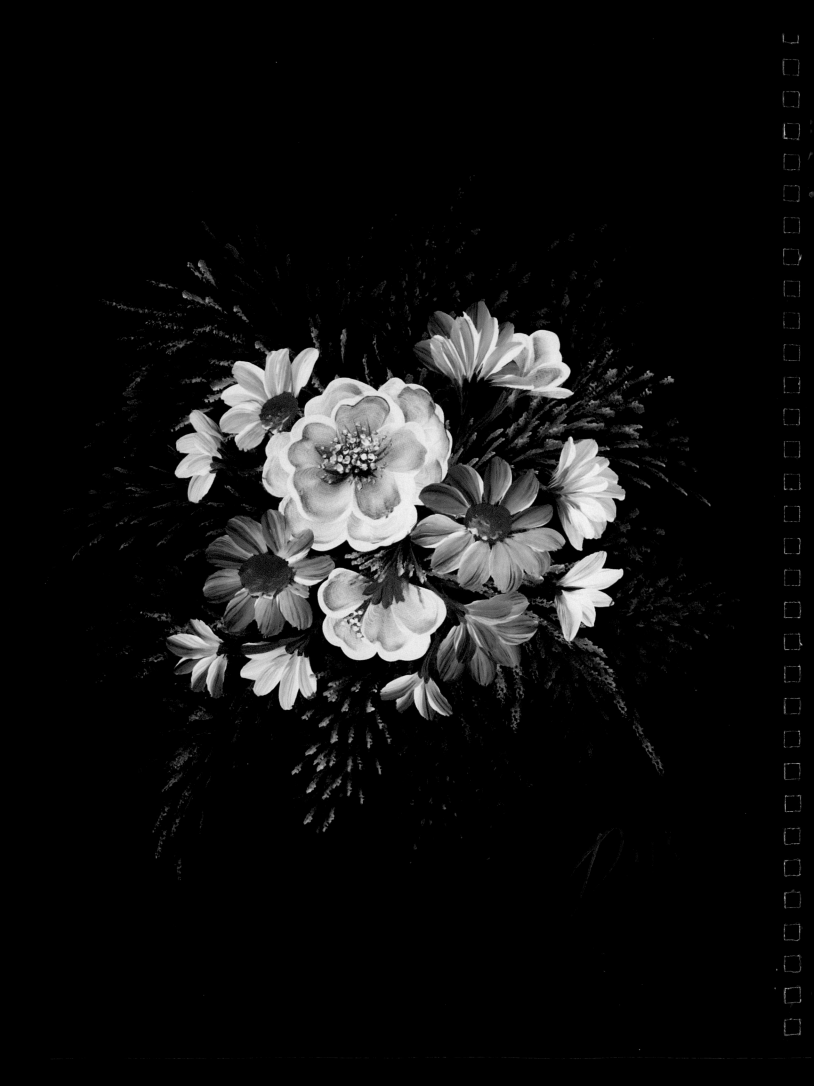

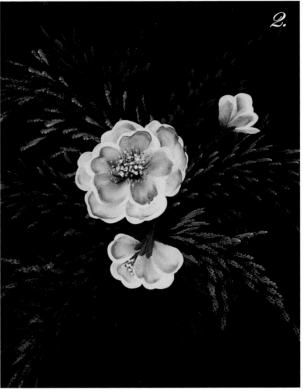

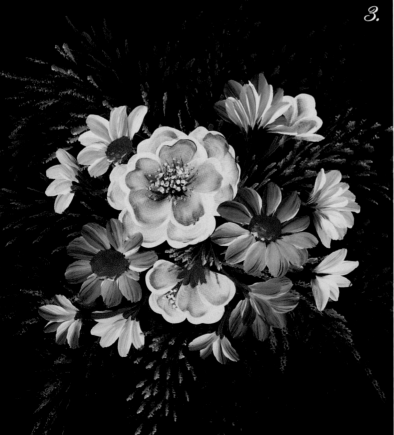

1. "Round" is the shape of bridal bouquets and posies. A successful round design should look like a sphere, not just a circle. It should also be allowed to break out of the boundaries around the edges, as I've done here with these tiny fern leaves. Begin with a basecoat of black and let dry. Lightly place a few stems radiating outward from the center, then tap on feathery fern leaves with the chisel edge of the brush.

2. Place the largest pear tree blossom near the center, but not dead center. Work outward with smaller sideview pear tree blossoms.

3. Fill in around the white blossoms with cosmos in varying shades of pink. To help attain a spherical shape, place your largest blossoms, the fully open ones, around the center. As you work outward from these, turn the blossoms to sideview, and as you reach the outermost part, finish with the smallest buds. If needed, fill in any empty areas with a few more fern leaves.

resources

index

U.S. RETAILERS

Paints, Brushes and Mediums

Plaid Enterprises, Inc.
3225 Westech Dr.
Norcross, GA 30092
Phone: 678-291-8100
www.plaidonline.com

Dewberry Designs, Inc.
355 Citrus Tower Blvd.
Clermont, FL 34711
Phone: 352-394-7344
www.onestroke.com

CANADIAN RETAILERS

Crafts Canada
120 North Archibald St.
Thunder Bay, ON P7C 3X8
Tel: 888-482-5978
www.craftscanada.ca

Folk Art Enterprises
P.O. Box 1088
Ridgetown, ON, N0P 2C0
Tel: 800-265-9434

MacPherson Arts & Crafts
91 Queen St. E.
P.O. Box 1810
St. Mary's, ON, N4X 1C2
Tel: 800-238-6663
www.macphersoncrafts.com

U.K. RETAILERS

Crafts World (head office)
No. 8 North Street
Guildford
Surrey GU1 4 AF
07000 757070

Green & Stone
259 Kings Road
London SW3 5EL
020 7352 0837
www.greenandstone.com

Help Desk
HobbyCraft Superstore
The Peel Centre
St. Ann Way
Gloucester
Gloucestershire GL1 5SF
01452 424999
www.hobbycraft.co.uk

FLOWERS A TO Z WITH DONNA DEWBERRY

Painting your favorite flowers is easy and fun with Donna Dewberry's popular One-Stroke technique! You'll see how to paint more than 50 garden flowers and wildflowers in an array of stunning colors. Discover Donna's secrets for painting leaves, vines, foliage, flower petals, blossoms, and floral bouquets. Add beauty and elegance to any project including furniture, walls, pottery, birdbaths and more!

ISBN-13: 978-1-58180-484-3
ISBN-10: 1-58180-484-9
Paperback, 144 pages, #32803

FANTASTIC FLOORCLOTHS YOU CAN PAINT IN A DAY

Want to refresh your home décor without the time and expense of extensive redecorating? Then painting canvas floorcloths is for you! Choose from 23 projects simple enough to create in a few hours. Favorite decorative painters Judy Diephouse and Lynne Deptula show you step by step how to paint designs ranging from florals to graphic patterns to holiday motifs, including some especially appropriate for kids' rooms. Plus, 12 accessory ideas inspire you to create coordinated looks for any room. *Fantastic Floorcloths You Can Paint in a Day* makes adding creative touches to the home as easy as picking up a paintbrush.

ISBN-13: 978-1-58180-603-8
ISBN-10: 1-58180-603-5
Paperback, 128 pages, #33161

PAINTING BORDERS FOR YOUR HOME WITH DONNA DEWBERRY

Donna shows you how to use her renowned One-Stroke method to create colorful borders that give elegance and style to every room in your home. Coordinating borders accompany each project so you can make perfect accessories. With photos showing the borders in actual homes, you'll find the inspiration you need to create masterpieces for walls and furniture throughout your house.

ISBN-13: 978-1-58180-600-7
ISBN-10: 1-58180-600-0
Paperback, 128 pages, #33125

FAST & FUN FLOWERS IN ACRYLICS

Popular artist Lauré Paillex shows you everything you need to create fun, bright and colorful flowers of all kinds! You'll find more than 60 step-by-step demonstrations that give you great results in a jiffy. No demo is more than six steps long, and the convenient lay-flat spiral binding makes this a book you'll keep open on your painting table for quick reference any time. From garden flowers to wildflowers, from spring bulbs to roses and orchids, you'll find just the flower you need for any project—or just for the fun of painting!

ISBN-13: 978-1-58180-827-8
ISBN-10: 1-58180-827-5
Hardcover, 128 pages, #33503

These books and other fine North Light titles are available from your local art & craft retailer, bookstore or online supplier.